Made for Walking

Made for Walking

Density and Neighborhood Form

Julie Campoli

LINCOLN INSTITUTE
OF LAND POLICY
CAMBRIDGE, MASSACHUSETTS

Library of Congress Cataloging-in-Publication Data

Campoli, Julie.
 Made for walking : density and neighborhood form / Julie Campoli.
 p. cm.
 Includes bibliographical references and index.
 ISBN 978-1-55844-244-3
 1. Pedestrians—United States. 2. Spatial behavior. 3. Urban transportation—United States.
 4. Choice of transportation—United States. 5. Community development, Urban—United States.
 I. Lincoln Institute of Land Policy. II. Title.
 HE336.P43C36 2012
 388.4'1 — dc23
 2012039064

Produced by Vern Associates, Inc., Amesbury, Massachusetts
Designed by Peter M. Blaiwas
Composition by Glenna Collett
Production by Susan McNally

Printed and bound by Capital Offset Company in Concord, New Hampshire.
The paper is Endurance Silk text, an acid-free, recycled sheet.

MANUFACTURED IN THE UNITED STATES OF AMERICA

Contents

Foreword

The image-rich urban design book *Visualizing Density*, coauthored by Julie Campoli and aerial photographer Alex S. MacLean, was an unusual "blockbuster" for the Lincoln Institute of Land Policy when it was published in 2007. It explored such topics as why we hate density and how we can come to love it, offered detailed guidance on ways to plan and design for density, and provided a density catalog with more than 1,000 aerial photographs representing a range of residential densities from less than one to more than 200 units per acre. The book included a compact disc of these images to encourage readers to use them in educational settings and at public meetings. It has been gratifying to learn that some development projects that, because of perceived density issues, initially encountered community opposition at planning and zoning hearings later gained approval following a viewing of comparable neighborhoods from the catalog.

Virtually from its launch, readers have called for an on-the-ground version of *Visualizing Density* that helps communicate people's everyday experience of density. *Made for Walking* contains more than 450 street-level views of neighborhoods in North America, but it is more than a sequel to the earlier volume. In this new work, landscape architect and urban designer Julie Campoli takes us beyond simple measures of density to describe the characteristics of places that provide an alternative to the automobile-dependent suburb. This will interest all who are concerned about the high cost of energy, seek a more urban lifestyle, or want to reduce their annual vehicle miles traveled (VMT) as a way to reduce greenhouse gas emissions that affect climate change and the quality of our urban environment.

Providing more transportation options that encourage walking, biking, and transit will necessitate a shift in land use patterns and the way we locate and shape future development. We need to think about urban density conceptually as including the density of jobs, schools, and services, such as retail, community resources, and recreational facilities. Fitting more amenities into a neighborhood within a spatial pattern that invites walking creates a built environment that offers real transportation options. Through her engaging text and dramatic photographs, Campoli challenges our notions of space and distance and helps us learn to appreciate and cultivate proximity.

Researchers who examine the impact of urban form on travel behavior identify specific characteristics of place that boost walking and transit use while reducing VMT. In the 1990s some pinpointed diversity, density, and design as the key elements of the built environment that, in specific spatial patterns, enable alternative modes of transportation. Later two other "Ds"—distance to transit and destination accessibility—were deemed equally important and together they became known as the "five Ds." The addition of another key player, parking, brought the count to six attributes that have become useful as shorthand for defining and measuring compact form and, in the process, predicting how that form will affect travel and reduce VMT. They also correspond to characteristics of compact development touted by smart growth advocates. Lowering VMT by any significant measure will require integrating these attributes at a grand scale.

While thinking big is essential, this book visualizes a low-carbon environment in smaller increments by focusing on 12 urban neighborhoods, each covering a comfortable pedestrian walk zone of approximately 125 acres. Some are in familiar cities with historically dense land use patterns, intertwined uses, and comprehensive transit systems; others have emerged in unexpected locations, where the seeds of sustainable urban form are taking root on a micro level. The following 12 case studies are richly illustrated to show both their variety and their commonalities.

- LoDo and the Central Platte Valley, Denver, Colorado
- Short North, Columbus, Ohio
- Kitsilano, Vancouver, British Columbia
- Flamingo Park, Miami Beach, Florida

- Little Portugal, Toronto, Ontario
- Eisenhower East, Alexandria, Virginia
- Downtown and Raynolds Addition, Albuquerque, New Mexico
- The Pearl District, Portland, Oregon
- Greenpoint, Brooklyn, New York
- Little Italy, San Diego, California
- Cambridgeport, Cambridge, Massachusetts
- Old Pasadena, Pasadena, California

Each of these sites was selected because it offers choices: travel options, housing types, and a variety of things to do and buy. Their streets are comfortable, attractive, and safe for biking and walking. They all show how compact development can take shape in different regions and climates. Six specific qualities make them walkable—connections, tissue, densities of housing and population, services, streetscape, and green networks—all of which are measured and represented in a consistent series of graphic diagrams for easy comparison among the 12 neighborhoods.

Many of these places have shared a similar historical arc—bustling growth followed by decline and depopulation as a rail-based transportation system was superseded by one that dispersed economic energy in more diffuse patterns at the edges of cities. The bad years often took their toll, eating away at the intricately connected urban fabric. By the end of the twentieth century, however, the story was beginning to change as new urban dwellers discovered the attractions of these older neighborhoods.

In addition to the potential offered by existing downtown neighborhoods, we can apply lessons from these older places to new and infill development that emulates their "good bones"—human-scale buildings and networks of small blocks and connected streets. In the process we can create many more appealing neighborhoods that are made for walking.

Armando Carbonell
Senior Fellow and Chair
Department of Planning and Urban Form
Lincoln Institute of Land Policy

Made for Walking

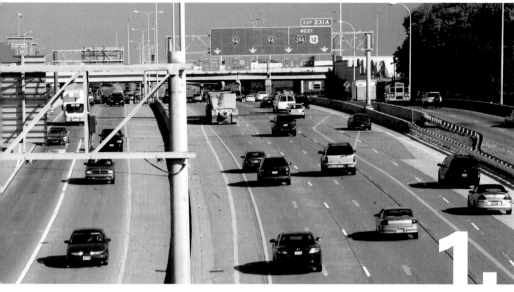

1. Everything Is Somewhere Else

Everything in life is somewhere else, and you get there in a car.

—E. B. White (1982, 109)

THERE AND BACK

Every weekday morning, Bill Hurst backs his Chevy Impala out of the garage and pulls away from his home in rural Venersborg, Washington. Cruising along the edge of the Cascade Mountains foothills, he passes though forests and fields peppered with farms and isolated homesteads. After several miles, the open landscape gives way to scattered houses and eventually to the subdivisions flanking Interstate 205 around Vancouver, Washington. Bill merges onto the beltway and works his way across the Columbia River through rush-hour traffic to his office in downtown Portland, Oregon. He has traveled 22 miles.

The Hurst's oldest child, Nicole, leaves home a half-hour later than Bill and drives much of the same route, diverting from her father's path only to enter Vancouver for her class at a local college 18 miles from home. Bill's wife, Darcy, has a shorter commute of about five and a half miles to her job in nearby Battle Ground, Washington. The only member of the Hurst family who does not begin her day alone in a car is the youngest, Jori. Leaving at 6:30 a.m., she is the first one out of the house. Jori walks to the end of the road to wait for the school bus to pick her up on its meandering nine-mile journey to Battle Ground High School.

In the afternoon, Darcy returns from work and waits for her daughter's bus, and they both climb into the car to take Jori to rugby practice eight miles away. Next Darcy travels six miles to a local park to enjoy a walk with friends. Even though the Hursts do most of their shopping and errands on the way to and from work, they often find themselves in Battle Ground on weekends, too. Darcy also makes a weekly 27-mile round trip to visit family.

All told, just for essential travel in 2011, the Hurst family drove roughly 627 miles each week (figure 1.1). And like most families, they added more miles to their odometers by making occasional trips for health care visits, family gatherings, summer vacations, visits to friends, college tours, and sporting events.

The Hursts' routine is familiar to most American families whose daily schedules send them off to work or school at different times and in different directions, usually in a car. Like the Hursts, they tend to drive farther than the average, and these families are what the U.S. Department of Transportation's National Household Travel Survey (NHTS) classes a high-mileage household (FHA 2009). They live in a single-family neighborhood in a low-density town, two family members' daily destinations are located 30 minutes from home, and all the places they visit regularly are beyond walking distance. They own several cars because that proves more time-efficient and convenient than sharing rides.

Since 1969 the NHTS has questioned Americans regularly about the details of their travel habits, their household demographics, and their living environments. It gathers information on the number of trips people take and the miles their vehicles travel. These data help guide decisions about transportation policy and provide a rough sketch of a nation devoted to and dependent on cars. Embedded in the 2001 tables are statistical profiles of uniquely American travel behavior (FHA 2004). Within a single day the average American makes roughly four car trips and spends an hour traveling a total of about 40 miles, usually alone. In 2009, 59 percent of households owned at least two cars, and 23 percent claimed three or more vehicles.

Americans rarely go anywhere without first reaching for their car keys. A tiny fraction of the population regularly climbs on a bus,

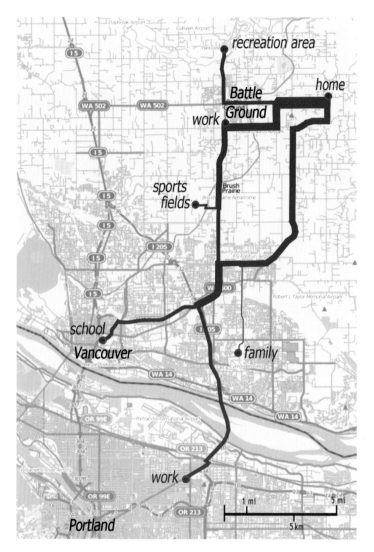

Figure 1.1 **Hurst Family Commute Zone**. With daily destinations extending over 80 square miles (their commute zone), the Hurst family drives a combined 627 miles each week for essential travel. The thickness of each blue band reflects the frequency of travel along a particular road segment. Source: Map data © OpenStreetMap contributors, CC-BY-SA.

and an even smaller number sets foot on a subway platform. Although we may stroll through a mall or around the block for exercise, only 8 percent of routine trips are on foot, and only 2 percent of workers walk to their job locations. We may pull our bikes out of the garage for a family vacation, but the number of people who pedal to work accounts for just 0.4 percent of the population—a figure so low it's often lumped into that vague and insignificant statistical category "other" (Davis, Diegel, and Boundy 2010).

On an individual basis, this reliance on the car may be acceptable, depending on the traffic conditions or the price of gas, but the fact is that we have no choice. For most of us, there is no convenient bus and certainly no job within walking distance. In most of the places we live and work, we can take a walk, but we can't walk to get somewhere because that somewhere is too far away. Most communities are designed with the assumption that distance is a virtue, that more space between neighbors and neighboring activities is better than less. Behind the wheel of a fast, comfortable car those distances are imperceptible. Without a car, however, all that excess space—the large lots, the buffers, the setbacks, the turning lanes, on-ramps, and clear zones—creates a huge barrier between us and the places we need to go.

Jori Hurst understood this implicitly. In the winter of 2011 she was counting the days to her sixteenth birthday, when she would trade in her learner's permit for a driver's license and claim the Ford Focus her sister left behind when she moved away for college. Jori was frustrated by her distance from her friends and was eager to gain control of her schedule by driving herself.

In this era of volatile energy prices and persistent congestion, an increasing number of Americans would prefer alternatives that are cheaper, faster, or more convenient than driving. In order to leave the car at home once in a while, they want to take a bus, walk, or ride a bicycle. But providing transportation options is more complex than creating a bus route, building sidewalks, or striping a bike lane. It's not a problem that can be solved simply by greater transportation funding. It demands a shift in our land use patterns and the way we locate and shape future development. To make that change, we must challenge our current notions of space and our obsession with distance and learn to appreciate and cultivate proximity.

When the price of gas spiked in 2008, the Hurst family made some changes. They shifted their schedules in order to share rides and eliminated unnecessary journeys into town by combining errands whenever possible. This was when they consolidated their major food shopping into two trips per month, and Darcy began stopping for produce on her way home from work. Bill got into the habit of keeping shopping lists handy and commuted in whichever car needed gas to avoid unnecessary trips just to fill the tank. Later, when gas prices declined, the family gave up these money-saving practices only to return to them a few years later when the pump price inched back toward four dollars per gallon.

The Hursts face a problem common to households all over North America—how to prevent the cost of filling their gas tanks from consuming too large a share of the family budget. They needed to drive less or, to use transportation planners' lingo, to lower their VMT (vehicle miles traveled).

Researchers who analyze travel behavior with an eye toward lowering VMT have identified three separate components of travel: *trip frequency*—the number of times you go somewhere; *trip length*—how far you go; and *mode choice*—whether you travel by private vehicle, public transit, bicycle, or on foot. Trip frequency is affected more by a household's personal circumstances than its built environment. Trip length depends more on the built environment and less on personal circumstances. Mode choice is influenced by both factors (Ewing and Cervero 2010).

When the price of gas goes up and the Hursts need to lower their household VMT, trip frequency is the only variable they can control. They reduce the number of times they drive by sharing rides and altering their routines. But the length of each trip is dictated by the built environment. They can't choose a closer supermarket, hardware store, or athletic facility because there aren't any. Their corner of Clark County, Washington, has a population density of 341 persons per square mile (ppsm)—too low to support more than a few widely scattered services. This dispersed development pattern also prevents the Hursts from choosing a different mode of travel.

According to comedian Steven Wright (2010), "Everywhere is walking distance if you have the time." But no one living in exurbia has the kind of time it would take to walk to the places they need to go. The eleven-mile round-trip walk to Darcy's job would add four hours to her workday. And getting to his job in downtown Portland without a car would take Bill five hours each way: a three-hour walk to the nearest Clark County transit (C-TRAN) stop plus two hours on four different bus routes. Their neighborhood doesn't offer a large enough pool of potential riders for C-TRAN to warrant extending the service. Biking would be faster than walking but, according to Darcy, they would not consider that option given the hilly terrain and the danger of biking on narrow roads with fast-moving cars.

While Mark and Sally Brown Russ of Houston, Texas, have similar personal circumstances—their family of five navigates a complex daily routine—their built environment provides more leeway for them to reduce the number of miles they drive. They live in a more densely built-up area, and because many destinations are within a few miles of their house, every week they travel half the distance the Hursts do. Mark commutes 23 miles each way from his Houston neighborhood to an exurban office park, but the rest of the family members' trips are short—most under three miles—to nearby schools, sports fields, and grocery stores. The family's weekly total is about 350 miles (figure 1.2). Like the Hursts they can share rides and combine errands to limit their trip frequency, but because they live in a place with a wider array of businesses and services, they also can opt to limit the length of their trips by choosing closer destinations.

The West U district of Houston, where Sally and Mark live, is subdivided into narrow parcels, most of them smaller than a third of an acre. The neighborhood consists entirely of detached single-family homes, but the tight arrangement of buildings on small lots results in a population density of 6,200 ppsm—about twice the density of the typical American suburb. Most of the family's trips are a few miles long or less, and some destinations are as close as a quarter mile.

Despite the relatively high density and short distances, the Russes still drive almost everywhere they go. Sidewalks run the length of their tree-lined street, and the blocks around their house are quiet and pleasant, but the stores, schools, and most other places they go every day lie beyond these residential zones, strung along seven-lane highways and isolated by parking lots. Sally is weary of her role as family chauffeur, but the prospect of her children darting 90 feet from curb to curb in front of idling engines and then dodging around moving vehicles prevents her from letting them walk. And although she thinks she might benefit from the exercise of biking to the store

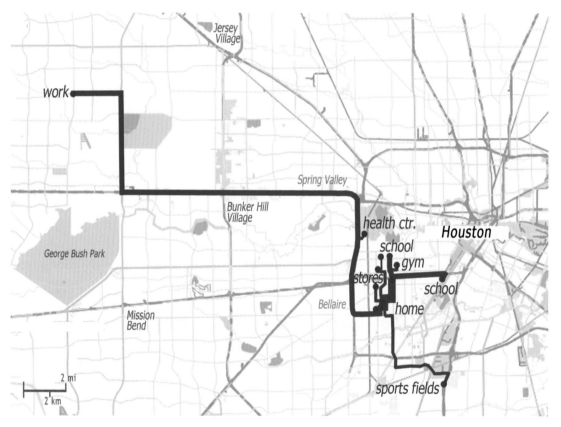

Figure 1.2 **Russ Family Commute Zone**. Despite Mark's long commute to work, the rest of the Russ family's routine travel is confined primarily to an area of roughly 20 square miles. The West U district of Houston, with a density of 6,200 ppsm, offers a wide variety of services, but walking to them is not easy.

Source: Map data © OpenStreetMap contributors, CC-BY-SA.

or gym, she rarely does so because it's simply not a pleasant experience. In transportation terms, their neighborhood offers short trips but little in the way of mode choice. The West U area is dense by the square mile but not by the foot. It lacks the kind of connected urban fabric that makes walking an attractive option.

DENSITY BY THE FOOT

Density is often defined in terms of population per square mile, but such a crude measure makes it difficult to understand the relationship between density and transportation systems. We need to think about urban density in more complex ways, by including the density of jobs, schools, and services such as retail, transit, and recreational facilities in our consideration. Fitting more amenities into a neighborhood within a spatial pattern that invites walking will create the type of built environment that offers real transportation options. This requires planning at a pedestrian scale and designing an environment that is comfortable for a human being as she moves through it at a walking pace—building density measured not by the square mile but by the foot.

The best density—the kind found in urban places to which people become attached and cherish over time—is designed to be experienced on foot. Sidewalks are flanked by functional spaces such as entrances, window displays, small gardens, or public parks. Street frontage has a high value and every foot of it is maximized, with space divided in small increments. The scene varies with each step, unfolding invitations to look at and possibly enter a diversity of places along the way. Uses stack vertically, buildings share walls, and everything is nearby and connected by sidewalks, hallways, stairways, or elevators. Space is allocated in small, human-sized units. This quality can be found on the streets of the New York City borough of Manhattan as well as in communities of all sizes from Toronto, Ontario, to Savannah, Georgia, to Bisbee, Arizona.

With an average density of 18,000 ppsm, North American cities in 1910 were dense by the foot, and very few cars were on the streets. A century ago, urban neighborhoods offered the pedestrian most of the amenities, services, and destinations she would need within walking distance. But over the course of the twentieth century, as we strove to accommodate the circulation and storage needs of the car, the increments of urban space mushroomed. Our sense of scale, which had been grounded in human footsteps, shifted to one measured in miles per hour.

As cities expanded outward, their densities shrank (Angel et al. 2011). Our notion of what fits within a given space is now very different. We no longer seem able to think small, which makes it difficult to create fine-grained urban environments. In fact, the failure to grasp pedestrian scale may be the biggest obstacle to replicating the patterns of our best-loved urban places. Eight decades behind the wheel have distorted our sense of distance and eroded our ability to divide urban space into increments that are comfortable for human beings. From a driver's perspective it is hard to believe that 60 feet could be an appropriate width between opposing building fronts. But when walking along a street between three-story buildings, 60-foot spacing feels just about right.

Plenty of neighborhoods are dense by the foot—real places in the United States and Canada where one can live well without spending much time in a car. Many of these places survive from the pre-automotive era, when they had been built around harbors, train stations, or streetcar lines. Their dense networks of homes and shops on small lots and narrow streets were designed to be traversed on foot.

The Boston, Massachusetts, neighborhood of Jamaica Plain, where Etty Padmodipoetro and her husband Joe Allegro live with their five children, is such a place. Like the Hursts and the Russes, their family performs a complex daily ritual of travel as its members disperse across a wide area. Unlike those two other families, however, Etty and Joe drive only about 150 miles a week. They and their children rely heavily on the T, Boston's public transit system, to get to work and school (figure 1.3). Apart from a weekly trip to an outer suburb for their son's science class, which doubles as a trip to the big box stores, their social lives, shopping, and children's activities take place in the dense network of institutions, shops, and homes in the vicinity of their street in Jamaica Plain, all of which

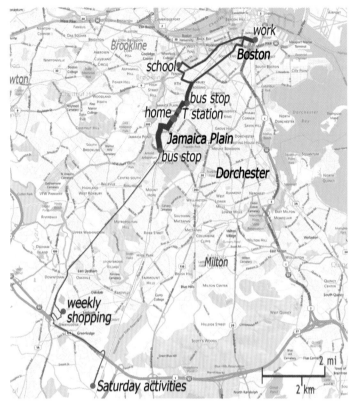

Figure 1.3 **Commute Pattern of the Padmodipoetro-Allegro Family.**
Despite their busy schedules (two working parents and four children living at home), this family drives many fewer miles daily than the other two. They use school buses, the T, and walking to get to their daily destinations, all of which lie within two and a half miles of their home.
Source: Map data © OpenStreetMap contributors, CC-BY-SA.

lie within a 15-minute walk. Short car trips include taking the children to the school bus stop or the T stop where, Etty admits, she often picks up her kids by car if it's late or cold or they're loaded down with bags. Otherwise the children, who are all at least eleven years old, depend on their feet or the T, rather than their parents, to get around.

Comparing these three families' commute patterns illustrates the range of conditions and challenges they and millions of other families face each day (figure 1.4). The Hursts' regular activities are spread across the broadest geographic area, most of the Russ's destinations are clustered around their inner-ring suburb, and the Padmodipoetro-Allegro family's weekly routines take them across the Boston metropolitan area, but few of this family's trips are made by car. Unlike exurban Battle Ground and the more auto-oriented Houston, Jamaica Plain's compact, public transit–oriented neighborhood offers alternatives.

Jamaica Plain gained its density in the late nineteenth and early twentieth centuries, when a trolley line from Boston connected this small, sleepy neighborhood to the city center. As the streetcar suburb grew, land within walking distance of the trolley held greater value. Developers maximized the parcels closest to the line by building at a high density and mixing uses. Many inner-ring suburbs in the Northeast and Midwest owe their walkable patterns to similar circumstances.

Over the last few decades other places outside central cities have grown denser, as multistory, mixed-use blocks have been developed around transit stops. Gangly suburbs and strip developments have matured into walkable neighborhoods, and once-withered urban industrial districts have been resuscitated by waves of new workers and residents. Buildings have been recycled and space repurposed, adding more intensive uses to create a fabric of proximity. Many features of these places—their density, mix of diverse uses, integrated transit, and the pedestrian quality of their streets—are the same elements that research shows help reduce VMT. These existing places can serve as models for more walkable neighborhoods of the future.

THE CARBON CHALLENGE

Imagine purple clouds pouring from the tailpipes of cars everywhere. This was a fantasy of essayist Noel Perrin (1997), an environmentalist and early proponent of renewable energy. He drove an electric car across the United States in the early 1990s to promote interest in alternative-fuel vehicles. Frustrated by our failure to recognize the

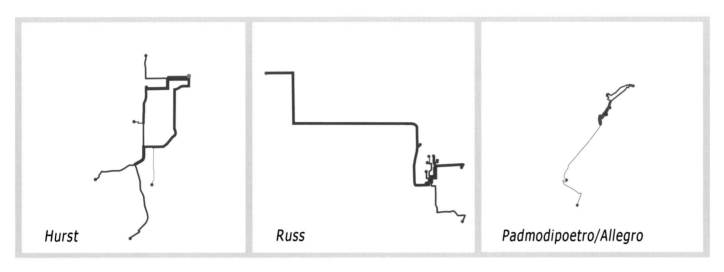

Figure 1.4 **Three Families' Commute Patterns at the Same Scale (20 × 20 miles).**

link between our personal driving habits and their consequences for society at large, he imagined a small pill that could be dropped into the gas tanks of cars to render their emissions a brilliant, highly visible, and impossible to ignore hue.

American household travel routines, combined with industrial and commercial transportation, add up to a lot of VMT. In 2009, the national odometer ticked up another 2.9 trillion miles—averaging almost 14,000 miles per licensed driver per year. The economic premium for that travel ranged from the small contributions by individuals—filling the gas tank and paying off the car loan—to massive public investment, such as underwriting military operations to defend oil supplies in foreign countries. Refining petroleum, building roads, maintaining bridges, and keeping the asphalt smooth and the parking lots plowed make up just the tip of an immense budgetary iceberg, and many costs will not emerge until years after the oil is spilled or burned. Americans have had at least 40 years to observe and catalog the economic, political, environmental, and public health consequences of our national driving habit, but so far we've been slow to make the necessary correction in our transportation system that will achieve greater equilibrium between automobiles and other modes of transportation and lessen the impacts of travel.

In recent decades, we've become aware of another danger issuing out of the tailpipes of cars—one with which we may not be able to live—the carbon dioxide (CO_2) accumulating in the atmosphere and altering the earth's climate. Carbon dioxide has always been present, but carbon-rich fossil fuels like petroleum have not, and the unprecedented rates at which they have been burned in recent decades is accelerating the greenhouse effect. The United States pumped 5,921 million metric tons of CO_2 into the atmosphere in 2008, about 20 percent of worldwide emissions—far more than our 4.5 percent share of the world's population warrants. A full third of that CO_2 is from energy used for transportation, and 60 percent of those emissions comes from automobiles (Davis, Diegel, and Boundy 2010). All the commutes, the leisure trips, the picking up and dropping off, and the daily errands of 208 million licensed drivers have added up to a significant contribution to climate change.

The race against time to trim our travel-related CO_2 suggests two basic strategies. The first is to burn gasoline more efficiently so

that less carbon is emitted per mile. Developing low-emission vehicles, such as electrics and hybrids, and raising the minimum allowable miles per gallon (mpg) for new cars and trucks have dominated the national dialogue around climate change and transportation. In 2007, the U.S. Congress mandated an incremental increase in average mpg for new light trucks and sport utility vehicles (SUVs) that is to reach a minimum of 35 mpg for most vehicles by 2030. And very low-emission cars—first-generation electrics and plug-in hybrids—are now available.

Federal mandates improved fleet efficiency significantly in the late 1970s, when all classes of cars and light trucks began burning less gasoline and emitting less carbon for every mile driven. In 2009, the carbon footprint of a midsize car was 57 percent lower than it was in 1975. An SUV built in 2009 emits about 8 tons of CO_2 per year—more than most vehicles, but about half the amount spewed by its 1975 counterpart (Davis, Diegel, and Boundy 2010).

From a statistical perspective, however, that's only half the story. Each SUV packs less of a carbon punch than it once did, but many more of them are on the road. In the 1970s Chevy Suburbans and Toyota Land Cruisers were considered novelty cars for use primarily on ranches or in military convoys. Large SUVs held a mere 0.1 percent of the market. Now they are viewed as handy vehicles for commuting to work or transporting children. Almost a third of new cars on the road in 2009 were midsize or large SUVs, while the more fuel-efficient midsize car struggled to hold onto its modest 16 percent market share. Even more disturbing was the slumping popularity of the small car, which boasts the lightest carbon footprint of all classes (5.8 tons/year). It lost 21 percent of the market in 34 years, and in 2009 fewer than one in five American car buyers selected a fuel-sipping small car (Davis, Diegel, and Boundy 2010).

There are signs that this trend may be changing, however. As car makers transition to the higher federal efficiency standards, they're creating cars with smaller, more efficient engines, and Americans are buying them. Half the new cars and trucks sold in the the first part of 2012 featured four-cylinder engines rather than the energy-intensive V-8s popular for generations (AP 2012). Sales of large cars were down 90 percent from June 2011 to June 2012, and many of the hottest sellers were hybrids and other low-emission vehicles (WSJ 2012). More efficient vehicles can play a role in lowering the national carbon output. But how will we use them? So far, the modest gains made in lowering the carbon output of individual engines have been wiped out by the much higher increases in miles traveled. Although we certainly had gas-guzzlers 40 years ago, we drove them 1.6 trillion fewer miles than today (FHA 2011).

Energy experts have seen a rebound effect accompany past gains in fuel efficiency. When the cost of fuel or power remains steady, greater efficiency leads to lower operating costs, which results in greater consumption. For example, if you replace your SUV with a hybrid, you'll be able to go farther for the same amount of money, which may encourage you to drive more. How significant the rebound effect might be remains a topic of discussion for economists, but it reveals the role that prices play in how we use energy and how we might hope to lower carbon emissions from burning gasoline (Small and Van Dender 2005).

Better efficiency through technology, the strategy that has commanded most of our attention to date, must be joined by a second one for lowering the number of miles we drive each year. Because our contemporary driving habits are based more on need than whim, changing driving patterns is easier said than done. It requires a major correction in how we develop land and fund transportation. First, we need to reverse a century-long decline in urban densities to make transit and other alternative transport modes viable again. In 1910, American cities held about 18,000 people per square mile, far more than the average of 3,700 ppsm in modern urban areas. This is well below the threshold of 7,000 ppsm for operating a minimal transit service and far from the 12,000 ppsm required to sustain a convenient and comprehensive system (Angel et al. 2011). Increasing the population density of urban areas is just a start, however, and accomplishing it is not simply a matter of adding more people. That requires creating a balance of housing, jobs, services, and institutions within shorter radii and fitting all these elements into a spatial pattern that accommodates and celebrates the experience of walking.

A more compact, transit-rich urban form will help reduce VMT by giving many more people alternative ways to move around. And when driving is necessary, we won't have to go quite as far on a daily basis. It will take many years to reach the point where we see the benefits of these changes, but within a generation we could cut our transportation-related emissions to levels that will align them with those of other developed nations.

URBAN FORM MATTERS

It may seem obvious to anyone shuttling from their child's soccer game to the hardware store to the supermarket that a low-density land use pattern demands more time behind the wheel. But, would we drive less if we lived in denser cities, and would an altered urban landscape help slow climate change?

Three recent empirical studies analyzed the relationship between land use patterns and driving habits by measuring the impacts of a more compact urban form on VMT. *Growing Cooler* (Ewing et al. 2008), *Moving Cooler* (Cambridge Systematics 2009), and *Driving and the Built Environment* (Transportation Research Board 2009) all concluded that developing at higher population densities and mixing land uses will reduce the number of miles Americans drive each year. Locating jobs and people in close proximity would shorten trips, and people would be more likely to walk or ride a bike. Greater density also would make public transit possible by shifting more trips away from private vehicles and toward modes that emit fewer greenhouse gases.

The studies diverged on the question of how much difference such a density change would make, but all three focused on a target date of 2050. *Growing Cooler* envisioned a scenario in which we could be driving 20 to 40 percent fewer miles and lowering our greenhouse gas emissions by 18 to 36 percent (Ewing et al. 2008). The authors of *Moving Cooler* (Cambridge Systematics 2009) outlined various levels of reductions based on how aggressively we change our land use practices, estimating that expanding current best practices could achieve a 20 percent reduction. A maximum effort, including comprehensive growth boundaries, minimum required densities, and jobs/housing

balance, as well as nonland use strategies could reduce emissions by 60 percent. In *Driving and the Built Environment* the Transportation Research Board (2009) estimated a more modest reduction in the range from 1 to 11 percent.

The divergent opinions resulted from different assumptions about how likely we are to change our land use policies and how quickly our growth rate might alter the built environment through redevelopment. Critics of *Driving and the Built Environment* said the report underestimated the market appeal of compact development, and that changing demographics and rising gas prices will increase the potential for a shift toward denser urban forms (Ewing, Nelson, and Bartholomew 2009). Indeed, recent trends covered in chapter 6 indicate they may be right.

These three studies are not the final word, as research on the topic continues to show. A 2011 land use–transportation modeling analysis of the Charlotte, North Carolina, area found that long-term reductions of CO_2 emissions are possible by shifting to a more compact development pattern. Comparing a high-density, mixed-use, transit-oriented model with a low-density, auto-dependent pattern, the study determined that climate-warming carbon dioxide, along with the pollutants carbon monoxide, nitrogen oxides, and hydrocarbons, would be 5.5 to 7.1 percent lower overall in the dense transit model (Rodriguez et al. 2011). Combined with better fuel efficiency and alternative energy use, this shift could make a significant difference by 2050. The authors stress, however, that the scenario they modeled will not be sufficient. Since they expect population growth and the associated increase in travel to double CO_2 emissions over the next 40 years, an even more aggressive reduction in urban footprints must be paired with breakthrough automotive technologies to slow the build-up of greenhouse gases.

The most dramatic reductions in VMT would come from combining land use changes with other strategies that create economic incentives for driving less. Pay-as-you-drive auto insurance, congestion pricing, higher parking fees, intercity tolls, and other pricing policies can induce people to combine trips or leave a car at home (U.S. DOT 2010). In the absence of a higher gas tax, these

measures would place price more squarely at the center of individual travel decisions.

While adjusting the price of parking or car insurance can affect behavior immediately, modifying land use regulations and waiting for the existing housing stock to be redeveloped is another matter. Unlike other carbon-reduction strategies, realization of a sufficiently compact pattern will take several decades to materialize, which is why most studies of the potential of compact development predict only minimal CO_2 reductions in the early years. Those who think it's not worth doing, though, must consider that without density many other strategies will not be possible. Dense cities make public transit and intercity rail feasible.

Increasing densities to levels near or exceeding those typical of cities in 1910 by concentrating housing, jobs, schools, stores, parks, and population is the best way to shrink commute zones from 80 or 20 square miles to ones as small as two and a half square miles. If we hope to enter a low-carbon age, we must create fewer Battle Grounds and Houstons and a lot more Jamaica Plains.

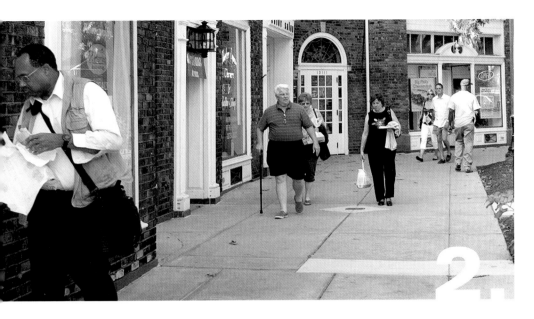

2. Five Ds and a P

As researchers delve into the question of how urban form affects travel behavior, they're identifying specific characteristics of place that boost walking and transit use while reducing VMT. In the 1990s some pinpointed diversity, density, and design as the key elements of the built environment that, in specific spatial patterns, enable alternative transportation (Cervero and Kockelman 1997). After a decade of successive studies on the topic, these "three Ds" were joined by two others deemed equally important—distance to transit and destination accessibility—and together they are now known as the "five Ds." Added to the list is another key player: parking, which inconveniently bears neither a D initial, nor a synonym beginning with D (Ewing 2010). The Ds have evolved into a handy device for defining and measuring compact form and, in the process, predicting how that form will affect travel and reduce VMT. Research models demonstrate that places that combine the Ds to a high degree enjoy lower driving rates than those that don't.

Essentially, the five Ds have the same characteristics of compact development as those touted by smart growth advocates, but transportation researchers renamed them to highlight their effects on travel behavior. Like all research tools that are discussed and cited frequently, it helps to put them into a real-life context and show how they look in existing places.

DIVERSITY

Diversity, or the mix of uses, creates a dense texture of destinations (Ewing et al. 2011). Residents can find more of the products and services they need in the neighborhood, so they don't need to drive to get them. The degree of diversity, or how many uses coexist in a place and how close together they are, matters. Types may be mixed—housing next to retail alongside commercial—but how many iterations of each use overlap or intermingle? A high level of diversity would include apartments and townhouses mixed with single-family homes. Restaurants, drugstores, supermarkets, banks, hair salons, coffee shops, day care centers, fitness studios, software companies, and law, dental, and insurance offices all can be closely spaced along the street or in upper stories (figure 2.1). Greater diversity creates a higher number of services within a small area that employees as well as the residents of the neighborhood can reach on foot or by bike. With a broad mix of businesses comes a greater potential for employment, and a sufficient mix of housing units means many people can work close to home (figure 2.2).

DENSITY

Density usually refers to population (in persons per acre or hectare, square mile, or square kilometer) and housing (dwelling units per acre or hectare). Population density is sometimes combined with a count of the number of jobs in a given area to calculate an activity density (Ewing and Cervero 2010). As a measure that can be applied to anything in the urban environment—housing, parking, jobs, floor space, intersections, bus stops, food outlets, crosswalks, bike racks—density reveals the intensity of a particular element or activity.

Planners have long considered population density to be the key to lowering VMT. Recent studies show, however, that density is only one of several necessary ingredients. Alone, it does not make a big difference. You may live in a high-rise building, but if the neighborhood is remote, unpleasant to walk in, and cut off from transit, you will drive often and far. In fact, living close to a downtown or other center of activity matters more. Places with the best destination accessibility have the lowest rates of VMT (Ewing and Cervero 2010).

DISTANCE TO TRANSIT

When faced with the opportunity to take a bus or train, people tend to weigh their options: How long will I have to wait? Will it be crowded or uncomfortable? Can I count on getting there on time? Would it be cheaper than driving? These are concerns that transit providers must address to make public transportation the more appealing option. Research shows that in the calculus of decision making, the biggest question is, How far away is the bus stop?

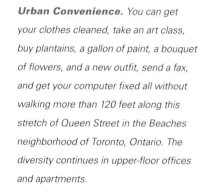

Urban Convenience. You can get your clothes cleaned, take an art class, buy plantains, a gallon of paint, a bouquet of flowers, and a new outfit, send a fax, and get your computer fixed all without walking more than 120 feet along this stretch of Queen Street in the Beaches neighborhood of Toronto, Ontario. The diversity continues in upper-floor offices and apartments.

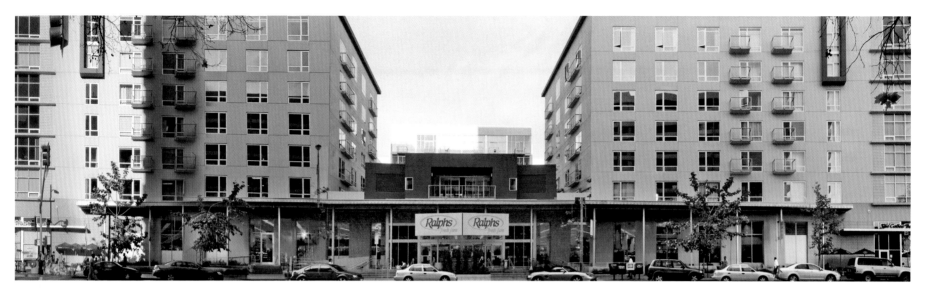

Beyond the Minimart. *Developers are incorporating large food markets into the ground floors of infill housing developments. Built into the ground floor of a midrise apartment complex, Ralph's supermarket in downtown Los Angeles, California, provides the basics that people need every day.*

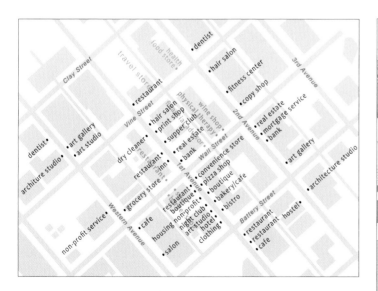

Figure 2.1 **Diversity on the Street.** *In Seattle, Washington's Belltown neighborhood, ground-floor uses include a wide range of everyday services.*

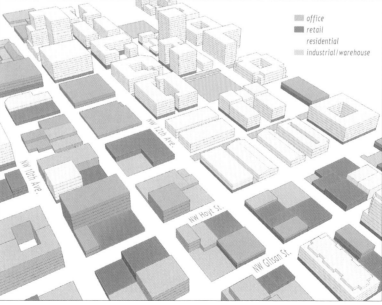

Figure 2.2 **Multistory Diversity.** *In Portland, Oregon's Pearl District, residential, commercial, industrial, and retail uses are woven into the neighborhood both horizontally and vertically. All manner of retail services can be found on the ground floor, while the upper levels hold a mix of businesses, homes, and even rooftop green spaces.*

Hand in Glove. *Urban mobility depends on a snug fit between density and transit. Several blocks along San Diego, California's light rail line have filled in with multistory housing. The many residents of this East Village apartment complex have easy access to transit. A trip to the rail stop is not much farther away than an elevator ride.*

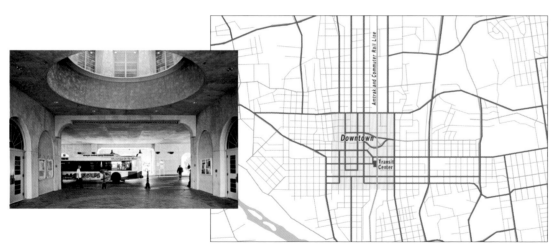

Figure 2.3 **Transit Workhorse.** *Light rail and streetcar modes generate excitement, but buses make transit work. They are affordable, flexible, and available to towns and cities with emerging density. In Albuquerque, New Mexico, for just one dollar—thirty-five cents if you're a student or a senior—you can travel through about 350 square miles of the greater metropolitan area. The map shows only a portion of the system, which includes several "rapid-ride" routes. Fewer stops and quicker loading shorten travel time and make bus travel more convenient.*

Distance to transit, or transit accessibility, is the key to luring more passengers. A dense network of routes and stops insures that transit users don't have long walks tacked onto the beginning or end of their transit rides (figure 2.3). And this is where density comes back in—many people close together within a tight web of access points. It's the "virtuous cycle" of density and transit. Concentrating people and jobs next to transit feeds the system with riders, which helps upgrade and extend service and in turn makes transit more attractive and useful and the city more livable (Angel et al. 2011). The key is locating everything together.

DESIGN

Every trip by bus, subway, streetcar, or train begins and ends on foot. Shortening that walk and furnishing it with a visually rich, comfortable streetscape increases the likelihood that people will choose public transportation. A pleasant streetscape also makes walking and biking appealing alternatives for shorter trips. To lower VMT, urban designers should focus on two strategies: connecting streets, which

will shorten trips; and making them pedestrian- and bicycle-friendly, which will improve the quality of the journey.

An interconnected street system gives pedestrians what they want—a more direct path and a choice of routes. It's easy to measure connectivity: just count the intersections. Neighborhoods with smaller, rectilinear blocks have more intersecting streets than places with large blocks and curvilinear networks (figure 2.4). Intersection density has been identified as one of the most crucial ingredients of the built environment for reducing VMT (Ewing and Cervero 2010). A doubling of intersection density results in about a 44 percent increase in walking.

Among the D variables, streetscape design is a critical player, but it is more complex and difficult to measure than the other four. It involves altering the space within the public right-of-way—narrowing streets; widening sidewalks; and adding crosswalks, street trees, and bus shelters—as well as defining its built edges to make the space more appealing for people on foot or bicycle. A pedestrian-oriented street combines many basic urban design concepts that once came naturally to city builders: enclosure, human scale, architectural diversity, transparency, and permeability. In our automotive age, incorporating these qualities into development projects requires deliberate and sustained efforts by planners, landscape architects, and developers. The details of creating pedestrian-friendly design, defining the main concepts, and illustrating how they are employed in real places are examined in chapters 4 through 6.

DESTINATION ACCESSIBILITY

The D most strongly associated with lowering VMT is destination accessibility—how closely a place is located to the destinations to which people travel most regularly. This variable may be measured in the distance to a central business district (CBD) or by how many jobs or attractions are within a three-minute drive or a fifteen-minute walk (Ewing and Cervero 2010). Places close to downtowns have easy access to the jobs and services concentrated there. Trips into and out of the CBD can be made on foot or by bike or transit, and car trips tend to be short. Destination accessibility is highest when a development is located close to a CBD that offers a full array of regional employers and attractions. But local accessibility—a commercial corridor or intersection hosting a smaller range of local and neighborhood services—also helps reduce VMT (figures 2.5 and 2.6).

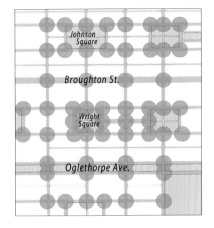

Figure 2.4 **Savannah's Historic Street Grid.** The historic district of Savannah, Georgia, has a street network made for walking. Small, one-acre blocks are laid out in a rectilinear grid, which ensures a high density of intersections, many of which are four-way. Pedestrians arrive at a corner every 125 or 350 feet. Small lots with narrow frontages dictate a human-scale building pattern. Greens bisected by public walkways are interspersed among the blocks of Savannah.

Pedestrian Heaven. The small blocks, narrow streets, and checkerboard pattern of historic buildings and green spaces, combined with a leafy canopy, make walking across Savannah a pleasure.

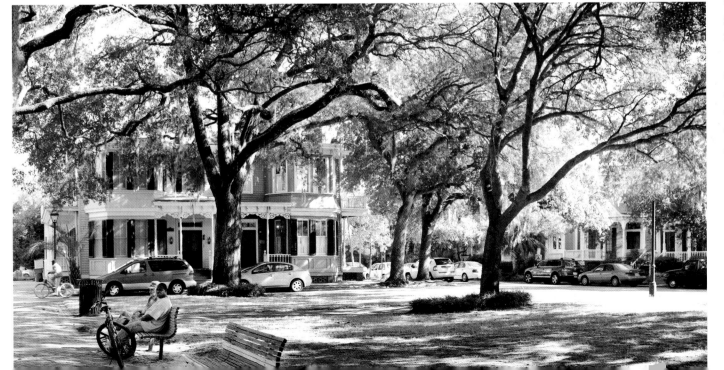

Optimal Streetscape. Wide sidewalks lined with shop entrances and window displays hug the perimeter of Shaker Square in Shaker Heights, Ohio. The landscaping along the opposite edge encloses a space worth spending time in.

Intimate Streets. Vancouver, British Columbia, has built pedestrian-friendly streetscapes throughout the city by stepping its "skinny" high-rise towers back and setting them atop lower buildings (podiums) that fit the scale of the street. Along the sidewalk in Coal Harbor, the atmosphere is intimate, despite the block's high density. From this perspective one sees a row of two-story townhouses fronted with gardens rather than the thirty-story towers behind them.

▼ Figure 2.5 **Bridging the Gap.** In Denver, Colorado, the Highland neighborhood is less than a mile from the city's CBD. In recent years, redevelopment of industrial land between the two areas has brought them closer together. New streets, parks, and footbridges spanning the Platte River and an interstate highway have created a seamless pedestrian connection. Recognizing good destination accessibility when they see it, developers have filled in the wedge of land closest to downtown with a mix of housing and neighborhood commercial uses in four- and five-story buildings.

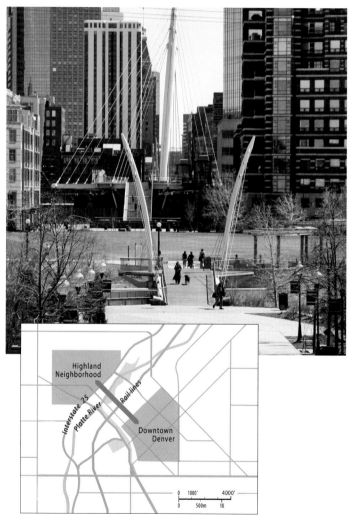

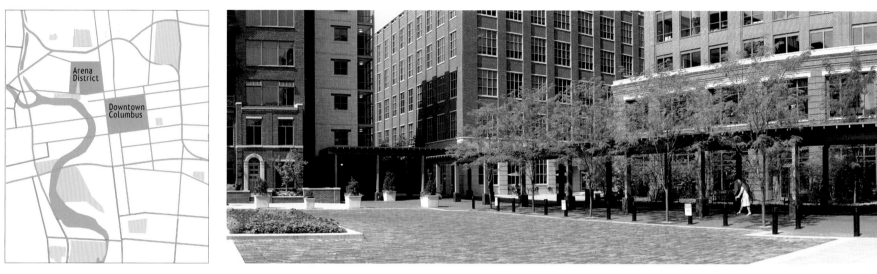

Figure 2.6 **In on the Action.** Columbus, Ohio, located its new Nationwide Arena adjacent to downtown, then surrounded it with six-story buildings filled with offices, restaurants, shops, and apartments. In the process the city reduced the travel distance between two major destinations to a short walk and bestowed the gift of accessibility on every new resident of the Arena district.

THE Ds IN CONCERT

The five Ds make the biggest impact when they work together. Density, for example, plays a crucial supporting role by shoring up the other Ds. It feeds diversity by supplying customers and workers to businesses. And it creates a deeper pool of transit riders that can support a comprehensive system with many routes and access points, thus shortening the distance to transit. Better transit accessibility makes density possible. It can also attract a greater diversity of uses, which in turn improves destination accessibility with a critical mass of population, housing, and jobs in close proximity.

The extent to which the D variables are combined in a neighborhood or city determines whether residents choose to make trips in a car or by another mode. It also affects the length of those trips. Using various iterations of the five Ds, Reid Ewing and his colleagues (2011) analyzed household travel data from hundreds of mixed-use developments across the country and found that neighborhoods with the most Ds have lower VMT. They also concluded that each variable

has its own distinct effect. In a place with a high diversity of uses, people take more of their trips within the neighborhood. In one that has a dense network of transit stops, people are more likely to walk and take transit. And in centrally located places that are accessible to many destinations, car trips tend to be short.

PARKING

If you want to understand why so many North American cities are low in density, sit in on a development review meeting at your local town office and keep a tally of the number of minutes devoted to the topic of parking. Unless you live in a very densely populated place, the conversation will most likely linger over that particular subject. When discussion moves to other topics, such as building design or stormwater discharge, it may well veer back to issues of parking and circulation—the number of spaces, vehicle entrance and exit, turning radii, lighting, and maintenance of parking lots. More than any other aspect of a development project, parking is what we seem to care

Minneapolis, Minnesota.

development project, but this reality is hidden from drivers, who pay little or nothing to use them. Since only 5 percent of employees nationwide pay for parking at their workplaces, it's not surprising that most commuters drive alone (U.S. DOT 2010). Local governments play Santa Claus by providing curbside parking spaces along city streets and requiring developers to construct off-street facilities. This two-pronged strategy not only keeps the supply high, it sustains the illusion in the minds of the driving public that parking is cheap, if not free.

Under this system, developers are forced to allocate roughly 10 percent of their budgets to meeting zoning standards. They bundle the cost of parking facilities into the sale of commercial space or living units. Buyers and tenants pay for the spaces, whether they want them or not, just as taxpayers underwrite the costs of paving, sweeping, and plowing on-street parking spaces, whether they use them or not. We all pay for parking, but if we're not handing over money at the lot or curb, we think of it as free. Compared to transit, which requires an out-of-pocket purchase for each trip, driving appears to be the more affordable option.

At the heart of municipal parking policies lay certain assumptions that feed a cycle of auto dependency: the car is the best way to get around; parking should be free; and there is no alternative. Cheap and abundant parking holds down the cost of driving, which in turn encourages greater car use, spurs auto-oriented design, degrades the pedestrian environment, and discourages trips by foot. Parking consumes a disproportionate amount of space that doesn't serve active human uses because it lowers densities, forces destinations apart, and renders transit inefficient (Weinberger, Kaehny, and Rufo 2010).

The notion that parking is an entitlement is so deeply ingrained in our thinking that it is rarely challenged. A few cities, however, have recognized the disadvantages of flooding their downtowns with cheap parking and have begun to align their parking policies and zoning regulations with their goals for a more integrated transportation system. Boston, Massachusetts; Chicago, Illinois; Jersey City, New Jersey; and a few others have upended long-held attitudes toward parking by limiting rather than boosting the supply.

about most. Like gasoline, it's an essential component of an auto-dominated transportation system, and our dependency on cars puts it at the center of decisions about development and land use.

Parking is a feature of the built environment that has a considerable impact on travel behavior, yet its role is often overlooked, perhaps because it is so pervasive and widely embraced as a necessity. Parking lots—especially garages—increase the cost of a

Philadelphia, Pennsylvania.

congestion pricing controls the flow of parking and allows those who benefit the most to shoulder the cost burden.

Parking fees are a disincentive to driving, and in cities that manage parking carefully they can create an incentive to walk. Boulder, Colorado's downtown Parking Benefit District collects revenues from on-street meters and city-owned garages that it then channels into alternative transportation. Parking money goes to pedestrian and bike-friendly streetscape improvements and buys free transit passes

Portland, Oregon, has taken a leading role in this direction. Instead of *requiring* parking, the city *allows* it and sets a maximum rather than a minimum number of parking spaces for development downtown, in neighborhood commercial districts, and around transit stops. The city also permits bike parking to substitute for automobile parking. Developers pass savings along to those tenants who don't want parking and charge a higher market-driven rate to those who do. Urban space that might have gone to parking is used for housing, commercial, or other uses that increase densities and feed the transit system (Weinberger, Kaehny, and Rufo 2010).

In addition to zoning changes, some cities are taking an innovative approach to curbside parking. Instead of giving it away, they let value dictate price. More desirable locations command higher meter fees making motorists pay for the convenience of leaving their cars at the curb. In San Francisco, California, "smart" meters adjust the price of parking up or down depending on the current demand. At moments when many spaces are in use, the price rises, discouraging driving downtown while raising revenues. This stationary version of

Public Parking. *Boulder's downtown parking structures are set back from the street behind multistory retail and office buildings (below). Revenues from these municipally owned garages are used to subsidize bike lanes and pedestrian-friendly streetscapes (left).*

for downtown employees. A wave of suburbanites enter Boulder every day, but there is no free parking downtown. The city controls the cost of parking, tweaking the prices to encourage short-term shopping trips while discouraging single-occupancy commuters (Weinberger, Kaehny, and Rufo 2010).

How we manage parking—whether we make it cheap or charge its true cost—has an impact on travel choices. Local governments can nudge people out of their cars and into other modes by limiting the supply and shifting the cost of parking directly to the motorists who use it. Rather than feeding auto-dependency, smarter parking policies help initiate a cycle of urban pedestrianism. Fewer parking lots and garages free up space for housing, employment, and recreation, which brings more people who live nearby to support transit, which in turn makes more frequent service possible and parking less necessary. Replacing surface lots and street-level garages with homes or businesses improves the quality of the street and encourages trips by bike or on foot.

3. Neighborhood Form

Lowering VMT by any significant measure will require integrating the D attributes at a grand scale. We need networks of public transportation and open space that connect whole regions as well as policies that balance and focus growth strategically across a metropolitan area. But, while thinking big is essential, it may be easier to visualize a low-carbon environment in smaller increments. At the heart of sustainable transportation lies walking, and the greatest potential to exploit that simple, cheap, healthy mode of travel comes from incorporating the Ds into neighborhoods.

THE DIMENSIONS OF WALKING

As the Hurst and the Russ families demonstrate, people are willing to drive many miles to get where they need to go. But how far is the average person willing to walk? Although the answer depends to a large extent on the quality of the walking environment, a rule of thumb applied in transit planning is between a quarter to a half mile (1,500–2,500 feet or 450–800 meters). Extending a line a quarter mile in all directions from a central point creates a pedestrian shed or walk zone of roughly 125 acres (50 hectares). This planning tool is used to help define areas where growth should be concentrated. Locating more destinations (stores, offices, schools, homes) within that zone creates the potential for replacing frequent car trips with shorter walking trips.

Planners use the quarter-mile radius and pedestrian shed to help pair density with transit. A subway stop, a light rail platform, or the intersection of bus routes are ideal center points for a pedestrian shed. Filling that space with higher-density housing and businesses ensures that a critical number of residents and employees can walk to their stop

Streets into Parks. *The circulation of private vehicles is restricted in Vancouver's West End, but pedestrians and bicyclists are free to come and go. These transformed rights-of-way offer direct connections as well as places that are comfortable for sitting and strolling.*

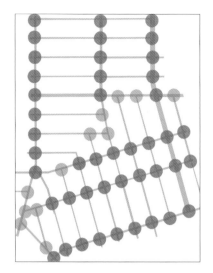

Figure 3.1 **Sample Intersection Density Map**. *A diagram of the street network shows the frequency or density of intersections. A higher number of intersections indicates better connectivity. Four-way intersections, which offer more route choices, are shown in darker red; three-way intersections are shaded more lightly.*

in fewer than 10 minutes. Mixing uses within the pedestrian shed adds destinations, and a richer array and denser pattern of activities mean more trips can be made on foot.

What fits into 125 acres? In terms of population density, that question is answered differently in Austin, Texas, than it is in Cincinnati, Ohio, or in New York City, Paris, or Hong Kong. The fit depends as much on culture and expectations as it does on resources and infrastructure. While there may be an optimal walking distance, there is no such thing as an optimal density—an "ideal" number that maximizes both urban efficiency and livability. There is a favorable range, however, the upper limit of which depends on the context. The lower end begins at around eight units of housing per acre or 7,000 ppsm—the minimum population density, spread across a city or town, that makes public transportation viable and services available. Since this is about twice the average population density of most North American cities, one answer to the question of how many people fit into 125 acres is: a whole lot more.

The goal is to combine housing with many other uses in a tightly woven fabric that includes a dense array of the essentials of daily life. To our car-centered culture, in which space is perceived in miles rather than feet, 125 acres seems miniscule. How do we fit it all in?

Chapter 4 answers that question in 12 different ways. It features a dozen North American sites, each approximately 125 to 130 acres in area—pedestrian walk zones. Some are in familiar places, such as New York City; Toronto, Ontario; Vancouver, British Columbia; Portland, Oregon; and Cambridge, Massachusetts—cities with historically dense land use patterns, intertwined uses, and comprehensive transit systems. But others have emerged in unexpected locations, where the seeds of sustainable urban form are taking root on a micro level. Neighborhoods in Columbus, Ohio; Albuquerque, New Mexico; and San Diego and Pasadena, California, are growing denser. They are slowly filling in and up as they mature into places where walking and biking make sense. Using the D attributes, researchers have sketched out the rough contours of a travel-efficient urban form. These neighborhoods show how that conceptual framework can be filled in with particulars that create 12 real and distinctly different

places, each with an urban form that encourages walking. They all show just how large 125 acres can be.

ELEMENTS OF WALKABLE FORM

Why were these particular sites selected? Each offers choices: travel options, housing types, and a variety of things to do and buy. Their streets are comfortable, attractive, and safe for biking and walking. They demonstrate how compact development can take shape in different regions and climates. Six specific qualities make them walkable: connections, tissue, housing and population density, services, streetscape, and green networks.

Connections

Each of the 12 sites has a fine-grained network of sidewalks and off-street rights-of-way that offer pedestrians and bicyclists a choice of routes, especially quick, direct links throughout the neighborhood. This connection pattern is illustrated with an intersection density map (figure 3.1). Blocks in walkable neighborhoods tend to be small, with intersections placed at frequent intervals. Where blocks are large, pedestrian paths offer shortcuts, which often lead through courtyards and other public spaces. Walking and biking are considered valid modes of transportation worthy of infrastructure investments.

Street layout determines how directly one can get from point A to point B. A grid of streets with relatively small blocks and frequent intersections suits pedestrians because every intersection presents a choice of routes. They can go straight, turn left, or turn right to suit their purposes. This makes the trip quicker as well as more interesting. In neighborhoods with more intersections per square mile and a smaller average block size, the streets are woven into a fine mesh of connecting strands, with more route choices and a better walking environment (figure 3.2).

The mesh of streets can be drawn tighter still with pedestrian rights-of-way that thread through the middles of blocks. These midblock connections extend the sidewalk network beyond the street through smaller passages between buildings (figure 3.3). Not only do they go where cars cannot, offering shortcuts and better access for pedestrians, they offer alternative perspectives and experiences of the neighborhood.

Walkable neighborhoods feature alternate routes for pedestrians and cyclists that offer shorter trips or quiet, safe respites from traffic. Some cities achieve this by excluding motorized vehicles from selected streets, such as pedestrian-only spaces along shopping streets. A more aggressive approach, taken by a few cities like Portland and Vancouver, is the creation of a pedestrian-only network where vehicles are restricted from several streets within a neighborhood. Portland's Pearl District and Vancouver's West End both employ this strategy, closing some minor streets to traffic while leaving them open to nonmotorized vehicles (figure 3.4). This disrupts the circulation of cars through the neighborhood while it aids the flow of people. In both cases the cities have replaced asphalt with landscaping and transformed the rights-of-way into small linear parks. The result is a calmer, quieter urban environment despite the high densities of surrounding blocks.

Sometimes it takes extreme measures to get from point A to B. In cases where a river, highway, or steep hill poses a barrier—a condition found in most North American cities—it may not be as simple as claiming an existing right-of-way. Constructing a bridge, elevator, or even a tram may be necessary to overcome the obstacle. As cities grow denser it makes sense to consider walking as a primary rather than

secondary mode of travel, and this more expensive infrastructure is a key transportation investment. A footbridge once considered a nice amenity for strollers or joggers becomes an essential link in the daily rush-hour commute system. Depending on where they're located and

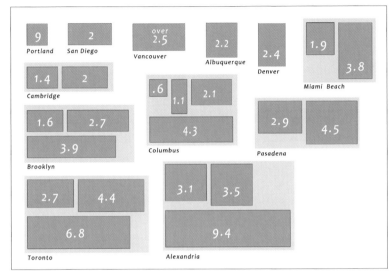

Figure 3.2 **Block Size**. Blocks in the 12 sites—shown here at the same scale—range in size from just over one-half acre to more than nine acres, but most of the blocks are less than four acres in size. In Portland, San Diego, Cambridge, Albuquerque, and Denver, where streets are closely spaced, the blocks are smaller than two and a half acres.

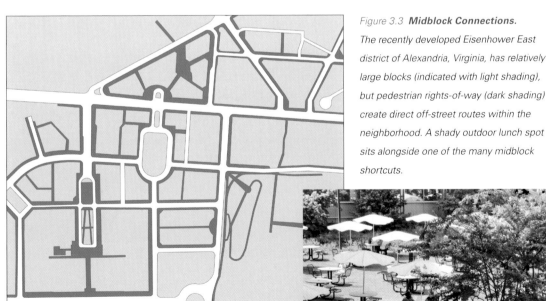

Figure 3.3 **Midblock Connections**. The recently developed Eisenhower East district of Alexandria, Virginia, has relatively large blocks (indicated with light shading), but pedestrian rights-of-way (dark shading) create direct off-street routes within the neighborhood. A shady outdoor lunch spot sits alongside one of the many midblock shortcuts.

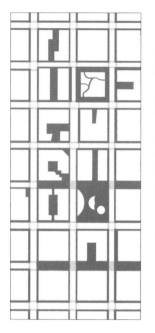

◀ *Figure 3.4* **Back Routes.** *In its Pearl District, Portland, applied the same technique as Vancouver, creating an interconnected network of pedestrian paths that lead to and through the neighborhood's parks. Dark shaded areas indicate streets closed to traffic, midblock connections, park paths, sidewalks, and crosswalks.*

Going up. *Steep terrain and an elevated highway stand between the downtown and waterfront areas in Seattle, Washington. Construction of an elevator and pedestrian bridge has eased the journey from new apartment buildings, hotels, and restaurants along the shore to the Pike Place Market and downtown business district. The bridge provides a promenade and overlook from which to take in the stunning view of Puget Sound. This infrastructure is expensive, but high densities along the waterfront make it both necessary and cost effective.*

Waterway. *The California oceanfront path that extends 8.5 miles from Venice Beach to Santa Monica is scenic, pleasant, and—given Los Angeles traffic—may be the quickest way to travel between the two cities. It attracts tourists and athletes, but also serves the 45,000 people who live within a mile of the beach and can use this alternate route linking the many neighborhoods and commercial centers.*

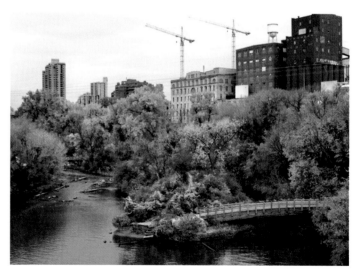

Ties That Bind. *The Stone Arch Bridge in Minneapolis, Minnesota, carried trains across the Mississippi River for almost a century. Now it offers a convenient and scenic link for walkers and cyclists. It's a transportation corridor as well as a recreational amenity that connects people across the city to one another as well as to the open spaces along the riverbank.*

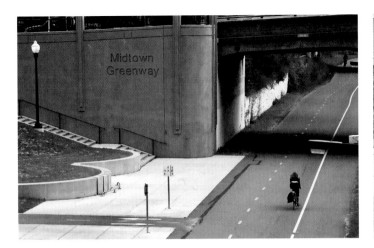
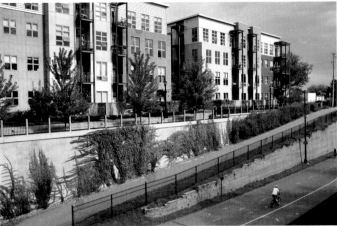

Economic Development. The Midtown Greenway is a former rail corridor in Minneapolis that has been repurposed as a bike path. Built below grade to eliminate conflicts between train and automobile traffic, the route now allows cyclists to pass unimpeded beneath the 20 streets that intersect the route. Like a true transportation corridor, the path is available for use every day and all night. Commuters count on city plows to keep it clear during snowy Minnesota winters. And like other transportation investments, it is seen as a magnet for development. Loft-type apartments have sprung up along the greenway, which runs parallel to and one block away from an infilling commercial corridor.

how far they extend, off-route paths can link distant parts of a city, greatly extending the range of territory open to cyclists.

Tissue

Streets subdivide land into developable urban blocks and create channels of movement, both of which are essential elements of urban form. A third factor is the pattern of ownership: how the land is divided into individual parcels within those blocks. Parcel lines set the framework for architecture, influencing the shape, size, and orientation of buildings. This web of property lines and rights-of-way—sometimes referred to as urban tissue—is an invisible but powerful force (figure 3.5).

In *The Evolution of Urban Form*, Brenda Case Scheer (2010) explains how building design springs from tissue, with specific types evolving as they adapt to the underlying pattern of property ownership. The row house is a good example. Many of its signature features,

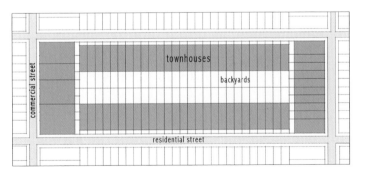

Figure 3.5 **Urban Tissue.** Many blocks in New York City are rectangular and feature long, narrow lots. In the Park Slope neighborhood of Brooklyn, commercial corridors run along the short ends of the block and are intersected by the residential streets that line the longer sides. Although some lots have been combined into larger parcels, Park Slope lots were platted to a dimension of roughly 20 by 100 feet.

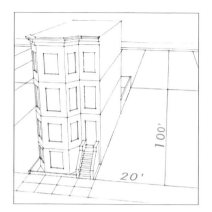

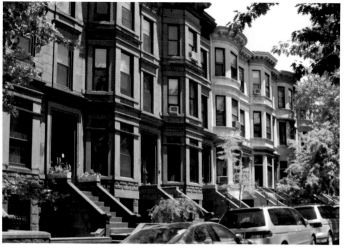

Figure 3.6 **Adaptation**. *The townhouse or row house building type makes efficient use of a long, narrow parcel. Multiple stories provide more than 4,000 square feet of living space on a lot half that size. Set a few feet back from the sidewalk, it occupies about two-thirds of the parcel, leaving room for a small backyard.*

same because the framework dictates a certain type of building or house (Scheer 2010).

All 12 neighborhoods featured in the next chapter of *Made for Walking* share this static tissue type. Their ownership patterns are fine grained with small parcels that prescribe pedestrian-friendly forms. A few of the sites are located in former industrial areas that until recently had larger parcels of undefined space left over from rail operations. In Denver, vacant land was subdivided into streets and blocks to approximate the urban fabric of adjacent neighborhoods. While these new blocks are small, the tissue in them is not as fine grained, and it offers significantly larger parcel sizes that allow bigger building footprints. On the other hand, larger parcels, and the wider frontages they create, can diminish the diversity of the street if whole or half blocks are devoted to a single use (figure 3.7).

such as its slim profile, party walls, entrance and staircase along a party wall, and backyard make the most of a narrow yet deep lot. Placing the building directly on or near the sidewalk maximizes the building's size on a small lot. Raising the main floor a half story off the ground increases privacy and creates a semi-public outdoor space—the stoop. The row house's characteristics flow from the two-dimensional constraints of a specifically shaped lot and its relationship to the public right-of-way (figure 3.6). Many older cities, including some of those illustrated in this book, feature a tissue of long, narrow lots with variations of building types adapted to it.

Cities grow and change in response to economic, political, and cultural conditions, which shift over time. But as Scheer points out, tissue is the one element that remains relatively constant. Once urban land has been subdivided and sold, it is very difficult to realign streets and alter property lines. This is especially true if the tissue is fine-grained, with small lots and multiple owners. She calls this tissue type "static," and it comprises many small cells that can be altered individually but not all at once. In a static tissue, such as an urban grid or suburban subdivision, buildings and houses come and go, but the overall structure and character of the place remains the

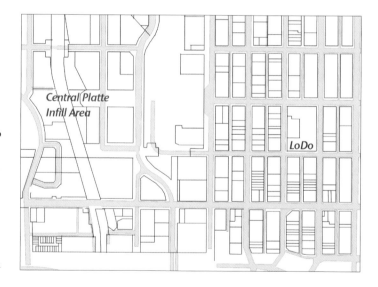

Figure 3.7 **Scale Differences**. *Formerly industrial land in the Central Platte area of Denver has been subdivided into an urban grid. Although the new street system ties to the existing network, scale differences are evident between this new city neighborhood and the historic pattern of nearby LoDo.*

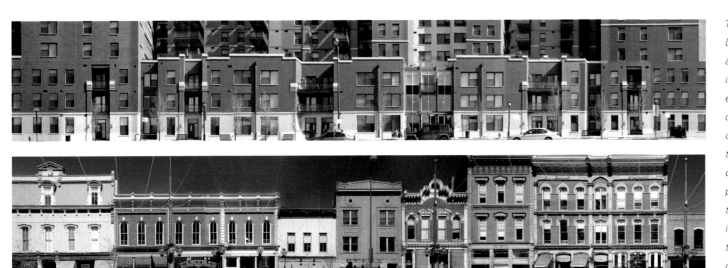

Tissue and Character. Parcels in Denver's Central Platte District (top) are large and, unlike the narrow lots in nearby LoDo (bottom), can more easily accommodate contemporary development practices. Buildings that occupy an entire urban block, such as those in Central Platte, offer an economy of scale as well as the option of large floor plates that appeal to different types of tenants. Unfortunately, this often results in a uniformity that affects the quality of the streetscape. Blocks under the same ownership sometimes lack the variety of those developed over time by multiple owners.

Housing and Population Density

High-density neighborhoods are common in older, industrial cities in the Northeast and Midwest as well as in Portland and Vancouver, where land use policies channel growth into contained areas. In other regions, particularly the West and Southwest, densities have tended to be lower, but now they are rising as infill proceeds in targeted areas of cities such as Pasadena, San Diego, and Denver. The 12 sites represent diverse regions and vary greatly in density, but all of them meet the minimum density necessary to support transit and retail services—at least eight housing units per acre.

Housing density maps for the sites in the United States show the number of housing units per block according to 2000 U.S. Census data. The population per block and the number of persons per square mile in the larger neighborhoods are indicated in population density maps, which show the most recent data available from the 2010 U.S. Census. Both maps reveal patterns of density—how the housing units and population are distributed throughout the neighborhoods (figure 3.8).

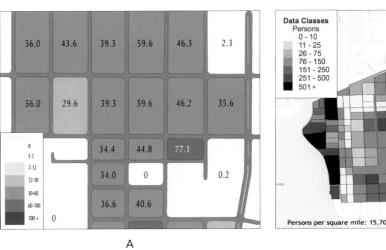

A

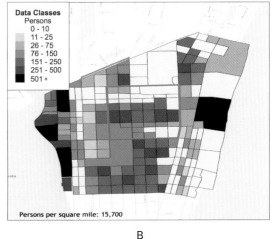

B

Figure 3.8 **Sample Density Maps: (A) Housing Density**. *Housing densities for each block (dwelling units per acre) in 2000.* **(B) Population Density**. *Population per block and persons per square mile for the larger vicinity in 2010.*

Services

Each of the 12 sites represents the kind of diversity that typically comes with mixing retail, commercial, and civic uses in a neighborhood. In the services map, shops, banks, restaurants, health centers, schools, and other everyday destinations are located and color-coded to show the range of services and their locations in the neighborhood (figure 3.9). In a few places these nonresidential uses are found throughout the site, putting restaurants, offices, and shops just steps away from residents' front doors. More commonly the services are clustered along commercial corridors that flank or bisect the site. Diversity and transit accessibility go hand in hand. All of these sites have transit service—whether a bus, streetcar, light rail, or subway—that travels through the neighborhood at convenient intervals. The context map shows the larger network connecting those routes (figure 3.10).

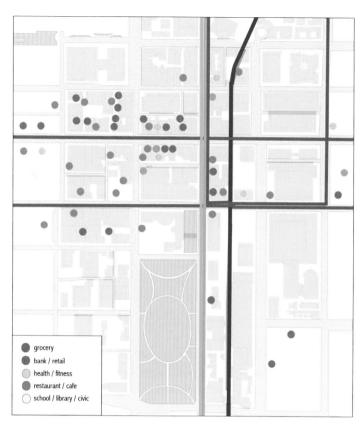

Figure 3.9 **Sample Services Map.** The color-coded dots show the arrangement and mix of stores, restaurants, schools, and other destinations. Colored lines indicate transit routes within the site.

Legend:
- grocery
- bank / retail
- health / fitness
- restaurant / cafe
- school / library / civic

Bike and Ride. The simple addition of bike racks to public transit vehicles greatly extends the range of alternative transportation across a metro region. Riders can step off the train or bus at the outer edge of the service area with their wheels ready to take them where they need to go. For example, the TriMet trains in Portland are equipped with hangers (left), while bus riders in Burlington, Vermont, can use the front-mounted bike racks (right).

Streetscape

Density, services, and connections may shorten a journey, but good design makes it more pleasant. To understand the relevance of design, consider places where this crucial D is absent. Despite densities of more than 10,000 ppsm, closely spaced businesses, and plenty of sidewalks, walking is not popular in many cities because most city streets lack the physical qualities that could make it comfortable and attractive. Several elements of urban design create the kinds of streets that invite walking, and they are on display in each of the book's 12

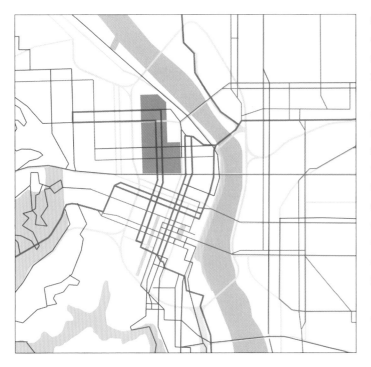

Figure 3.10 **Sample Context Map.** The context map shows both how the neighborhood (lavender) connects to the city through its transit lines (violet) and its proximity to larger open spaces (green).

street, such as vacant parcels and parking lots, create a more porous edge that leads to greater ambiguity. Figure/ground maps help us to see that, in urban settings, open space has a shape, and the integrity of that space is affected by its edges.

The term *wall* can be deceptive, however. While the street should be enclosed, the façades should be permeable, with regular entrances and views into the buildings along the sidewalk. Buildings set the tone and character of a streetscape. Their functions determine who uses the street, how often people come and go, and what times of day are most active. The design of a façade—particularly its door spacing and fenestration—affects how people move in and out of a building and how much it reveals of what lies within. Building walls with more frequent entrances and larger ground-floor windows tend to enliven a streetscape by increasing visual stimulation for passersby.

The 12 neighborhoods feature many different building types—duplexes, townhouses, apartment buildings, high-rises, and office

neighborhoods: enclosure, human scale, architectural diversity, transparency, and permeability.

A street is enclosed, and hence more comfortable in terms of scale, if its edges are made clear and consistent by buildings along the way. Where the pattern is intact—buildings line the street at a consistent setback—the public space is bounded by walls and feels like an outdoor room. Where the pattern breaks down—with gaps between buildings or an uneven setback—the street can be less appealing for walking. A figure/ground map for each site illustrates its degree of street enclosure (figure 3.11). Buildings are shown in red (figure) against a white field (ground). Where buildings are continuous, the streets are legible, even though they are not depicted. Gaps along the

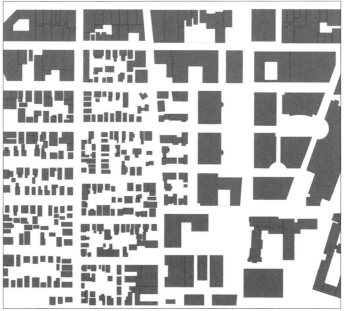

Figure 3.11 **Sample Figure/Ground Map.** Streets and sidewalks are not delineated on the diagram, but the consistent alignment of buildings makes the street pattern clearly legible. Buildings create edges or walls that enclose the streets and create outdoor rooms.

The Pontalba Buildings. An early North American version of the insula type is found in the French Quarter of New Orleans, Louisiana. It was adapted to the hot climate by incorporating high ceilings and upper balconies. Built around 1850, the Pontalba Buildings are still used as originally intended, with apartments situated above street-level shops.

buildings. But one type found in many of the sites creates a particularly animated and permeable street edge—the multistory building set at the sidewalk with ground-floor retail and housing and offices or a mixture of uses in the floors above. Scheer (2010) refers to this type as the "insula" and demonstrates how over millennia it has persisted throughout the world with slight adaptations to climate, culture, and technology. The name *insula* is Latin for "island," and it most likely derives from its relation to the streets around it (figure 3.12). In Roman times this building type occupied an entire city block that was surrounded on all sides by streets. Ancient insula structures contained apartments above ground-floor shops and worksites, but over the centuries other uses have been inserted into the upper levels.

The insula form, which emerged from a transportation system based on walking, provides multilevel spaces for a mix of uses just steps away from the street. Its openings on the ground floor are wide enough to invite public access to shops yet sufficiently narrow to maximize the number of retail spaces. In recent centuries, the insula type adapted to an industrializing world by becoming taller and accommodating larger numbers of people as well as new uses, such as factories and offices. It acquired lobbies, elevators, plate glass, electricity, and other technical innovations of the times (Scheer 2010).

Despite these variations, the basic form of the insula persisted because its pedestrian orientation and small scale suited prevailing modes of transportation. Innovations such as trains, omnibuses, trolleys, and subways entered the urban realm, but those modes complemented foot travel and reinforced the need for density that the insula building type served so well. In the mid-twentieth century, however, as the automobile replaced walking and public transit to become the predominant mode of transportation, the insula lost much of its appeal. The large setbacks and extensive parking areas required by automobile travel spawned new building types such as office parks, strip centers, gas stations, malls, and motels that are better adapted to a dispersed land use pattern. But the insula type has retained a place

*Figure 3.12 **The Insula.** The insula building type sits close to the street. The ground floor is used for commercial space and the upper stories for other uses.*

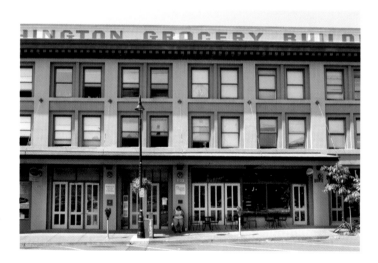

The Insula Continues. The insula remains a serviceable building type in North American cities. This building in downtown Bellingham, Washington, served as a warehouse for a grocery company during the early twentieth century and now mixes upstairs apartments with ground-floor shops and restaurants.

in popular imagination, perhaps because it suits our innate need for human scale or because it's so familiar (Scheer 2010). At the beginning of the twenty-first century the insula hovers in the wings, ready to return to center stage as public transportation and density resume their importance to North American cities.

Although most people think of a street as simply a conduit for traffic, it actually consists of a complex set of spatial relationships. Within a street corridor are things that you can see—pavement, concrete, curbs, utility poles—and things that you can't, such as easements, storm drainage pipes, and underground passages. All of these elements are apportioned above and below ground within the relatively narrow space of a right-of-way. In its most basic form, the street profile contains a sidewalk, a curb, travel lanes, and an opposite curb and sidewalk. That space can be divided up in many ways. The manner in which it is apportioned affects not only how the street functions, but also which users feel comfortable in the space.

Like rivers, streets are shaped by their edges. The use, size, and form of the buildings on a street influence the flow of pedestrian and vehicular traffic along the corridor. When taller buildings and more intensive uses tend to bring more people to the street, it is more efficient to accommodate them as pedestrians or cyclists than as drivers. Specific spaces within the right-of-way need to be well defined, with sufficient space allocated to bikers and walkers. Sidewalks, which hold the signs, poles, and meters that guide and regulate movement, should be expanded to accommodate the added foot traffic and to provide room for the furnishings that make streets more comfortable —trees, bus shelters, bike racks, and cafe tables.

Movement along a street often flows fastest toward the middle and more slowly along the edges. In a well-calibrated street, each travel mode has a band of space that suits its speed. At a building's edge, display windows, cafe tables, and stoops can create eddies in the flow of foot traffic, while faster walkers move out closer to the curb. Bicycles typically occupy a lane just beyond the curb, and cars and buses travel down the center of the street.

◄ *Safe Routing*. The streetcars that shuttle passengers into and through Portland's Pearl District add great mobility to the neighborhood, but the city had to accommodate the flow of bike traffic in its design of the streetcar stops. Bicyclists are skirted safely around the loading area and are not forced to enter the vehicular-travel lane.

▼ *Buffered Lane*. The parking lane on this Seattle street was shifted away from the curb, creating an excellent buffer between cyclists and moving cars. This alignment offers another safety benefit—a lower chance of being "doored." Parked cars face oncoming bikes so both cyclists and car passengers can see each other before a car door is opened. Creating a bike lane is physically simple but politically challenging, since space within a fixed right-of-way usually needs to be taken away from travel lanes or on-street parking.

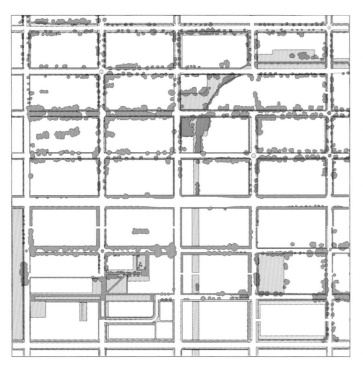

Figure 3.13 **Sample Green Network.**
*Green networks comprise the open
spaces and tree canopy that, together with
sidewalks, create a connected system that
serves pedestrians.*

Green Network

Green space may not affect travel behavior directly, but it's a major
component in making density work. When designed well, green net-
works perform double duty by filling a deep human need for contact
with nature while restoring ecological processes. Green spaces and
tall shade trees make the urban environment more palatable as they
perform services such as cooling, stormwater management, and car-
bon sequestration. People find respite in pocket parks, central greens,
boulevards, community gardens, playfields, roof gardens, and green-
ways, while trees and riparian corridors offer additional shelter for
wildlife. Public green spaces and canopies formed by street trees
thread through many of the sites described in this book. They form a
connective tissue of alternative routes away from traffic and along
pedestrian rights of way (figure 3.13).

A green network may contain several small spaces or one larger
park. It may have a mature, sheltering tree canopy or one still in its
infancy. Some of the 12 sites have only a little public green space
within their 125–130 acres, but they are within range of nearby
parks. The relationship between the green in each neighborhood and
its city's larger open-space system is shown in the context map for
each site (see figure 3.10).

4 Twelve Places Made for Walking

This sampling of 12 urban neighborhoods illustrates a dozen ways to build compact form. They are places where a walk, a bike trip, or a transit ride is a fine way to travel. For each of the sites, diagrams illustrate the form, while photographs convey the feel of the place. To help your eye "walk" down the street, a montage of one neighborhood street runs along the tops of the pages. Several photographs are laced together, maintaining a one-point perspective of the façades along the way. The vignettes are stitched into a whole that, while not optically accurate, tells a story of the street. A smaller "locator" version of the montage is at the bottom of each spread. The **Context** map shows the neighborhood's relationship to the city and open spaces around it as well as the larger transit network.

Various elements of urban form are peeled apart graphically to reveal their singular patterns in a series of smaller diagrams. **Figure / Ground** shows how the alignment of built structures forms the public street space. **Services** illustrates the arrangement of transit routes, businesses, retail services, and other neighborhood amenities. **Intersection Density** reveals the connectedness of the street network through the sizes of blocks and frequency of intersections. For U.S. sites, **Housing Density** shows dwelling units per acre for blocks within the study area according to the 2000 Census, and **Population Density** features 2010 population counts and lists the persons per square mile for the surrounding area. (The Canadian government does not publish comparable housing and population data.) **Green Space / Pedestrian Network** shows the existing tree canopy, open spaces, and the extent to which they are connected by pedestrian ways. All of the physical elements—streets, sidewalks, buildings, and green space—are combined in the **Neighborhood Pattern** diagram, which shows a unique composition of walkable urban form.

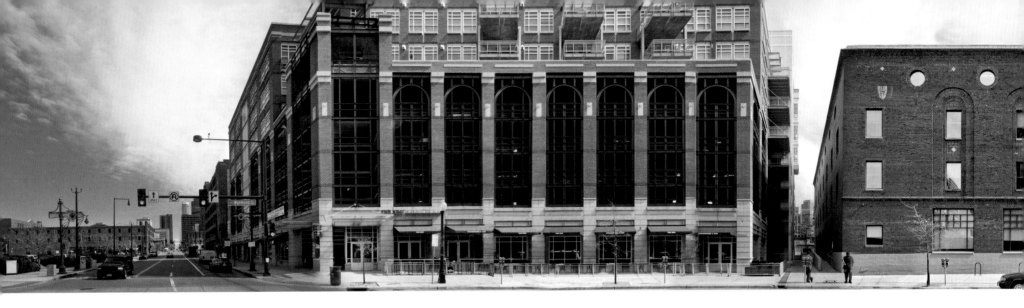

LODO AND THE CENTRAL PLATTE VALLEY DENVER, COLORADO

This site straddles Denver's oldest and newest neighborhoods—LoDo (Lower Downtown) and the Central Platte Valley, respectively. LoDo, Denver's original center, owes its early prosperity to a spur from the First Transcontinental Railroad. In 1870 the railroad reached southward to the banks of the Platte River and linked the struggling mining town with the flow of people and goods across the Great Plains. Denver's economy took off, and its population swelled. The urban grid, platted as early as 1864, began to take shape, filling in and up as the railroads thrived throughout the late-nineteenth and early-twentieth centuries.

By the 1930s the 40-block LoDo area was thick with three- and four-story buildings, and 80 trains traveled in and out of Union Station each day. But the eventual shift from railways to highways moved Denver's economic energy as well as its geographic center away from the train station. LoDo declined and reached a low point in the 1960s, when 20 percent of its buildings were demolished. The train station and many remaining buildings survived urban renewal, however, and by 1988 the neighborhood was designated a historic district.

In the 1980s the rail yards and industrial land that served LoDo in its early years were consolidated into an infill district known as the Central Platte Valley, and both areas were targeted for significant urban redevelopment. In 2010 work began to transform Union Station into a multimodal transportation hub that will consolidate national passenger rail, regional light rail, and the city's bus services into one expanded facility. Denver officials and community leaders expect the railroad to return to its former role as an engine of growth.

LoDo and the Central Platte Valley are located at the convergence of several transit lines, giving the site's residents ready access to points far and wide. Fewer than half of LoDo's residents use a car to get to work, with one-third walking, more than 10 percent using transit, and almost as many working at home. The high walk rate contrasts starkly with trends in the greater Denver metropolitan area, where only 2 percent of the population walks to work. Private auto commuting is likely to drop even further in the coming years when the multimodal center comes on line, and more retail, employment, and housing options arrive with the planned infill development. Many new buildings ranging in height from four to ten stories are planned for land currently used as surface parking. Most of the new projects will be for residential or office uses, some will combine both, and almost all of the upcoming development will contain ground-floor retail.

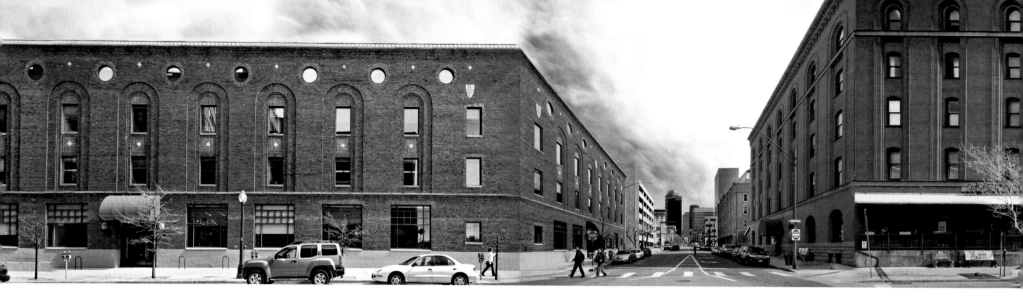

CONTEXT

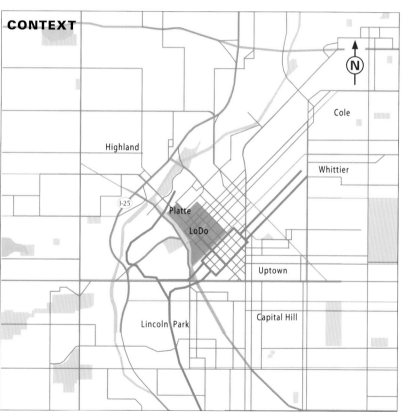

Highland

Cole

Whittier

I-25

Platte

LoDo

Uptown

Capital Hill

Lincoln Park

◀ *Central Platte and LoDo are found on Denver's original street grid, which was aligned with the South Platte River rather than the cardinal directions.*

▼ *An active rail line passes through the site.*

▼ *Little Raven Street.*

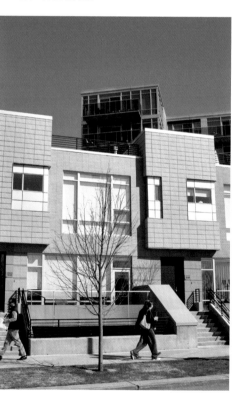

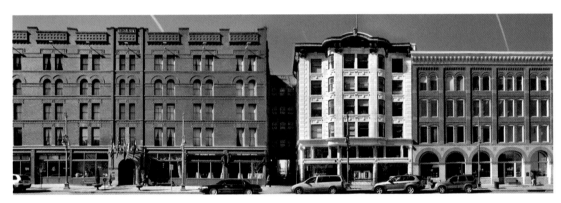

▲ LoDo's urban grid is punctuated by narrow alleys that allow passage through the middle of blocks. Buildings on 17th Street connect above the midblock alley.

▼ Mid- and high-rise apartments overlook the Cherry Creek Greenway.

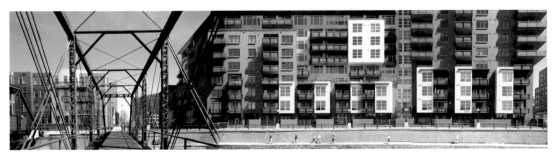

▼ In this figure / ground diagram, the street network in LoDo (shown on the right) is revealed though its buildings, whose alignments conform to a rectilinear pattern. Despite gaps in the fabric, the overall grid is visible. The pattern in Central Platte (left) is beginning to emerge with the first phases of infill development.

FIGURE / GROUND

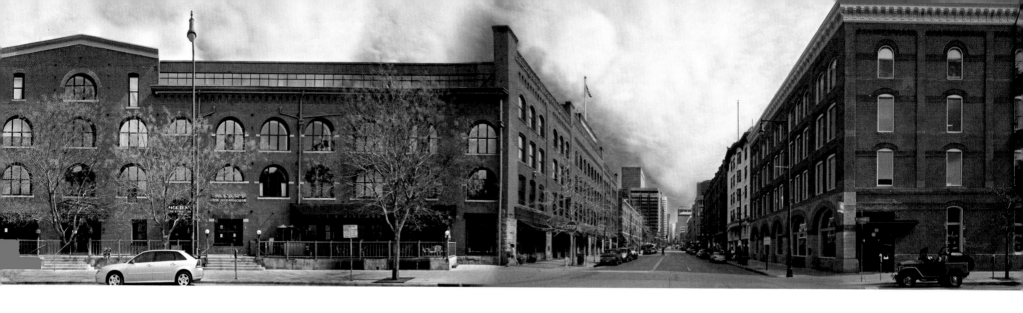

▼ Stores, restaurants, health clubs, banks, and other services are clustered throughout the neighborhood. The transit routes are located at different intervals, so residents need to walk only a few blocks to board a bus or train. Each color represents a different transit route.

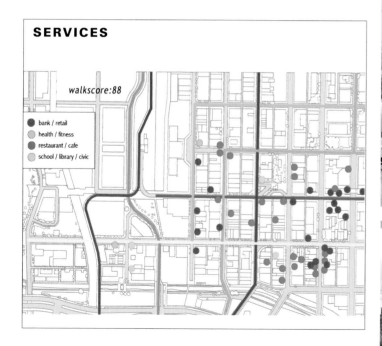

SERVICES

walkscore: 88

- bank / retail
- health / fitness
- restaurant / cafe
- school / library / civic

◄ The F Line connects downtown with suburban Lone Creek, 20 miles to the southeast.

◄ LoDo is both a residential neighborhood and Denver's entertainment district.

LoDo and the Central Platte Valley, Denver, Colorado

▶ Although 18th Street is interrupted by a rail line, the corridor offers a visual connection that extends into the Central Platte neighborhood.

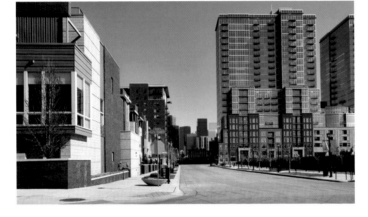

▼ Union Station is a landmark that is visible from many locations in the neighborhood.

▼ While LoDo (right) features a dense network of intersections, the rail line and river create barriers that limit street connections in Central Platte (left).

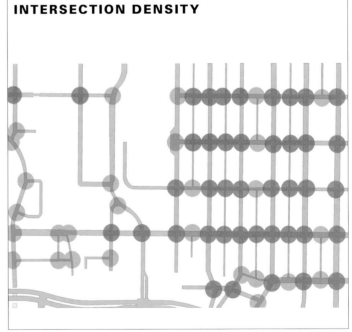

INTERSECTION DENSITY

▼ Residential densities have risen in the past decade and will continue to climb once the master plans for the Central Platte Valley and the area surrounding Union Station are completed and more than 2,300 new housing units are built.

▼ Although not built out yet, at 10,000 ppsm, Denver is on its way to establishing a significant residential population in its downtown core.

▲ Mid- and high-rise condominiums along Cherry Creek.

HOUSING DENSITY

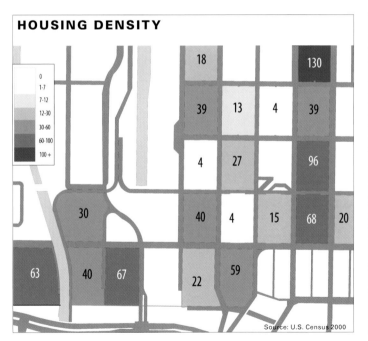

Legend:
0
1-7
7-12
12-30
30-60
60-100
100 +

18 130
39 13 4 39
4 27 96
30
40 4 15 68 20
63 40 67 22 59

Source: U.S. Census 2000

POPULATION DENSITY

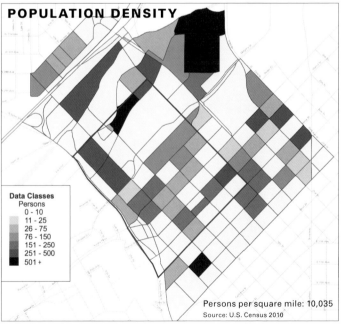

Data Classes
Persons
0 - 10
11 - 25
26 - 75
76 - 150
151 - 250
251 - 500
501 +

Persons per square mile: 10,035

Source: U.S. Census 2010

▼ *Infill buildings along Wynkoop Street (top) and 15th Street (bottom) have helped mend LoDo's historic urban fabric.*

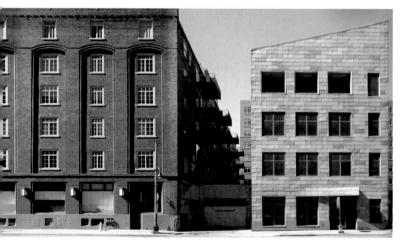

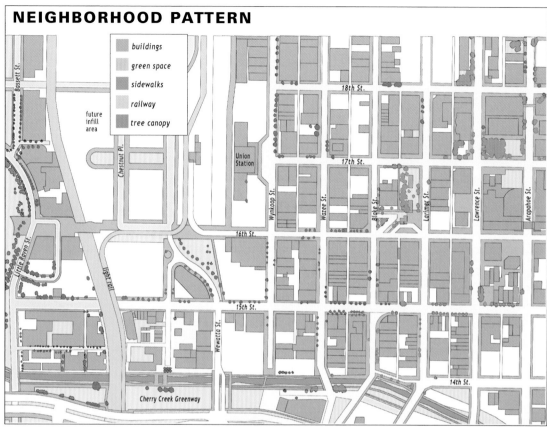

NEIGHBORHOOD PATTERN

- buildings
- green space
- sidewalks
- railway
- tree canopy

future infill area

Bassett St.

Chestnut Pl.

Little Raven St.

Light rail

Wewatta St.

Union Station

Wynkoop St.

Wazee St.

Blake St.

Larimer St.

Lawrence St.

Arapahoe St.

18th St.

17th St.

16th St.

15th St.

14th St.

Cherry Creek Greenway

▶ *Townhouses are mixed in with apartment buildings, extending the range of housing options.*

▲ To spur development of the vacant rail yards, Denver made several infrastructure investments including the construction of Commons Park, whose edges provide green promenades along newly constructed streets. The 40-acre park on the western edge of the site has become the centerpiece of the Central Platte Valley district.

▼ A park along Wewatta Street.

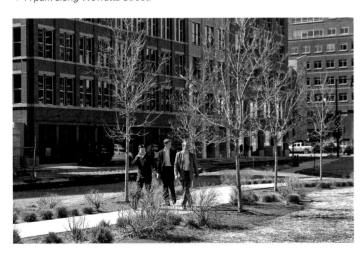

LoDo and the Central Platte Valley, Denver, Colorado

GREEN SPACE / PEDESTRIAN NETWORK

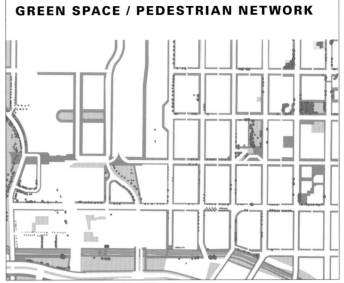

◄ In addition to green space investments, the city built footbridges spanning the rail line, river, and interstate highway just west of downtown and a series of bridges and plazas that connect LoDo with the Platte infill area and beyond to the Highland neighborhoood. These new pedestrian links complement the small blocks and extensive sidewalk network long established in LoDo.

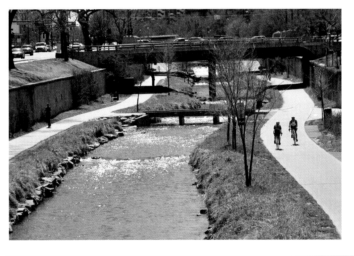

◄ The Cherry Creek Greenway extends over 12 miles into Denver's suburbs.

▼ Cherry Creek joins the South Platte River at Confluence Park, which includes a whitewater kayak run, a feature not often found in an urban setting.

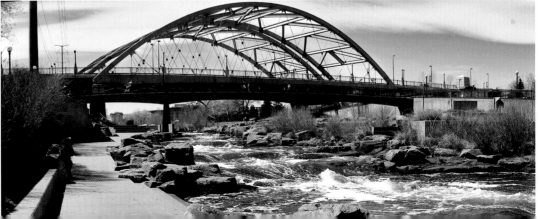

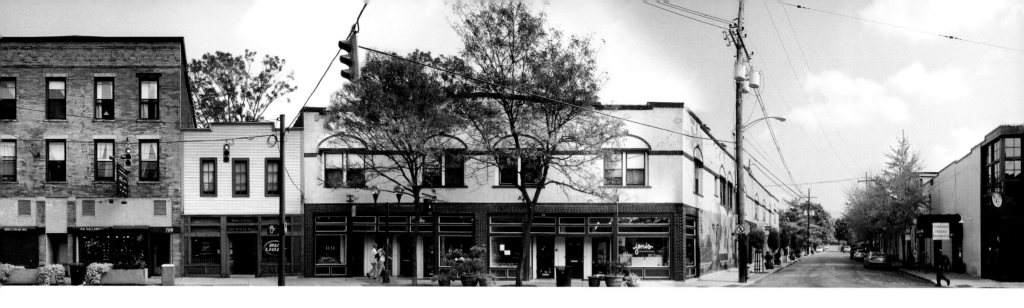

High Street is the backbone of Short North. It offers a wide array of cafes, restaurants, and other gathering places for residents from the surrounding neighborhoods as well as art galleries and shops. Unlike downtown Columbus, the scale here is intimate, with an uninterrupted urban fabric. With offices and apartments above street-level shops, the two- and three-story buildings that line these three blocks are exemplars of the insula building type. The revitalization of High Street continues to evolve, as businesses fill empty storefronts and façades are restored.

SHORT NORTH
COLUMBUS, OHIO

Short North, named for being just "short" of the northern edge of the central business district, lies between downtown Columbus and the southern edge of Ohio State University. The neighborhood emerged after the 1850 construction of nearby Union Station, which brought manufacturing industries to Columbus and businesses to High Street, Short North's commercial spine.

In the first half of the twentieth century, immigrants from many nations settled on the east side of High Street in what came to be known as Italian Village. To the west, prosperous residents of Columbus built homes around Goodale Park in Victorian Village. High Street served as both border and glue between these villages. Wooden arches erected in the late 1800s to commemorate a reunion of Civil War veterans spanned the street at regular intervals from Union Station to downtown. Built as supports for decorative lighting, the arches became a symbol of neighborhood identity. By 1927 Short North was humming with thousands of jobs and four streetcar lines serving the district.

Throughout the 1960s and 1970s, however, a widespread exodus to the suburbs left Short North in a state of neglect. Passenger rail traffic fell off, and in 1979 Union Station was demolished. In the early 1980s, crime persisted, and squatters occupied many derelict buildings. The city's attempts to revitalize Short North began with construction of the Columbus Convention Center on the former Union Station site and continued with the introduction of new multifamily residences. An influx of artists and entrepreneurs renovated historic properties and opened galleries and restaurants. Many of the district's historic buildings have been restored, and even the arches made a comeback when they were rebuilt in 2002 to celebrate the resurgence of the neighborhood.

As of 2000, densities in Short North were higher than the Columbus average—about 6,300 ppsm compared to 2,800. The mix of housing types yields a housing unit density of eight per acre—well above the rest of the Columbus metropolitan area, which has a residential density of fewer than two units per acre. Although public transit service today is a shadow of what was once offered in Short North, about 25 percent of the district's residents get to work without a car. This is higher than the 9 percent typical in the region. As Short North's new identity as a lively arts scene has developed, rental prices have crept upward. In response to this threat to the traditional diversity of the neighborhood, the city is making an effort to integrate affordable housing into future development plans.

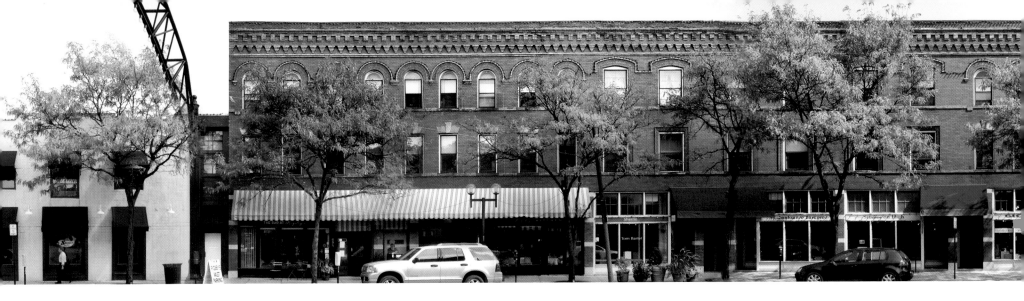

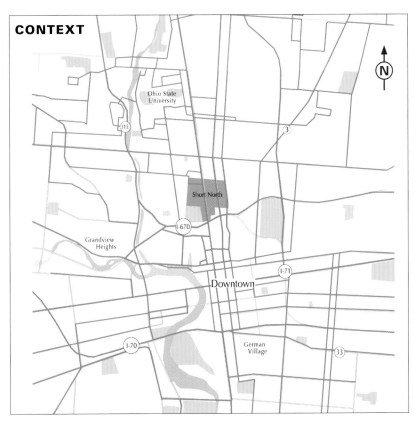

◄ Short North centers on High Street, the commercial corridor connecting the city center with Ohio State University.

▼ Although Interstate 670 cuts through the neighborhood here, the speeding traffic is not perceptible from High Street. The bridge above the highway was "capped" with this retail building designed to resemble historic Union Station.

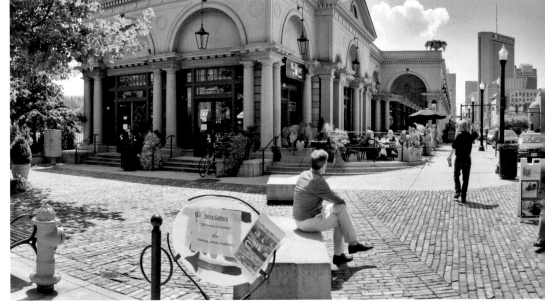

Short North, Columbus, Ohio

▶ New duplexes in Italian Village help fill the demand for affordable housing.

▼ A recent mixed-use development reinforces the continuous streetscape along High Street.

▼ Large buildings—commercial and multifamily structures—hug High Street (center). Smaller structures, their narrow ends parallel to the street, line residential blocks.

FIGURE / GROUND

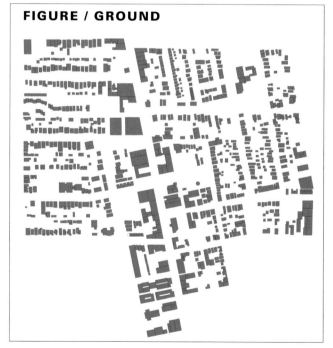

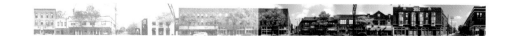

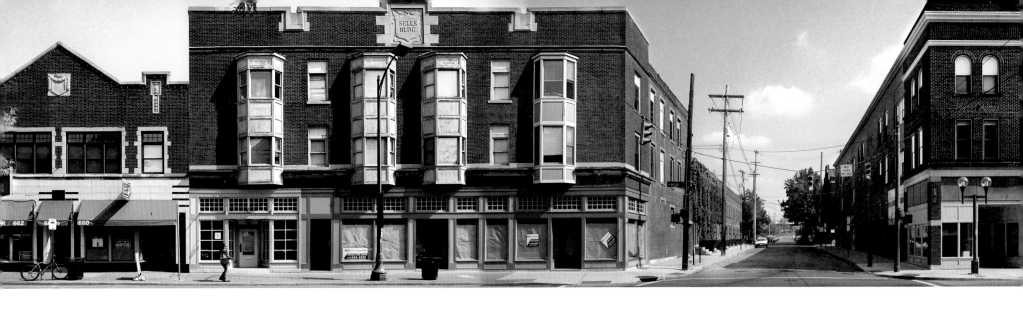

▼ Businesses are located along High Street, where buses run at 10- to 15-minute headways throughout the day.

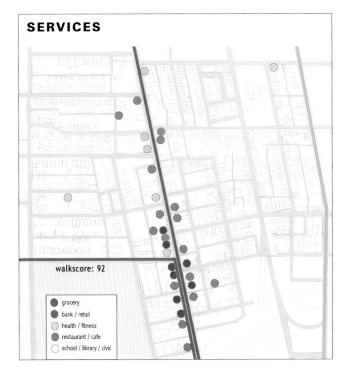

SERVICES

walkscore: 92

- ● grocery
- ● bank / retail
- ● health / fitness
- ● restaurant / cafe
- ○ school / library / civic

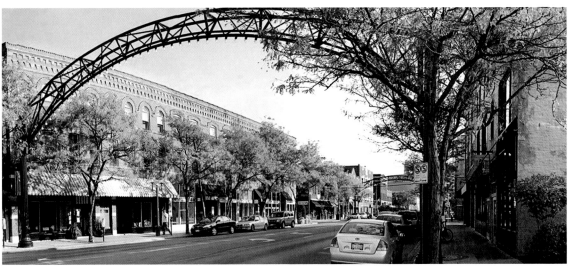

▲ The historic High Street arches were rebuilt in 2002 to celebrate the neighborhood's rebirth.

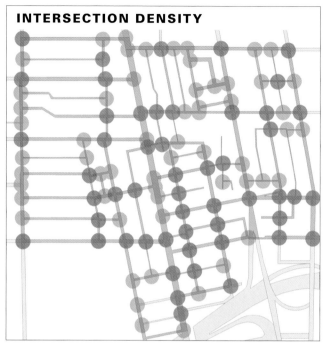

▲ The street network is highly connected, with 111 intersections.

▲▼▶ Art has played a major role in the resurgence of Short North. Mural paintings by local artists invigorate expanses of building walls, while sculpture enlivens many of the newly created pocket parks along High Street.

HOUSING DENSITY

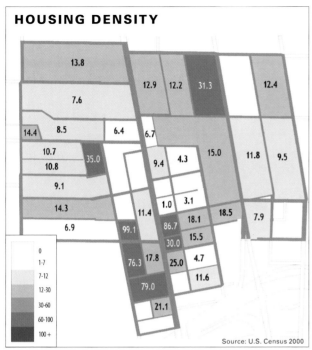

13.8
12.9 12.2 31.3 12.4
7.6
14.4 8.5 6.4 6.7
10.7 35.0 9.4 4.3 15.0 11.8 9.5
10.8
9.1
14.3 1.0 3.1
11.4 18.5 7.9
6.9 99.1 86.7 18.1
30.0 15.5
76.3 17.8 25.0 4.7
79.0 11.6
21.1

0
1-7
7-12
12-30
30-60
60-100
100 +

Source: U.S. Census 2000

POPULATION DENSITY

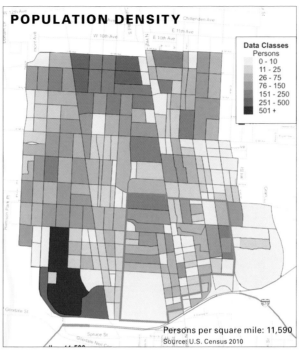

Data Classes
Persons
0 - 10
11 - 25
26 - 75
76 - 150
151 - 250
251 - 500
501 +

Persons per square mile: 11,590
Source: U.S. Census 2010

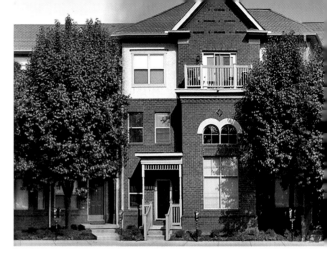

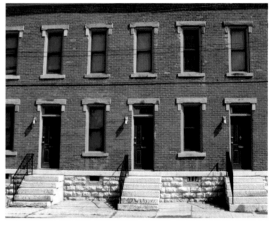

▲▲ *The latest wave of development in Short North brought multifamily housing, a trend that is reflected in blocks with densities over 25 units per acre.*

▼ *Kerr Street.*

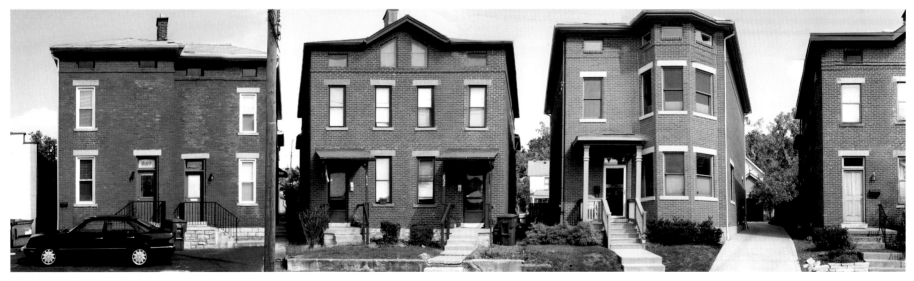

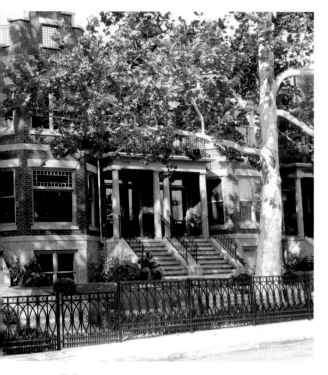

▲▼ *Buttles Avenue.*

NEIGHBORHOOD PATTERN

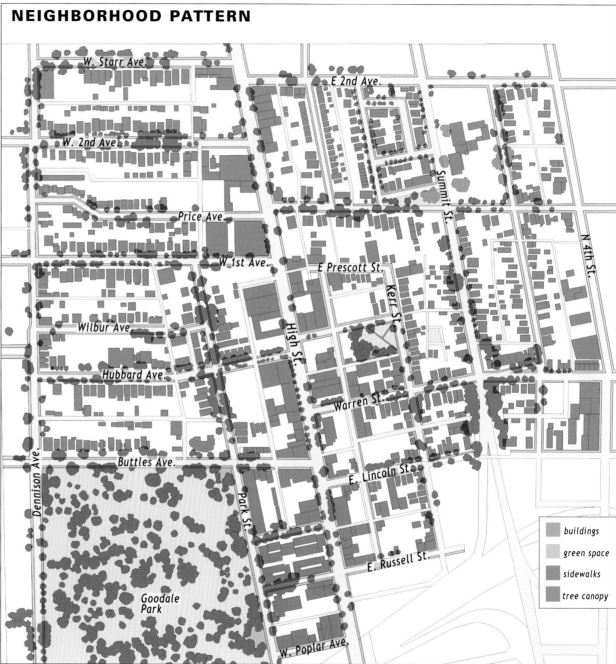

W. Starr Ave.

E 2nd Ave.

W. 2nd Ave.

Price Ave.

W. 1st Ave.

E Prescott St.

Summit St.

N 4th St.

Kerr St.

Wilbur Ave.

Hubbard Ave.

High St.

Warren St.

Dennison Ave.

Buttles Ave.

E. Lincoln St.

Park St.

E. Russell St.

Goodale
Park

W. Poplar Ave.

	buildings
	green space
	sidewalks
	tree canopy

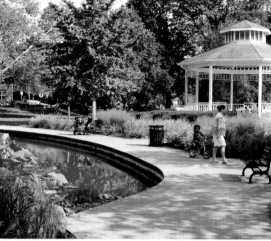

▲ Victorian Village Apartments courtyard.　　　　▲ Goodale Park.　　▼ Italian Village Park and Kerr Street.

▲ Columbus is well endowed with public gardens, including Victorian-era Goodale Park. With redevelopment in Short North have come new green spaces in the form of residential greens and pocket parks.

◄ Kerr Street is a quiet residential street two blocks east of High Street. Single-family homes, both attached and detached, predominate. The parcels are small and the frontages narrow (approximately 36 feet). This compact layout with many individual owners creates a varied streetscape.

KITSILANO
VANCOUVER, BRITISH COLUMBIA

Known locally as "Kits," Kitsilano is southwest of downtown Vancouver, on the shore of English Bay. Through the middle of the 1800s the area was mostly dense forest and wetlands, until settlers established sawmills and launched a salmon-fishing industry, eventually clearing the forest to make way for the emerging city. Growth in Kitsilano gained momentum through the 1930s and 1940s, as access to downtown and nearby commercial centers improved with the construction of the Burrard Street Bridge, which connects Kitsilano to downtown, and the opening of the electric streetcar lines along 4th Avenue and Broadway.

By the late 1940s, Kitsilano was a fully developed Vancouver neighborhood. Most of its residential buildings were single-family homes and older estates, but some were being converted into rooming houses to allow for lower rents and higher occupancy. This trend continued through the 1960s, when Kitsilano became a center for Vancouver's counterculture, and its population was dominated by college students and other young people.

The past 50 years have seen yet another shift in demographics and residential development as the allure of nearby beaches and parks attracted older, wealthier residents. The construction of midrise apartment buildings and conversion of historic homes into duplexes brought many more people—as well as higher real estate prices—to Kitsilano. City initiatives, such as the 1970s Neighborhood Improvement Program and the 1995 CityPlan, sought to reduce dependence on vehicles while diversifying housing options. Along with the apartment buildings came newly designed public spaces and a host of services. Four decades of smart redevelopment have resulted in an extremely desirable urban neighborhood, but it struggles to provide homes to people from a broad range of income levels.

Kitsilano has pursued ambitious goals for intensification and will reach relatively high densities before all the projects now in the works are completed. In addition to the larger developments of recent years, infill continues with smaller-scale, incremental infill—single- to multiple-unit conversions and a number of insula-type multiuse buildings. Planners project that, within its 5.4 square kilometers, Kitsilano's population will grow significantly. Currently, fewer than half of Kitsilano's residents drive a private vehicle to work, undoubtedly due to the site's improved walkability, safer bike lanes, and the comprehensive bus service it has enjoyed for the past 20 years. Vancouver officials plan to lower the amount of citywide driving even more by providing better alternative transportation infrastructure.

Kitsilano hosts a wide range of housing that varies from block to block. Single-family homes are common on some streets, low- and midrise apartments are the prevalent type on others. This leafy block of 12th Avenue between Vine and Yew Streets demonstrates how new multi-family buildings can fit into the context of a traditional neighborhood. Like the detached homes and duplexes of older Kitsilano, these townhouses, with front doors and yards that open to the sidewalk, present a friendly face to the street. Pathways between buildings provide midblock connections to a network of green spaces. At the end of the block is a retirement community that is fully integrated into this walkable network.

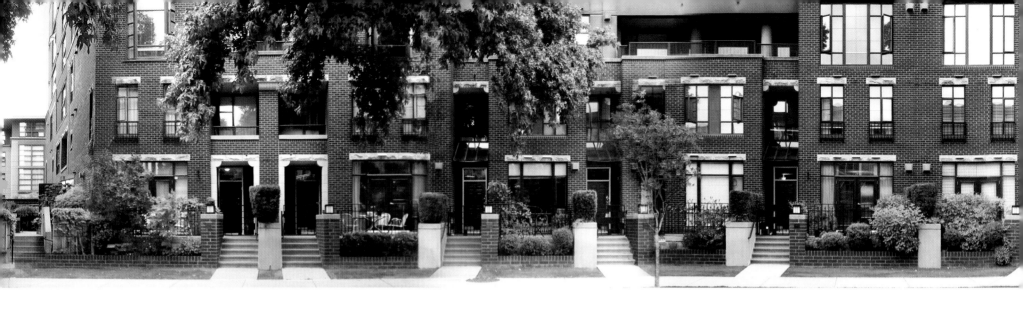

CONTEXT

North Vancouver

Stanley Park

English Bay

West End

Downtown

Eastside

Grandview Woodlands

West Point Grey

Kitsilano

Mt. Pleasant

Granville

◄ Kitsilano's central location makes it convenient to Vancouver's many parks, especially those along English Bay.

▼ Duplexes, such as these on Yew Street (top) and 10th Avenue (bottom), are common in Kitsilano.

◄ West Broadway is a commercial corridor and a major east-west bus route. Recent infill development, with ground-floor retail and residential units above, takes advantage of that access. Parcels along this major thoroughfare have been redeveloped more intensively in recent years, with buildings as high as eight stories set back atop three- to four-story podiums.

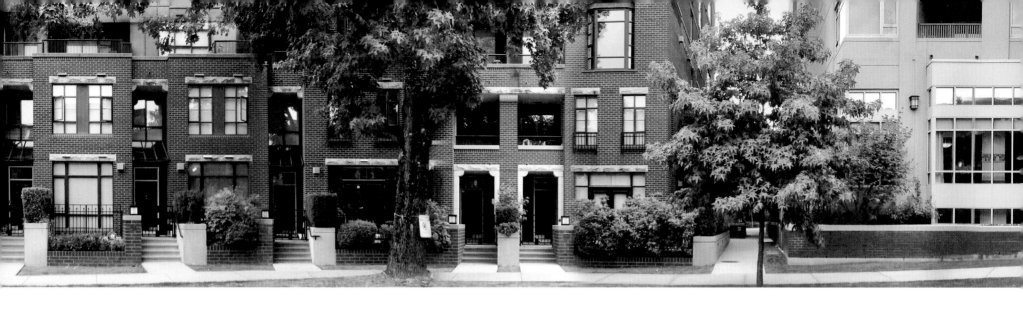

▼ Balconies are common in Vancouver, where temperatures are mild year round.

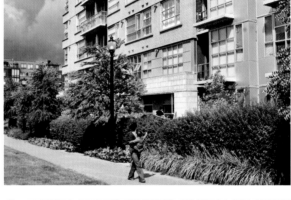

▼ The intensification of development in Kitsilano is apparent at the lower left of this diagram, which shows where larger, multi-family buildings have filled in a nine-block area.

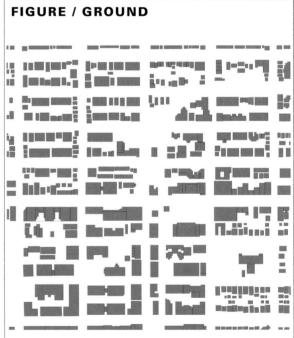

FIGURE / GROUND

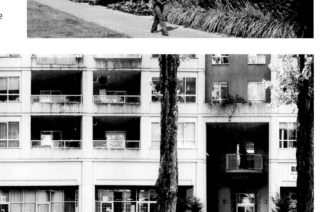

▼ Vancouver's urban grid features east-west commercial corridors every five to seven blocks. While Broadway carries more bus traffic, West 4th Avenue (top of diagram) hosts many services used by Kitsilano residents.

SERVICES

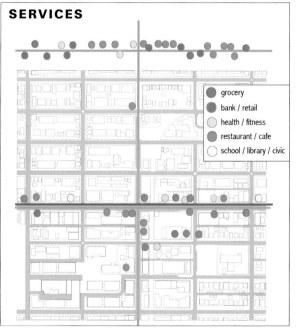

- ● grocery
- ● bank / retail
- ● health / fitness
- ● restaurant / cafe
- ○ school / library / civic

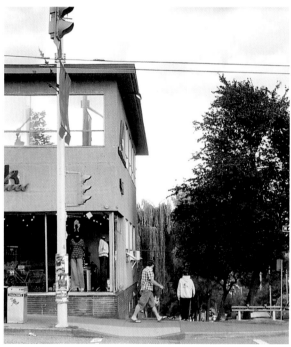

▶ Although they are within easy walking distance of Broadway and West 4th Avenue, most other streets are solely residential. This corner store on Yew Street is an exception.

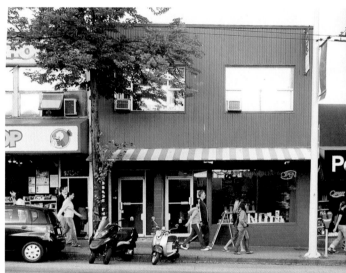

Kitsilano, Vancouver, British Columbia

▲▼ *Arbutus Street is one of Vancouver's north-south avenues. Here, new businesses line the street, and multistory buildings are filling the blocks where low-density structures once stood.*

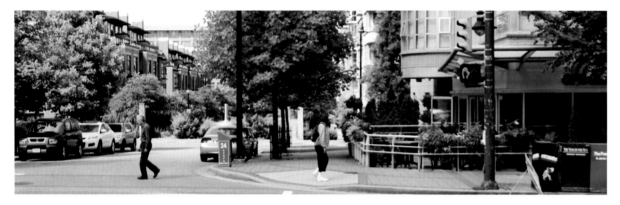

▼ *A former rail line slices though the site, creating narrow blocks along Arbutus Street.*

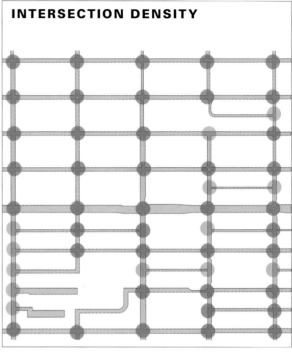

INTERSECTION DENSITY

▲ *South of Broadway, where recent infill has occurred, blocks are subdivided into smaller components with a higher intersection density.*

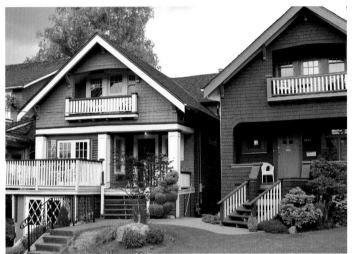

▲ Tall shade trees form canopies over many Kitsilano streets.

◄ Although Kitsilano has transitioned into a high-density neighborhood, many single-family homes remain between West 4th Avenue and Broadway and south of West 12th Avenue.

▼ As part of a redevelopment project, two blocks of West 11th Avenue became a greenway.

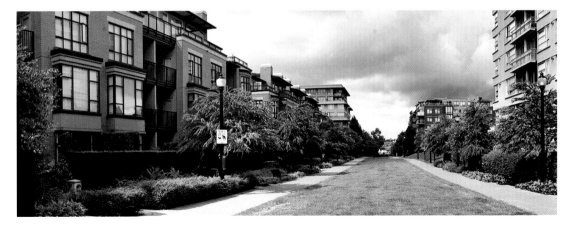

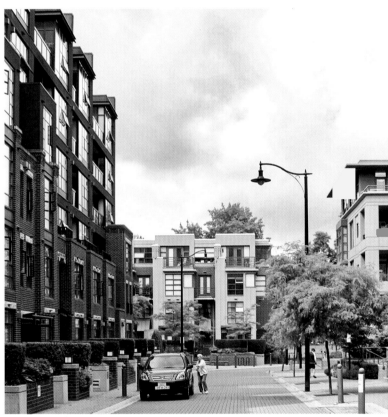

▲ West 4th Avenue.

▲ An alley between West 11th and West 12th Avenues has been transformed into a space that works both as public space and driveway.

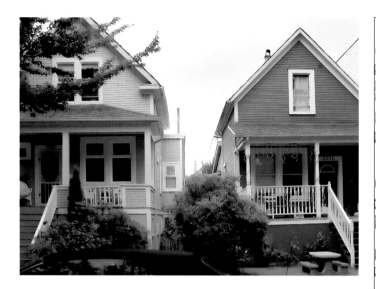

▲ 14th Avenue.

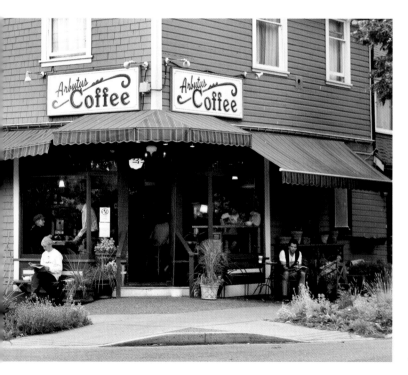

◀ Arbutus Street.

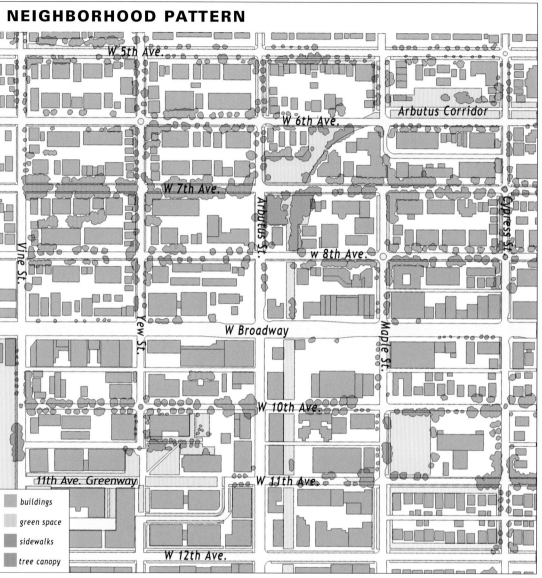

NEIGHBORHOOD PATTERN

W 5th Ave.

Arbutus Corridor

W 6th Ave.

W 7th Ave.

Arbutus St.

Cypress St.

Vine St.

w 8th Ave.

Yew St.

W Broadway

W 10th Ave.

Maple St.

11th Ave. Greenway

W 11th Ave.

- buildings
- green space
- sidewalks
- tree canopy

W 12th Ave.

▲ When Canadian Pacific Railroad ceased operation along the Arbutus Corridor in 2001, the thoroughfare became an informal green space. The city took legal action to keep the corridor intact for transportation and hopes to develop the 11-kilometer route as a bike and pedestrian path.

▲ The Cypress Community Gardens is alongside the Arbutus Corridor.

Kitsilano, Vancouver, British Columbia

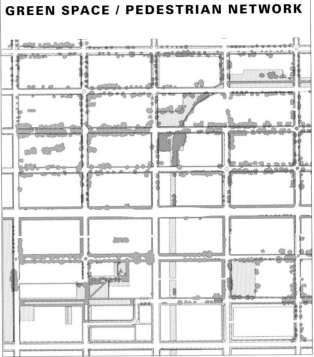

GREEN SPACE / PEDESTRIAN NETWORK

◄ While recent infill projects have brought new residents to Kitsilano, they also have resulted in more public green space. A new greenway along 11th Avenue connects the Arbutus Corridor with a city park just visible at the diagram's lower left corner.

▼ The 11th Avenue Greenway extends to West 10th Street in the form of a pocket park.

FLAMINGO PARK
MIAMI BEACH, FLORIDA

Flamingo Park is a neighborhood within Miami Beach, an island city with its own distinct character and history. After it was incorporated in 1915, the small resort community was transformed by an influx of newcomers—wealthy investors in oceanfront property, middle-class retirees, and a steady stream of tourists. Miami Beach thrived through the middle of the century and declined in the 1970s. Its rebound began the following decade when it served as the backdrop for several films and television shows and was discovered by a new generation.

It was the city's colorful setting that captured people's imaginations. Many of the hotels and apartment buildings that make up the city's dense fabric were built during the 1920s and 1930s in the Art Deco style popular at the time, but with a local twist—pastel colors and exotic motifs. Roughly 950 structures in this unique style make up what is now known as the Art Deco District. The distinctive architecture gained Miami Beach a designation on the National Register of Historic Places and has helped efforts to rejuvenate its southside neighborhoods. Flamingo Park is located on the quieter side of the Art Deco District, several blocks inland from the more famous South Beach and its tourist scene.

Miami Beach is a tourist town, but it has a year-round population of 88,000. The influx of Cubans and Central and South Americans accounts for the high number of residents who speak Spanish as a first language (55 percent). The variety of immigrants, along with sizeable Jewish and lesbian and gay populations, makes Miami Beach an unusually diverse place.

In addition to preserving its historic buildings, the city is taking steps to improve its alternative transportation infrastructure. Currently, one-third of Miami Beach's residents use alternative modes of transportation, and in South Beach that number is closer to two-thirds. Plans are in place to boost the numbers with more bikeways and pedestrian routes. They will connect the city's parks and waterways with the beach walk and a recreational corridor, a pedestrian pathway running the length of Miami Beach along the ocean. When complete these walkways will provide widespread access across the relatively narrow urban area.

Building heights vary, with towers from 10 to 30 stories high along the waterfront and lower structures toward the interior of the island. The Flamingo Park neighborhood features year-round residences in a mix of single-family houses, duplexes, townhouses, and two- to four-story apartment buildings. Unlike many resort communities, Miami Beach densities are high, with a citywide density of 12,520 ppsm.

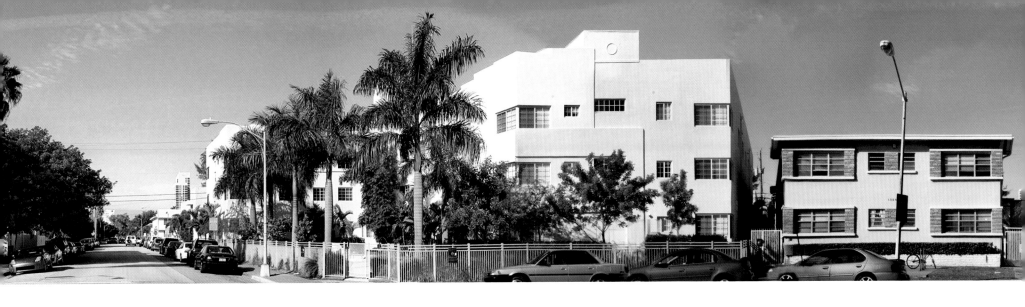

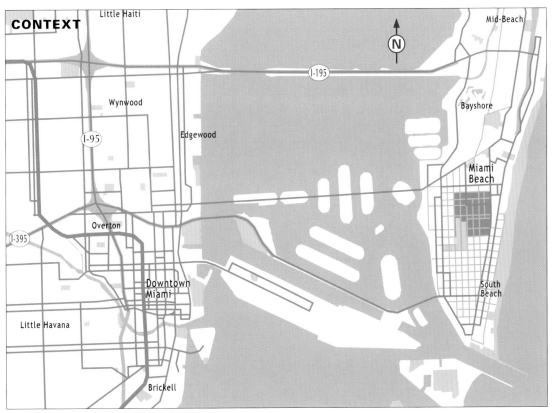

◄ Miami Beach occupies a barrier island across Biscayne Bay from the larger city of Miami. The public beach that faces the Atlantic Ocean to the east is the city's greatest natural asset.

▼ Art Deco apartment building, 11th Street.

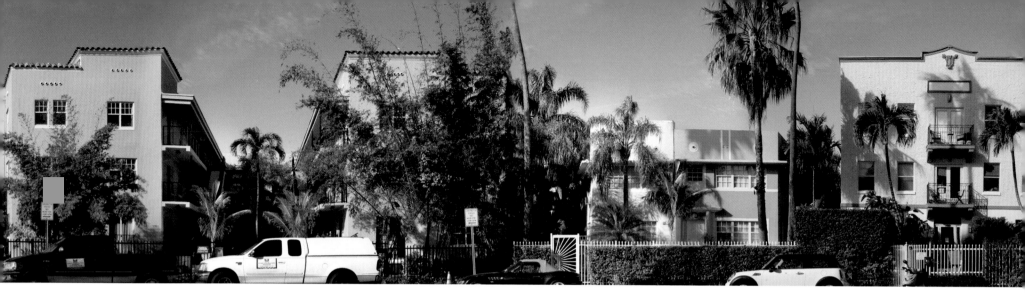

▼ *Washington Avenue at the Espanola Way pedestrian street.*

▼ *Entertainment options along Lincoln Road include theaters, bars, restaurants, and people watching.*

▼ *Three conditions contribute to Miami Beach's unique built form: (1) long, narrow blocks subdivided into (2) long, narrower parcels that have (3) a high building coverage.*

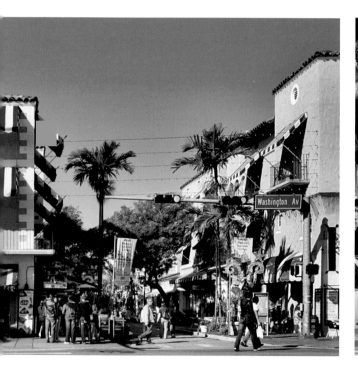

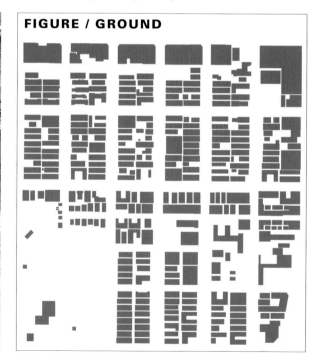

FIGURE / GROUND

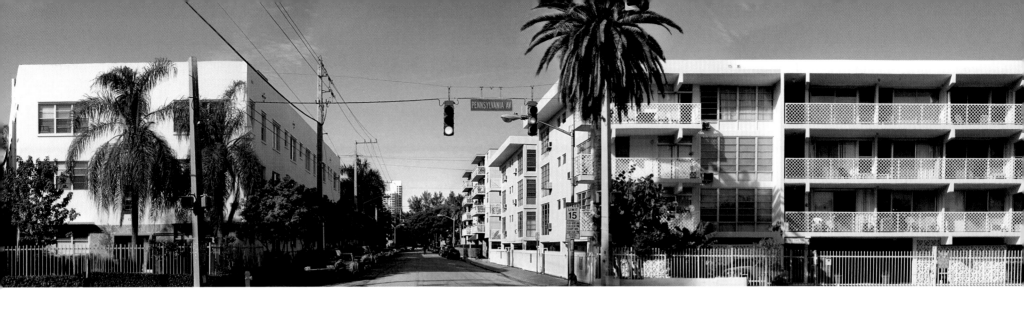

▼ Retail and dining dominate Lincoln Road Mall (top of diagram), and everyday shopping is located a few blocks to the west.

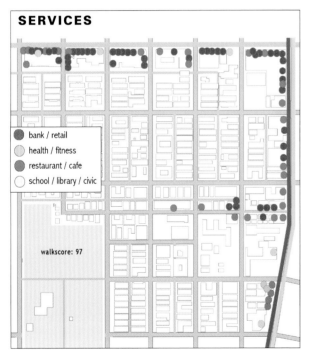

SERVICES

- bank / retail
- health / fitness
- restaurant / cafe
- school / library / civic

walkscore: 97

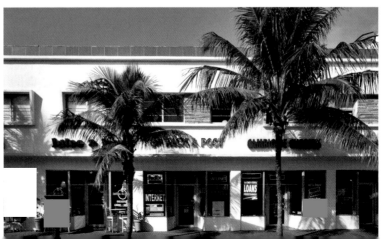

◀ Washington Avenue.

Flamingo Park, Miami Beach, Florida

63

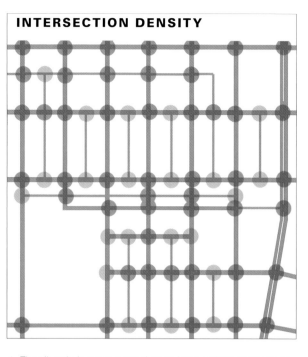

▲▼ The six blocks of Lincoln Road that pass through the site are closed to motorized vehicles. Drivers enter the pedestrian space at intersections designed to calm traffic.

▲ Alleys bisect most Flamingo Park blocks.

▲ The alleys help create more than 70 intersections across an area of approximately 125 acres.

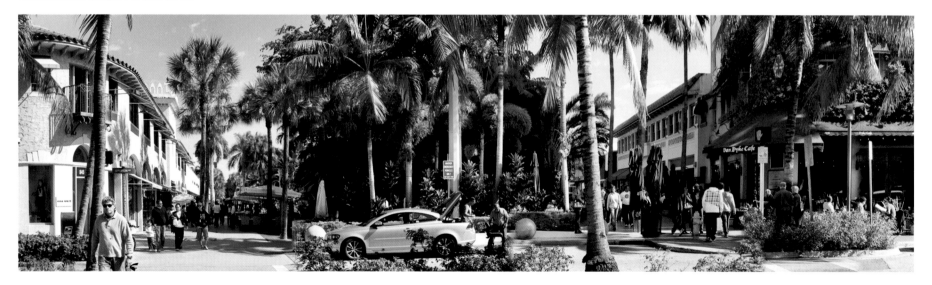

HOUSING DENSITY

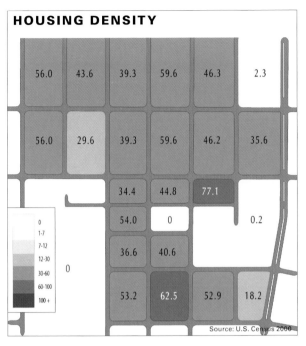

56.0	43.6	39.3	59.6	46.3	2.3
56.0	29.6	39.3	59.6	46.2	35.6
		34.4	44.8	77.1	
		54.0	0		0.2
0		36.6	40.6		
		53.2	62.5	52.9	18.2

Legend:
- 0
- 1-7
- 7-12
- 12-30
- 30-60
- 60-100
- 100 +

Source: U.S. Census 2000

▲ Few buildings in Flamingo Park exceed four stories but the high building coverage yields a relatively high density.

POPULATION DENSITY

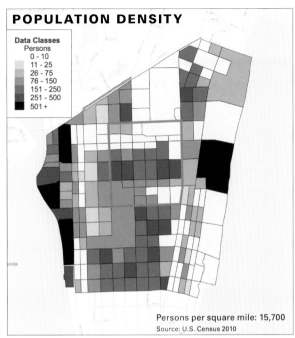

Data Classes
Persons
- 0 - 10
- 11 - 25
- 26 - 75
- 76 - 150
- 151 - 250
- 251 - 500
- 501 +

Persons per square mile: 15,700
Source: U.S. Census 2010

▲ Miami Beach's highest densities are found along the ocean and the bay, where buildings from 10 to 30 stories are common.

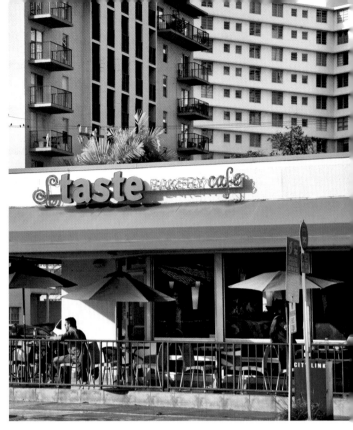

◀ Meridian Avenue.

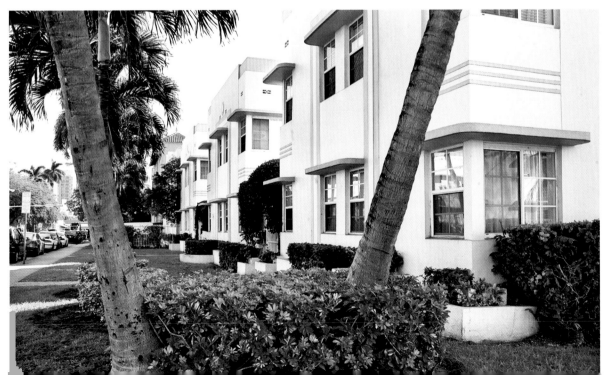

65

▲ Art Deco, Miami Beach style.

▼ Meridian Avenue.

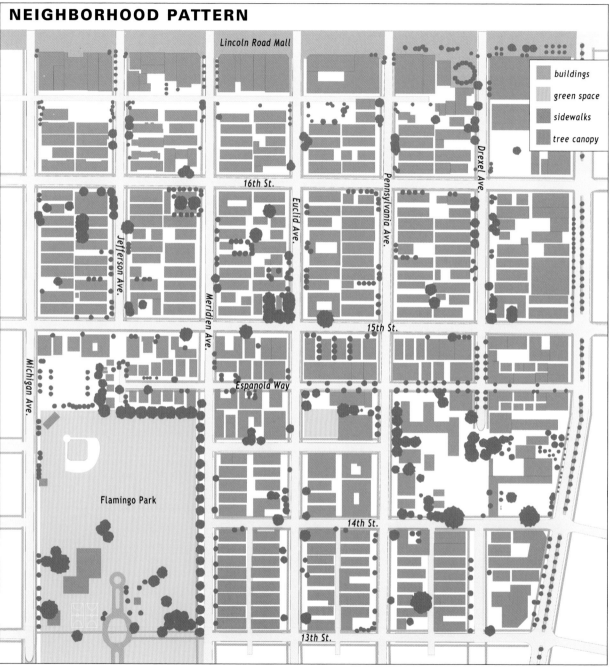

NEIGHBORHOOD PATTERN

Lincoln Road Mall

Drexel Ave.

16th St.

Pennsylvania Ave.

Euclid Ave.

Jefferson Ave.

Meridien Ave.

15th St.

Michigan Ave.

Espanola Way

Flamingo Park

14th St.

13th St.

buildings
green space
sidewalks
tree canopy

▲ The promenade in Lummus Park along the beach.

▼ Pickup basketball in Flamingo Park.

GREEN SPACE / PEDESTRIAN NETWORK

◄ Created in 1909, Lummus Park was Miami Beach's first investment in green infrastructure. The beach park is located a few blocks east of the site. Flamingo Park (shown at lower left on the map) complements Lummus Park with active recreation facilities.

▼ Seventy acres of beaches, walkways, and bike paths connect 10 city blocks along Miami Beach's eastern shore.

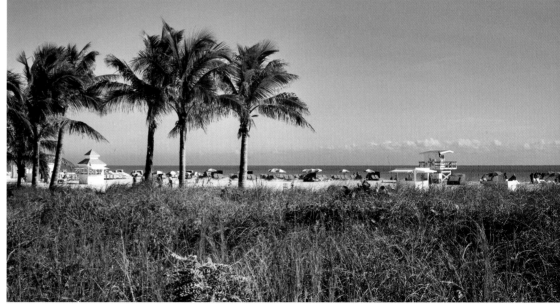

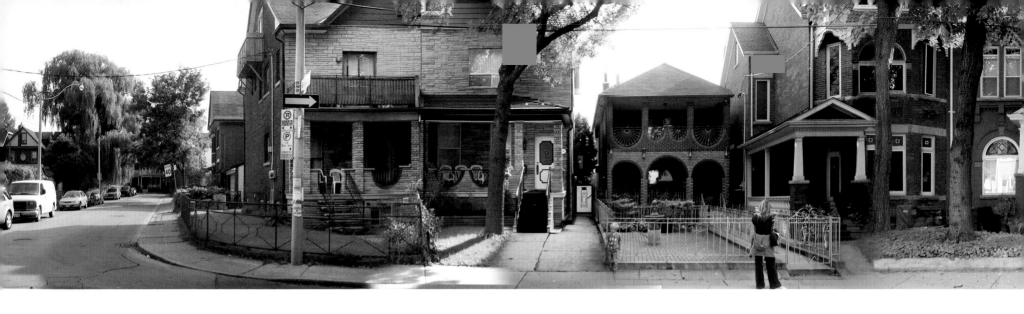

The attached single-family home is king in Toronto's older neighborhoods, and Shaw Street is no exception. A few free-standing houses are found here, but most homes share at least one party wall. Attaching houses in two- and three-unit buildings on narrow lots creates a lively streetscape. The buildings share similar massing and scale, but individual owners shape their properties with distinctive details. This pattern yields a density of 35 units per hectare (14 units per acre)—sufficient to support transit and other services.

LITTLE PORTUGAL
TORONTO, ONTARIO

Little Portugal and the neighborhoods that surround it contain a large share of Toronto's housing stock. This area has long attracted immigrants, first from Portugal, Italy, Ukraine, and Poland during the 1900s, and later from other European countries, Brazil, China, and Southeast Asia. For more than 50 years, the Portuguese were the predominant ethnic group living there, and they established many businesses and churches along Dundas and College Streets. Now the area is in transition. Second-generation Portuguese families are moving to the suburbs, while urban professionals seeking older homes near the city's downtown core are moving into Little Portugal. Recent demand for historic properties has pushed real estate prices upward. Combined with a growing number of art galleries, specialty food stores, and other upscale retail services, this trend has caused concern about the changing character of the district.

Single-family attached houses dominate Little Portugal, as they do in most older Toronto neighborhoods. Built during the Victorian era and aligned on narrow lots, the townhouses and duplexes, with their intricate façades, create a distinctive streetscape. Variations on attached housing followed in later decades until the neighborhood was fully built out with streets of a smiliar character. The community's fondness for this building type as well as a shortage of vacant lots have limited infill opportunities on the side streets of Little Portugal. Development is now focused on the commercial corridors, where plans are in the works to replace low-rise and underused structures with four- to six-story apartments and mixed-use buildings.

This neighborhood has already established itself as commuter- and pedestrian-friendly in comparison to the greater Toronto metropolitan area, where 71.4 percent of the population uses a private vehicle to get to work. Bicycles can be seen on every street in Little Portugal, and cycling seems to be widely recognized as a convenient form of transportation. Recognizing the transit benefits of urban residential areas like Little Portugal, the Toronto Planning Department considers it to be a model for future mixed-use neighborhood centers.

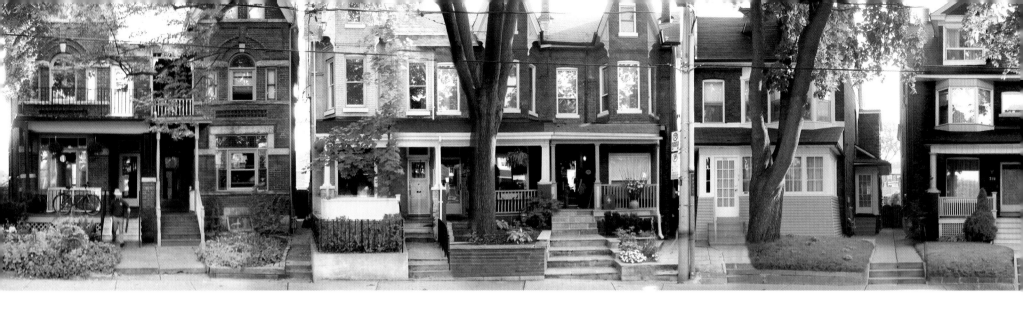

CONTEXT

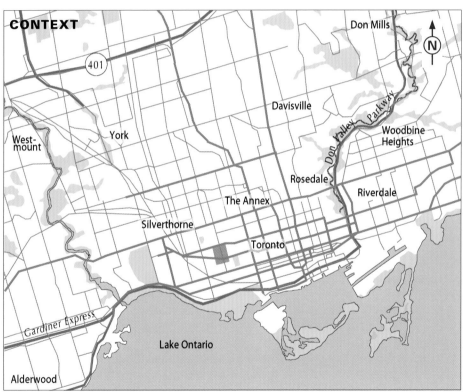

Don Mills

N

401

Davisville

Woodbine
Heights

York

West-
mount

Rosedale

The Annex

Riverdale

Silverthorne

Toronto

Gardiner Express

Lake Ontario

Alderwood

◄ Toronto's open space system centers on its
river corridors, waterfront, and harbor islands.
The city's robust transit network combines
subway, streetcar, and bus routes.

▼ Queen Street.

Little Portugal, Toronto, Ontario

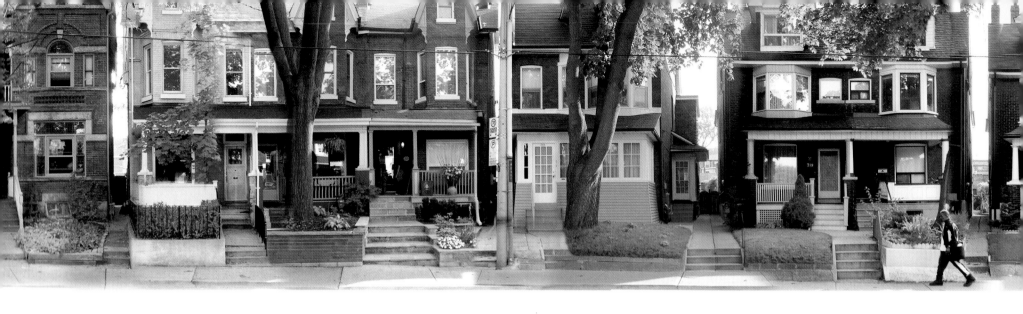

▼ A low fence and porch railing demarcate the two small yet vital transitional spaces between the street and the house.

▶ Parcels, and therefore buildings, in Little Portugal are small, which creates a fine-grained urban texture.

▼ College Street.

FIGURE / GROUND

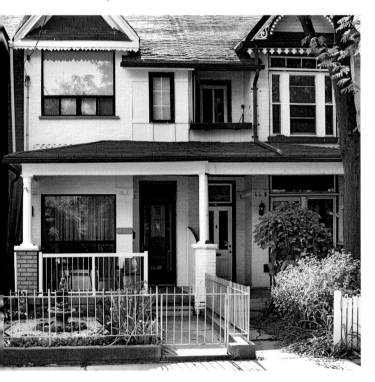

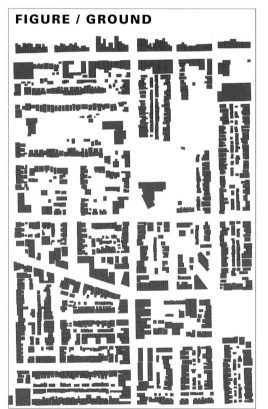

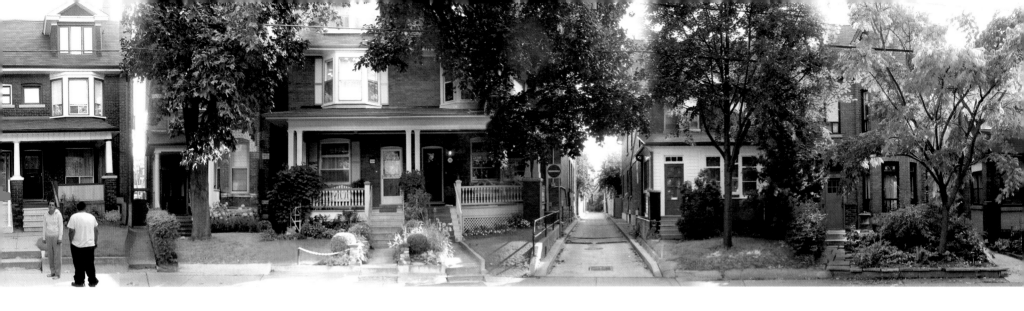

SERVICES

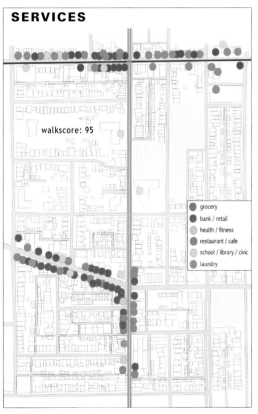

walkscore: 95

- grocery
- bank / retail
- health / fitness
- restaurant / cafe
- school / library / civic
- laundry

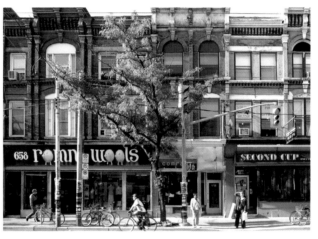

▲ Queen Street is a shopping street and transit route located just beyond the site's boundary along Little Portugal's southern edge.

◄ Ossington Street, which runs north-south to link the commercial corridors of College and Dundas Streets, is undergoing change, with restaurants and shops replacing older auto-related businesses. Recent proposals for midrise condominiums have stirred controversy in the neighborhood.

▶ College Street.

▲ Bike racks are common on Little Portugal's sidewalks, but it isn't always easy to find a free spot on College Street.

▼ College Street threads through the northern edge of Little Portugal. This major east-west corridor functions as a shopping street and gathering place for many neighborhoods.

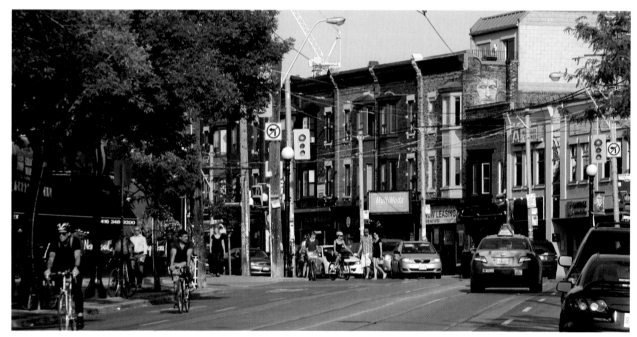

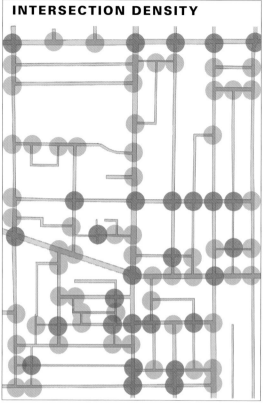

INTERSECTION DENSITY

▲ Although a few large blocks and cul-de-sacs are found here, this section of Little Portugal is highly connected, with 88 intersections.

▲ Fred Hamilton Park.

▼ College Street.

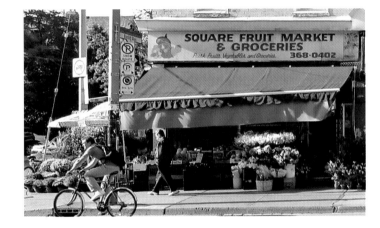

▲ Attached houses, painted to express multiple ownership.

▼ Queen Street.

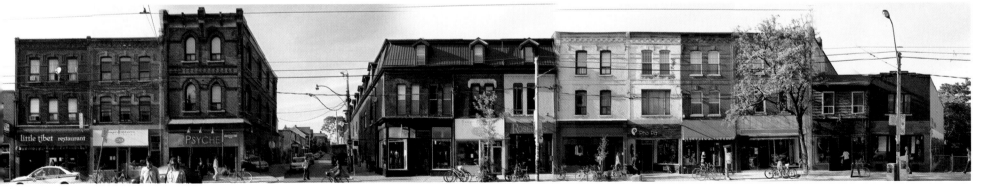

▶ *Most residents of Little Portugal have a small piece of ground to call their own.*

▼ *On Argyle Street, Santa Cruz Catholic Church still offers masses in Portuguese.*

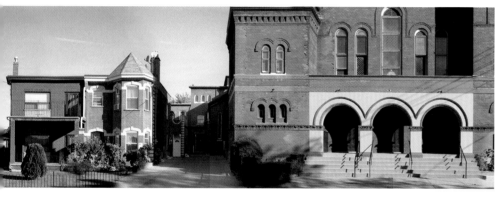

▼ *Lakeview Avenue.*

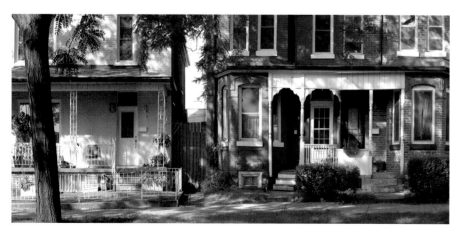

NEIGHBORHOOD PATTERN

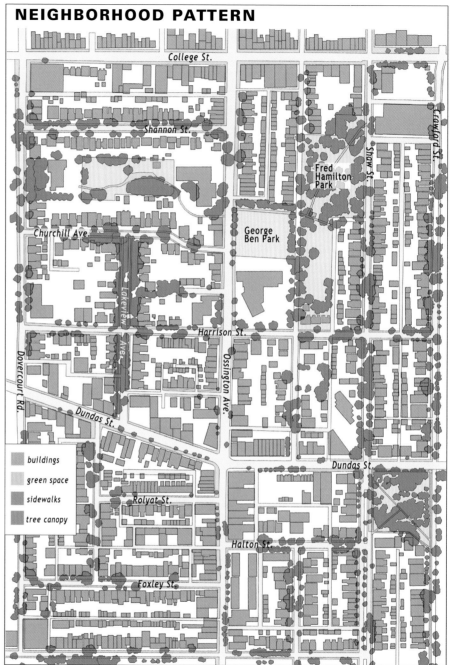

College St.

Shannon St.

Churchill Ave.

Fred Hamilton Park

Shaw St.

Crawford St.

George Ben Park

Lakeview Ave.

Harrison St.

Dovercourt Rd.

Ossington Ave.

Dundas St.

Dundas St.

buildings

green space

sidewalks

tree canopy

Rolyat St.

Halton St.

Foxley St.

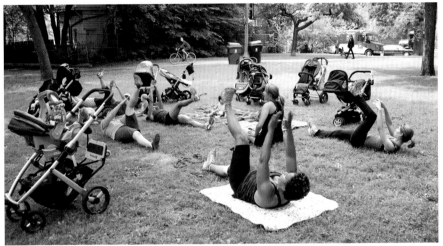

▲ Summer scenes in nearby Trinity-Bellwoods Park.

GREEN SPACE / PEDESTRIAN NETWORK

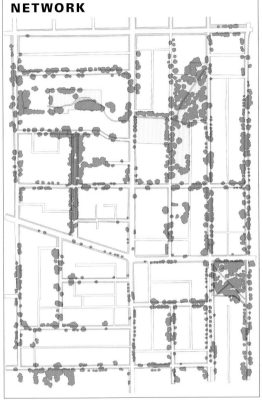

◄ Small, neighborhood-scale parks are plentiful in Toronto. The offerings in Little Portugal give residents easy access to grass and trees. Larger parks are located just off site in Trinity-Bellwoods and Little Italy.

▼ Lakeview Avenue, a residential street with tall trees and deep setbacks, doubles as a linear park.

King Street is Alexandria's historic main street. Its pedestrian-friendly form offered a compelling model for redevelopment of the Eisenhower East area. The scale of development here is small, with two-story buildings and narrow frontages. Entrances are closely spaced. Porches add sheltering elements. The challenge in redeveloping dense urban districts is replicating these humanizing effects when working at a larger scale, with bigger parcels and larger buildings.

EISENHOWER EAST
ALEXANDRIA, VIRGINIA

The 130-acre site encompasses a small section of historic downtown Alexandria and a larger transit-oriented redevelopment zone known as Eisenhower East. These neighboring districts share access to the King Street Metro station, which connects them to the greater Washington, DC, region.

Alexandria functions as a suburb, but it's an independent city with its own history. It began as a colonial outpost on the Potomac River and expanded inland along King Street. After the 1850s, a small mill village at the western edge of the city, home to the new Orange and Alexandria Railroad, exploded with industrial activity and remained a hub for 140 years. Like many economies built on rail, activity in the district slowed as commerce shifted to roads, but the cities around Washington did not abandon trains. They expanded transit service and by the 1980s, Yellow and Blue Line Metro service connected Alexandria with Washington. The former industrial area renamed Eisenhower East was transformed into a new kind of employment center.

The small number of property owners made it possible to plat the area with sizeable parcels attractive to larger companies. In 2006 the United States Patent and Trademark Office relocated its head-

quarters along with 9,000 employees to the district. This move could have resulted in a suburban-style office park built for automobile access from the adjacent Capital Beltway. But because it coincided with a decades-long effort by Washington and its suburbs to build density around commuter rail stations, the relocation helped transform Eisenhower East into a walkable urban neighborhood.

Since 2003, the city and developers have adhered to the Eisenhower East Small Area Plan, which outlines a growth pattern similar to Alexandria's historic downtown, where uses are mixed and people walk. It emphasizes office development as a local source of employment. To accommodate high-density growth, reducing private vehicle traffic through greater use of alternatives is a top priority.

Efforts to use the Metro transit system as a catalyst for growth are beginning to pay off. Just over half of Eisenhower East residents use private vehicles to get to work. Planners expect that rate to drop as development proceeds, further integrating office and residential space and reducing the availability of parking. With many development projects still in the works, overall densities in Eisenhower East remain low—4,263 ppsm—but when the planned addition of 11,000 residents is realized and the area is fully built out, density will rise to about 25,000 ppsm.

.

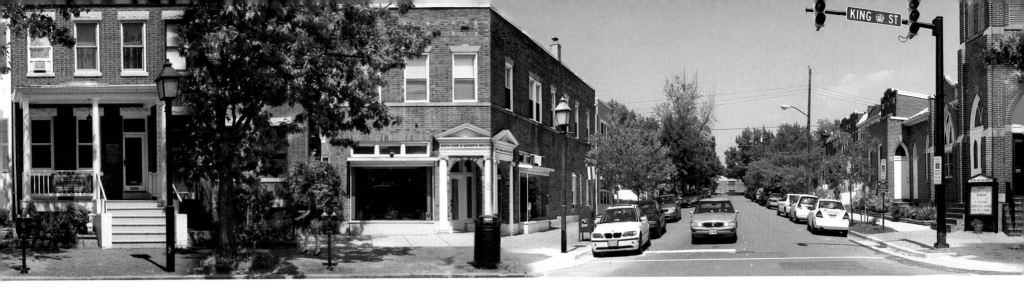

CONTEXT

◀ Alexandria is one of several suburbs in the DC area that have capitalized on transit, building dense city centers around subway stops.

▼ The downtown is filling in with a multistory mix of offices, apartments, hotels, and the many retail services that support them.

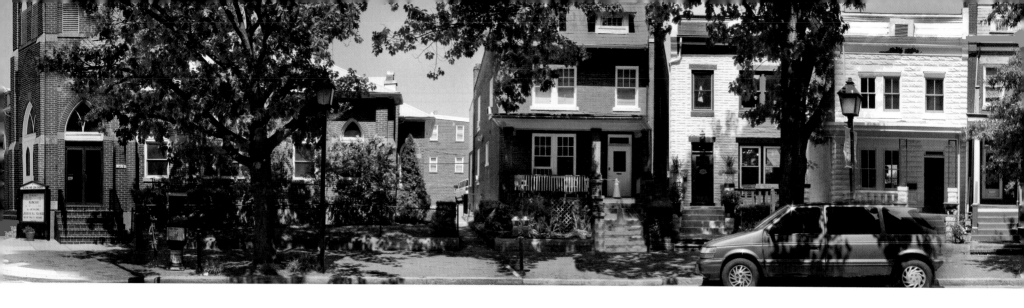

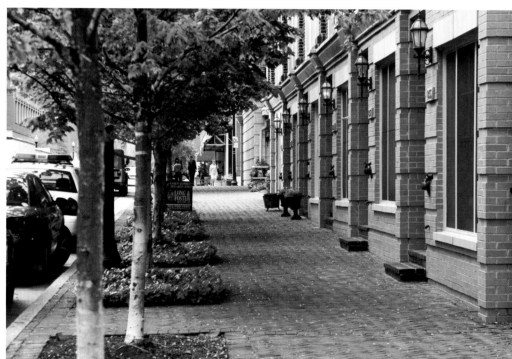

▲ A well-appointed sidewalk, a detailed and permeable façade, and a sheltering canopy are elements that make pedestrians comfortable in high-density neighborhoods.

▼ Because it had been an industrial zone, Eisenhower East offered parcels that could accommodate large companies needing block-size buildings. These structures were built out to the sidewalk, maintaining strong edges along the newly created streets. In a network like Alexandria's, with its diagonal streets and odd-shaped blocks, this is a challenge.

FIGURE / GROUND

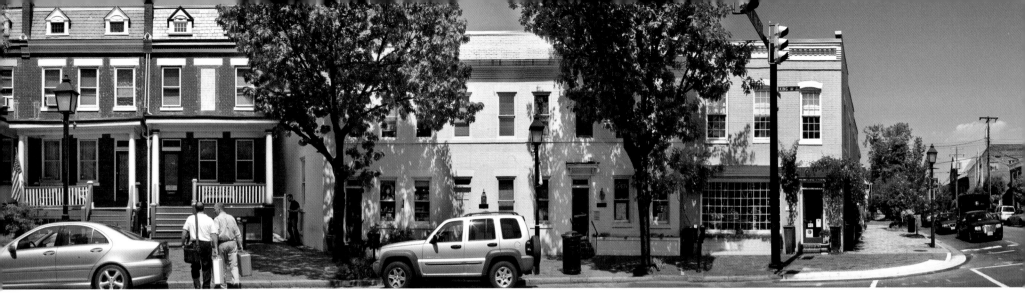

Businesses are found along King Street (right, middle) as well as scattered around the neighborhood, where they serve office workers throughout the day.

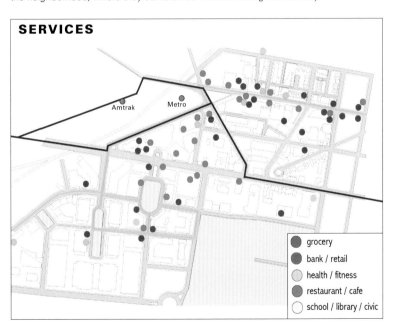

SERVICES

Amtrak Metro

- ● grocery
- ● bank / retail
- ○ health / fitness
- ● restaurant / cafe
- ○ school / library / civic

▶ Buses circulate through the site, connecting most blocks with the Metro and Amtrak stations.

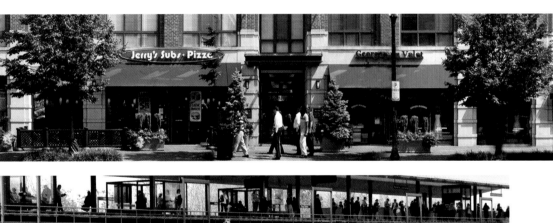

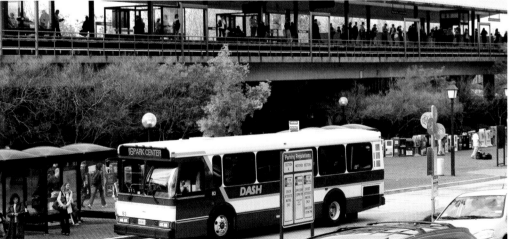

▶ *Hotels and offices are located across from the Metro station on Diagonal Road, where Old Town Alexandria overlaps with Eisenhower East.*

▶▶ *In terms of connections and block size, the recently constructed street network at the lower left in the diagram is a fair match to the older one shown at the upper right.*

▶ *A network of interconnected off-street sidewalks and public spaces extend route choices for pedestrians.*

▶▶ *Jamieson Avenue.*

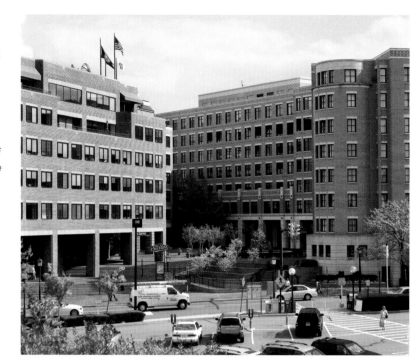

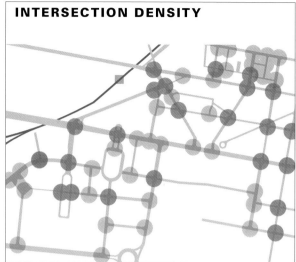

INTERSECTION DENSITY

HOUSING DENSITY

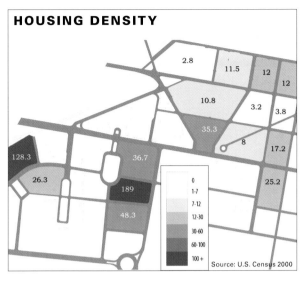

2.8 11.5 12 12
10.8 3.2 3.8
35.3
8 17.2
128.3 36.7
26.3 189 25.2
48.3

	0
	1-7
	7-12
	12-30
	30-60
	60-100
	100 +

Source: U.S. Census 2000

POPULATION DENSITY

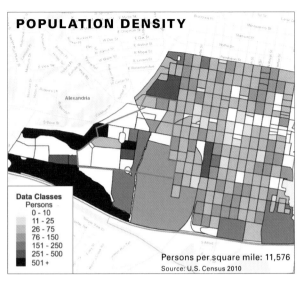

Alexandria

Data Classes
Persons
0 - 10
11 - 25
26 - 75
76 - 150
151 - 250
251 - 500
501 +

Persons per square mile: 11,576
Source: U.S. Census 2010

◄ *With its many offices, hotels, and institutions, Eisenhower East is alive with activity. Its residential density is just beginning to emerge as the new apartment buildings are completed, however.*

▼ *Two blocks facing Emerson Avenue—one complete, the other in the works.*

▼ *John Carlyle Street.*

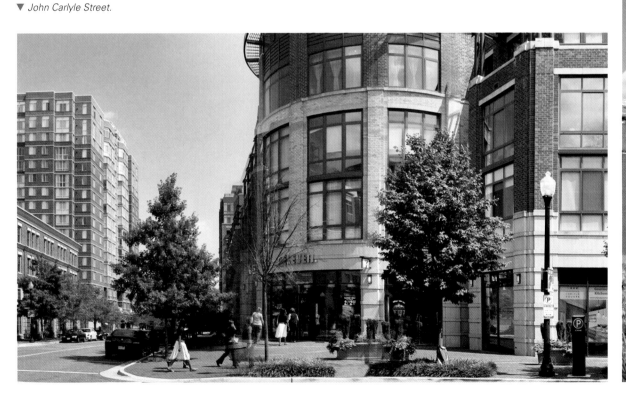

▲▼ *In dense urban settings, the benefits of tall shade trees can't be overstated.*

NEIGHBORHOOD PATTERN

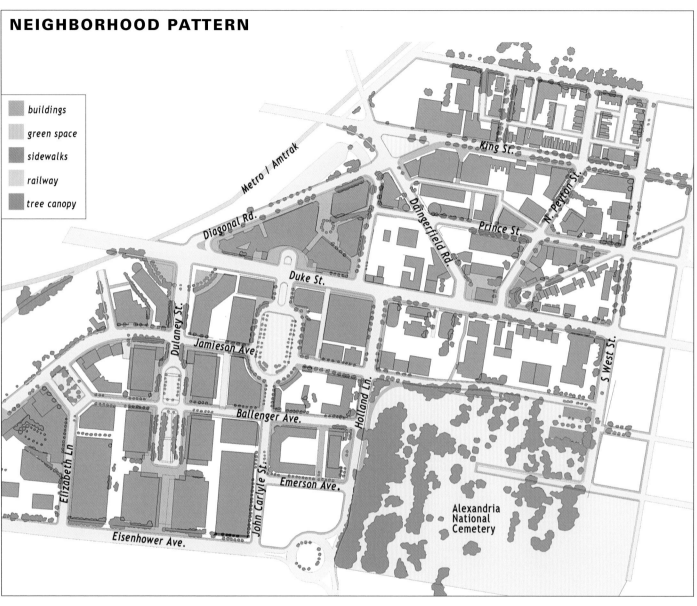

■	buildings
■	green space
■	sidewalks
■	railway
■	tree canopy

Metro / Amtrak

Diagonal Rd.

King St.

Daingerfield Rd.

Prince St.

N. Peyton St.

Duke St.

Dulaney St.

Jamieson Ave.

Elizabeth Ln.

Ballenger Ave.

Holland Ln.

S. West St.

John Carlyle St.

Emerson Ave.

Alexandria National Cemetery

Eisenhower Ave.

▲ Dulany Street picnic area.

GREEN SPACE / PEDESTRIAN NETWORK

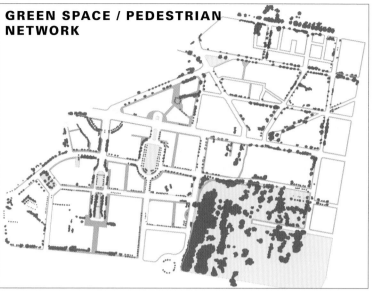

◄ Many of the buildings in Eisenhower East are grouped around public greens, which are connected by allées of trees. This network of small spaces complements the larger National Cemetery (lower right), which offers a set of green lungs as well as a quiet strolling area for Alexandria.

▼ Holland Lane Park.

▼ Offices facing the green on Dulany Street.

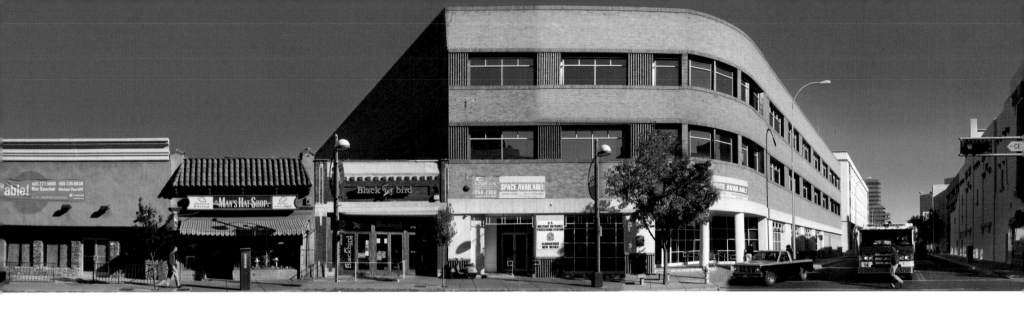

DOWNTOWN AND RAYNOLDS ADDITION
ALBUQUERQUE, NEW MEXICO

Central Avenue has seen its share of visitors. During the pre-interstate era, this Albuquerque segment of Route 66 was a conduit for much of the traffic passing through the Southwest. It was also Albuquerque's Main Street, home to several banks and other employers. Single-story buildings along these downtown blocks evoke memories of the avenue's earlier days as a commercial strip. The Kimo Theater, built in 1927 in a Pueblo-influenced Art Deco style, is a source of local pride. Its restoration in the 1980s initiated an ongoing effort to return Central Avenue to its former glory. For now, this downtown area functions as an entertainment district. Bars, restaurants, and theaters occupy most of the street-level properties.

The 130-acre site straddles the southwestern quadrant of downtown Albuquerque and a neighborhood known as Raynolds Addition. Platted in 1912, Raynolds filled in with apartments and bungalows through the 1940s. The multifamily structures built during those years were Albuquerque's first apartments, unusual in a predominantly low-density city.

Easy access to downtown made Raynolds an ideal location and both districts thrived until the postwar era when attention and energy moved elsewhere. Downtown lost its status as the commercial center of the region, which it had enjoyed since the arrival of the railroad in 1880. As markets and investors left for the suburbs, downtown and Raynolds slipped into decline. This neglect was coupled with the widespread urban renewal mindset of the 1960s. Historically significant but long-neglected buildings became the target of demolition and were replaced by office buildings, plazas, parking lots, and in many cases vacant lots with no prospects for redevelopment. Downtown atrophied and Raynolds lost a portion of its housing stock. The gaps in the urban fabric have lingered for decades and are now being repaired with infill development.

As residents worked to renovate buildings and revive parks, civic effort and an active neighborhood association helped turn things around. In 2000 Albuquerque's planning department produced a long-term plan for the downtown area, with Raynolds as a key residential component. The plan included initiatives to make all of downtown more pedestrian friendly and to increase the population by establishing housing districts in adjacent neighborhoods. This encourages development of three- to four-story townhouses and four- to six-story apartment buildings.

With these measures in place the city hopes to reach its goal of 20,000 people living within a mile of the central business district. A few developers have seen the potential of a district just blocks away from Albuquerque's new multimodal transit center, and are building loft-type apartments and townhouses. By offering a greater variety of housing options and urban amenities not found elsewhere, they are bringing residents back to the area.

Albuquerque has a long way to go to reduce its overall VMT. In spite of a comprehensive network of low-fare buses, only 6 percent of residents citywide get to work without a car.

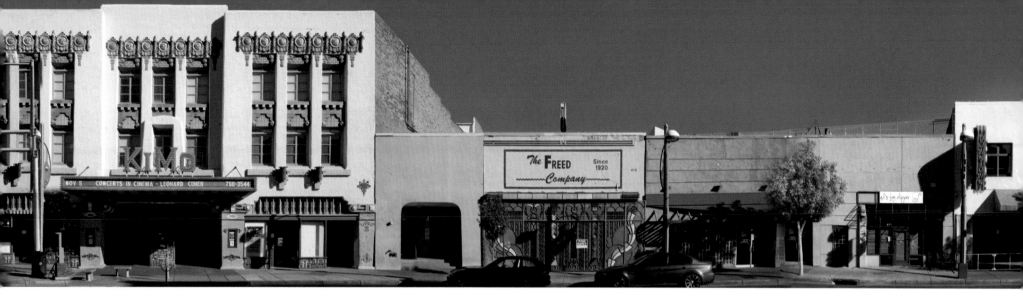

CONTEXT

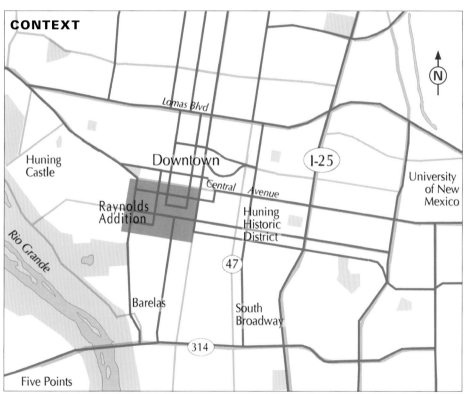

◀ *The site is located on the southwest edge of downtown, within a mile of the Rio Grande corridor.*

▼ *A commuter train arrives at the Alvarado Transportation Center, which is also a hub for local and intercity buses and a stop on Amtrak's Southwest Chief route.*

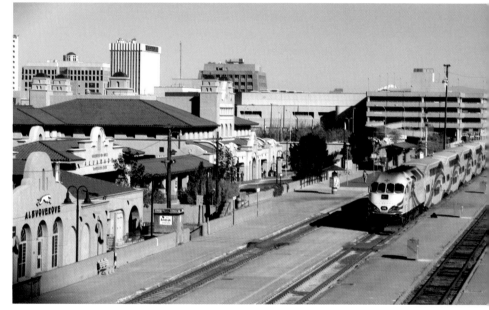

Downtown and Raynolds Addition, Albuquerque, New Mexico

▲ Infill housing on Silver Avenue SW.

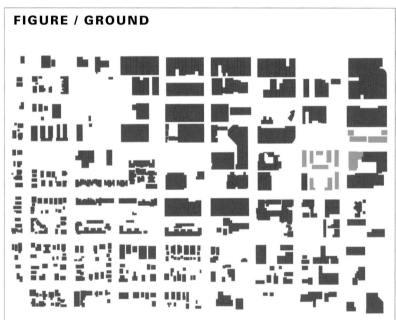

FIGURE / GROUND

▲ The urban renewal era took its toll on Albuquerque, and many gaps still remain in the city's built fabric. The lighter shading shows buildings soon to be completed.

SERVICES

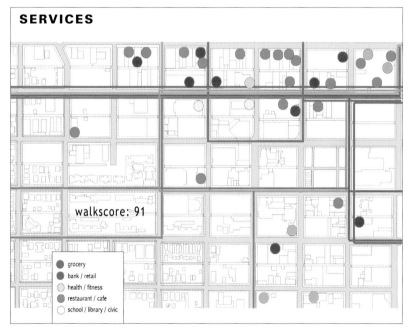

walkscore: 91

- grocery
- bank / retail
- health / fitness
- restaurant / cafe
- school / library / civic

▲ Bars, restaurants, and coffee shops are the most common businesses in this area of downtown. The lack of other services may reflect the currently low residential density.

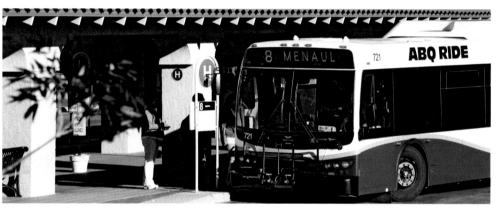

▲ Alvarado Transportation Center.

▼ Amy Biehl High School, 4th Avenue SW.

▲ Gold Avenue SW.

▼ The recent Silver Lofts development added a restaurant/cafe (right) to the neighborhood as well as live/work lofts, a housing type that was relatively new to the area.

INTERSECTION DENSITY

▲ Albuquerque's street grid is consistent and interconnected with alleys doubling the number of route choices.

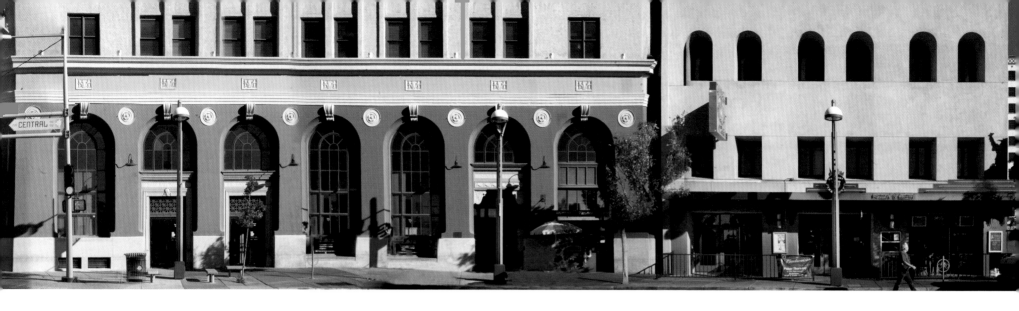

HOUSING DENSITY

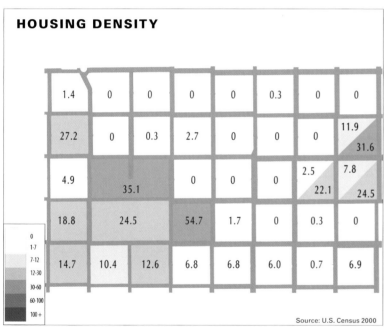

1.4	0	0	0	0	0.3	0	0
27.2	0	0.3	2.7	0	0	0	11.9 / 31.6
4.9	35.1		0	0	0	2.5 / 22.1	7.8 / 24.5
18.8	24.5	54.7	1.7	0	0.3	0	
14.7	10.4	12.6	6.8	6.8	6.0	0.7	6.9

0
1-7
7-12
12-30
30-60
60-100
100 +

Source: U.S. Census 2000

POPULATION DENSITY

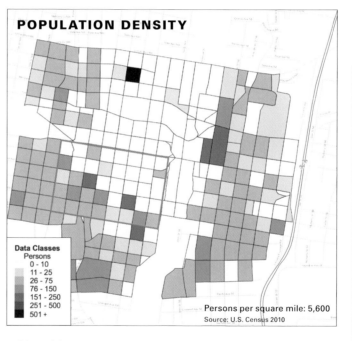

Data Classes
Persons
0 - 10
11 - 25
26 - 75
76 - 150
151 - 250
251 - 500
501 +

Persons per square mile: 5,600
Source: U.S. Census 2010

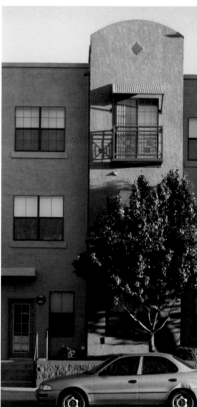

▲ Albuquerque has a long way to go to rebuild its downtown population. The development of multifamily units in Raynolds (left) and around the transportation center (right) has helped. Blocks with two values indicate both the current (upper left) and future (lower right) densities for blocks with projects that are underway.

▲ Most of the recent residential development has occurred in neighborhoods on the periphery of downtown.

Downtown and Raynolds Addition, Albuquerque, New Mexico

NEIGHBORHOOD PATTERN

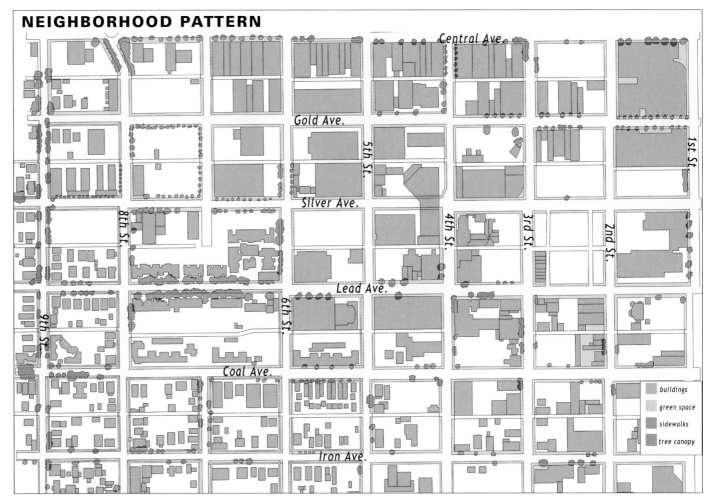

Central Ave.

Gold Ave.

5th St.

Silver Ave.

4th St.

3rd St.

2nd St.

1st St.

8th St.

Lead Ave.

6th St.

9th St.

Coal Ave.

Iron Ave.

	buildings
	green space
	sidewalks
	tree canopy

▲▼ The first phase of a 72-unit infill project on Lead Avenue and 3rd Street SW.

▶ The Downtown Theater Block, an early revitalization project, wrapped shops and restaurants around a 14-screen cineplex and located offices on upper floors.

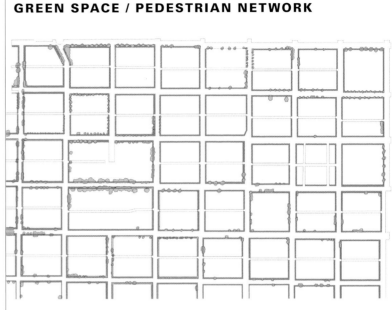

GREEN SPACE / PEDESTRIAN NETWORK

▲ Albuquerque has made efforts to green up the neighborhood by planting street trees, but open space is in short supply. The small blocks and sidewalks create good pedestrian connections.

▲ Within a broad riparian corridor of cottonwood and coyote willow trees, the Rio Grande passes through Albuquerque one mile from the site.

▶ The river corridor provided an excellent location for the Paseo del Bosque bike trail, which runs for 16 miles without a street crossing.

Downtown and Raynolds Addition, Albuquerque, New Mexico

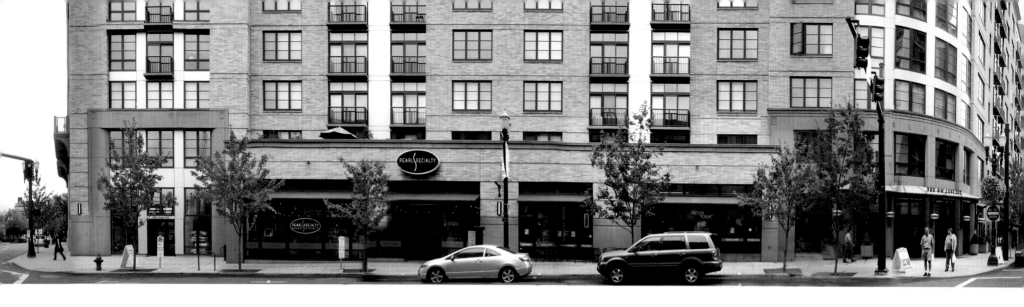

NW Lovejoy Street crosses the Pearl District at its northern end on the site of the old rail yards. Unlike the southern half of this site, which contained warehouses within a street grid, the urban fabric in this end of the Pearl was built from scratch. Lovejoy is a main thoroughfare, streetcar route, and neighborhood destination with several banks, coffee shops, restaurants, a bakery, and a supermarket. The diversity of businesses within walking distance is made possible by the families living in the 440 townhouses, flats, lofts, and penthouses in the upper stories of these three blocks. They provide a critical mass of customers that support the businesses.

THE PEARL DISTRICT
PORTLAND, OREGON

Until 20 years ago, the Pearl was known as the Northwest Industrial Triangle, home to dilapidated warehouses, light-industrial buildings, and railroad yards. The industrial district that had thrived from its accessibility to rail and sea freight lines was suffering from decades of decline. The seeds of revival were sown in the late 1970s, when a few artists bought the cheap warehouse space to use as studios. By the 1980s, developers began converting warehouses into loft apartments, and in the early 1990s the district's new direction began to take shape. The removal of an elevated roadway opened dozens of surrounding blocks to development and transformed the area's image from thoroughfare to destination.

Development took off, and as a result of a collaborative planning process and detailed design guidelines, the Pearl was transformed. Along with a neighborhood-wide housing boom, art galleries, retail stores, restaurants, cafes, and bars gathered at street level throughout the district. The historic urban fabric in the southern half of the site was extended into the empty rail yards to the north, where infill still continues. The North Pearl District Plan outlines Portland's goals for the area, emphasizing a more demographi-

cally mixed community, especially one that accommodates families with children. Achieving this goal requires investment in larger-unit, family-friendly housing; access to public amenities like schools and parks; housing in proximity to cultural resources, such as museums, libraries, and theaters; and buffering from land use areas deemed harmful to children.

The plan also addresses economic and environmental sustainability by balancing the large number of housing units with increased commercial space. While the Pearl offers many service jobs in its cafes, restaurants, and shops, the new office space being added along the Willamette River will boost the number of office workers in the district, offering Pearl residents a wider range of jobs within walking distance. Currently, 41.7 percent of people living in the Pearl District drive a private vehicle to work, while the rest walk, bike, or take advantage of several transit options including bus, light rail, and the recently installed Portland Streetcar. In the greater metropolitan area, which contains the sprawling city of Vancouver, Washington, more than 80 percent of commuters drive a private vehicle to work. The Pearl's low VMT is impressive by North American standards, but the city hopes to reduce it even further by intensifying the number and variety of land uses within this compact area.

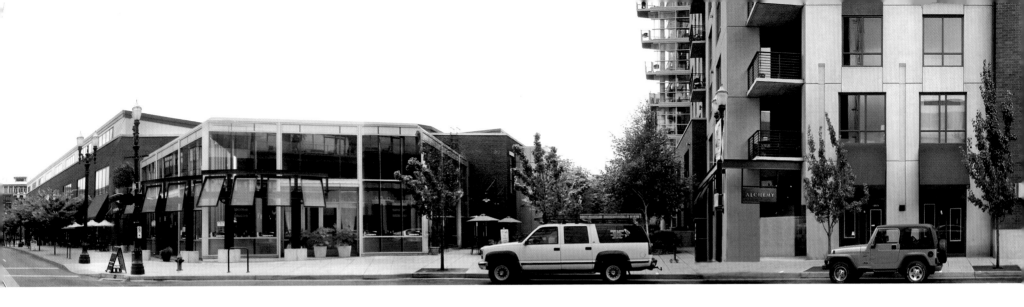

◄ *The Pearl is just north of downtown Portland, where the street grid shifts to align with the curve of the Willamette River.*

▼▼ *High-density, eclectic housing combined with popular business destinations gives the neighborhood its special character.*

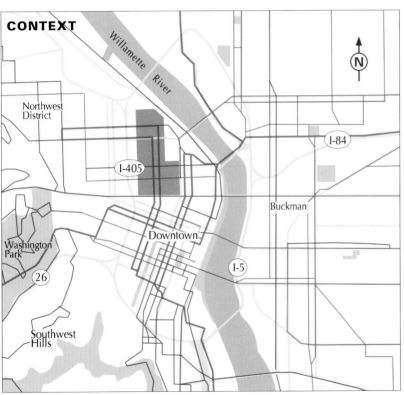

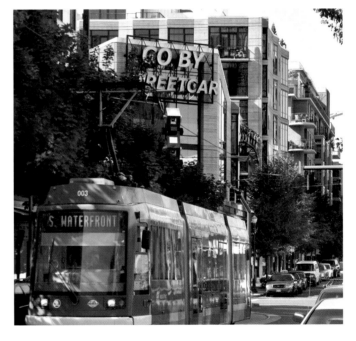

▶▶ Portland's grid was laid out in unusually small blocks (200 feet on a side). In the Pearl District, the block size is consistent but the subdivision pattern varies. Blocks developed in early years in the southern half were divided into four or more parcels, yielding multiple narrow buildings. Recent developments occupy entire city blocks.

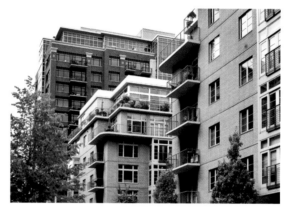

▼ Townhouses on NW 11th Avenue.

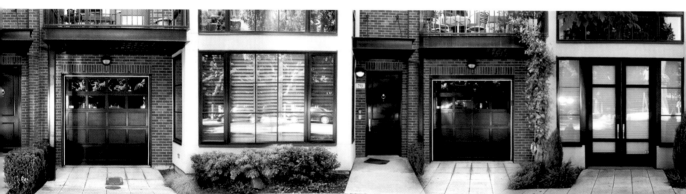

FIGURE / GROUND

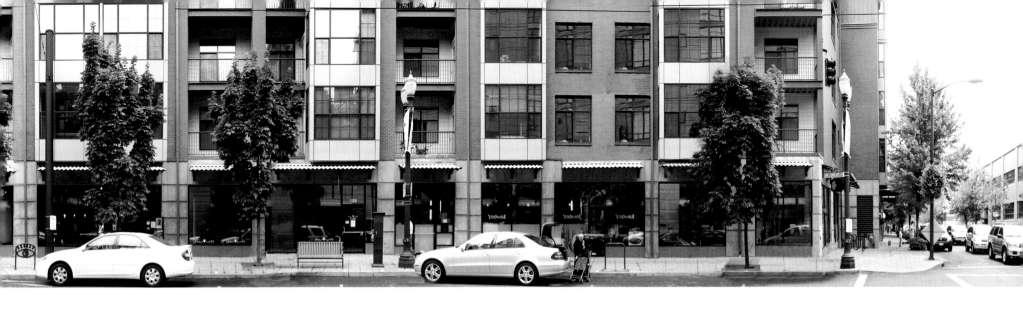

SERVICES

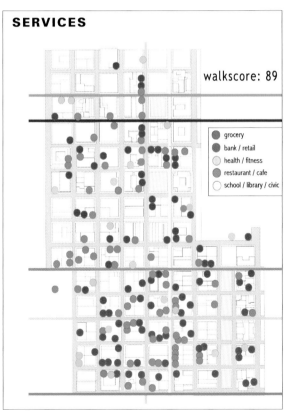

walkscore: 89

●	grocery
●	bank / retail
●	health / fitness
●	restaurant / cafe
○	school / library / civic

◀ Unlike many other urban neighborhoods where commercial uses are confined to certain avenues, businesses in the Pearl are evenly distributed as the result of a city policy that requires active ground-floor spaces on most streets.

▶ Local businesses predominate in the Pearl District, but those chains that are located here have adapted their design to the character and scale of the neighborhood.

▼ Farmers market on NW Irving Street.

The Pearl District, Portland, Oregon

▶ *NW Glisan Street.*

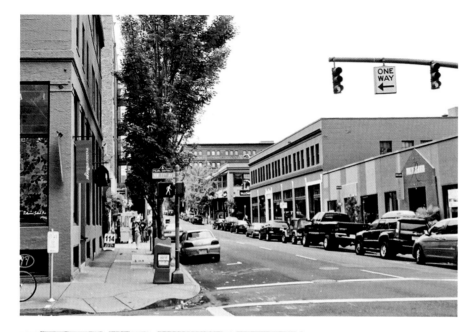

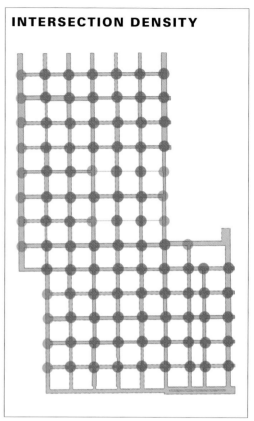

INTERSECTION DENSITY

▲ *Small blocks create a high intersection density and a very walkable structure.*

▶ *Portland recently built a streetcar system that connects neighborhoods around the downtown core. It operates along four Pearl District streets and makes stops every three to four blocks. The city's investment in this popular transportation alternative seems to be paying off, increasing the appeal of dense mixed-use projects, such as this one on NW 10th Avenue.*

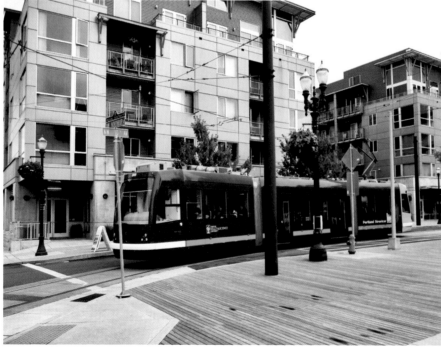

HOUSING DENSITY

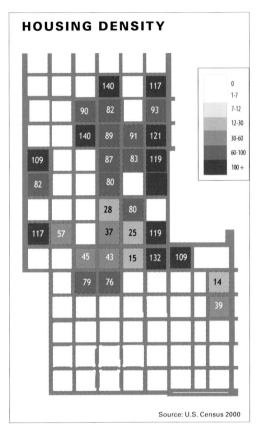

					0
					1-7
					7-12
					12-30
					30-60
					60-100
					100 +

Source: U.S. Census 2000

◄ Residential density has risen sharply, with 5,000 units supplementing the 1,900 that were scattered through the Pearl before redevelopment. The densest area of the neighborhood is now in its northern half, where new mid- and high-rise apartment buildings make up blocks with densities between 80 and 140 units per acre. By 2025, once the planned projects reach completion and the grid's northern reaches are filled, many more people will live here.

POPULATION DENSITY

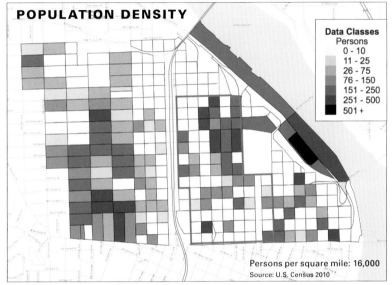

Data Classes
Persons
- 0 - 10
- 11 - 25
- 26 - 75
- 76 - 150
- 151 - 250
- 251 - 500
- 501 +

Persons per square mile: 16,000
Source: U.S. Census 2010

▲ *Tanner Springs Park at NW Northrup Street.*

▼ *NW Glisan Street at NW 13th Avenue.*

The Pearl District, Portland, Oregon

▼ *Streets in the Pearl District, like many in Portland, were designed to accommodate bicyclists.*

▼ *Jamison Square is one of three newly created city parks. The fountain with a wading pool is a favorite gathering spot.*

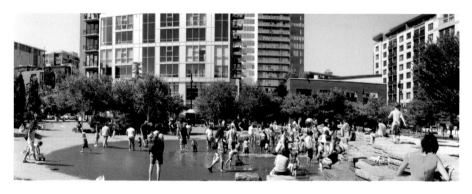

NEIGHBORHOOD PATTERN

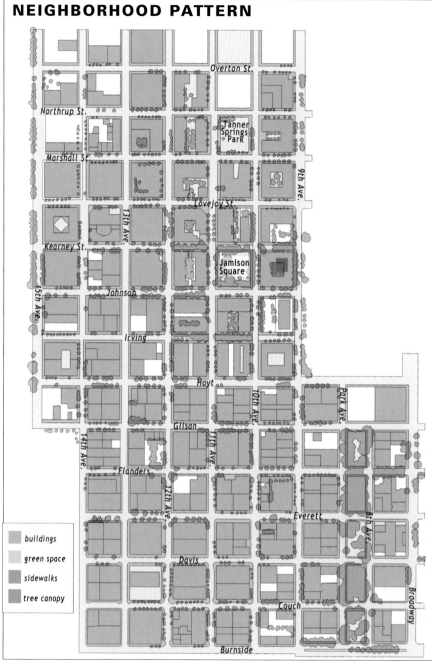

buildings
green space
sidewalks
tree canopy

▼ Jamison Square allée.

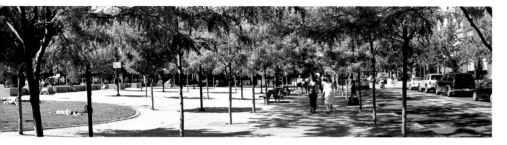

▼ For residents of this converted warehouse, a loading dock makes a fine front porch.

GREEN SPACE / PEDESTRIAN NETWORK

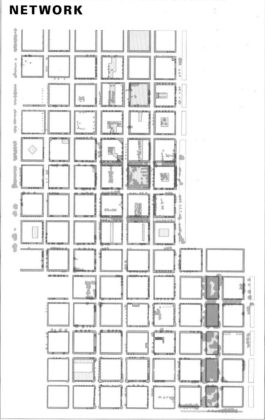

◄ Green space threads through much of the Pearl in various forms. The five-block-long North Park Blocks section (lower right) dates from the 1860s. But the recent wave of development brought three urban blocks into the open space column. Added to this were several pocket parks carved from streets closed to traffic and midblock courtyards.

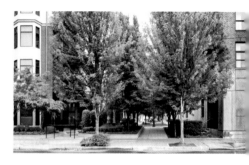

▼ A block between NW Northrup and NW Marshall Streets was also reserved for green space. The naturalistic landscape of Tanner Springs Park evokes the wetland and stream that once drained the area.

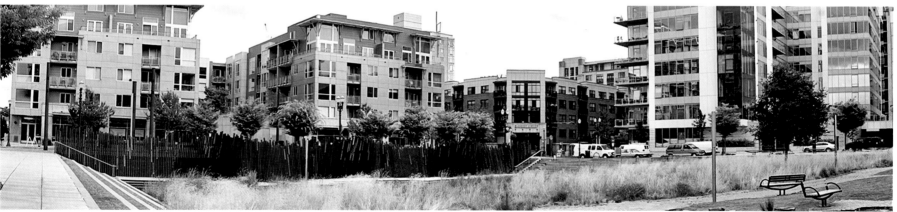

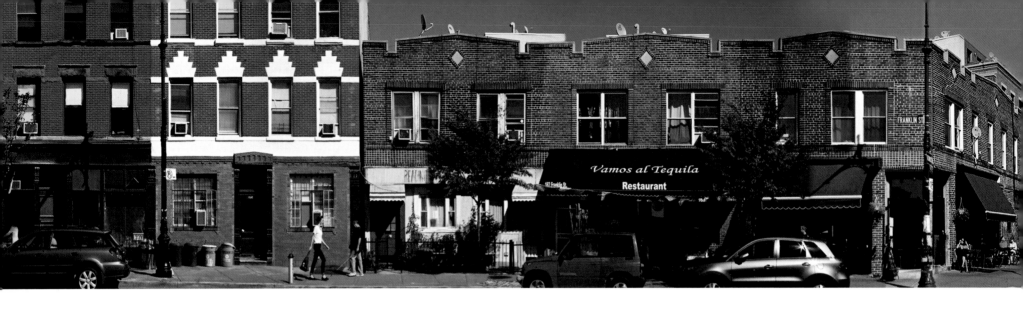

Franklin Avenue is the quietest of Greenpoint's commercial corridors. Unlike Manhattan Avenue, which runs above the subway line and is packed with businesses and shoppers, Franklin Avenue gathers residents looking to its many coffee shops and restaurants for food and a social scene. These four blocks show evidence that more extensive retail activity was found here in years past. Several of the ground-floor façades appear to have been converted to residential uses, with smaller window openings encased in modern building materials. As in Toronto, Ontario's Little Portugal and Eisenhower East in Alexandria, Virginia, the fine-grained urban tissue of Greenpoint—blocks subdivided into narrow lots with multiple owners—has resulted in a diverse streetscape at a human scale.

GREENPOINT
BROOKLYN, NEW YORK

The Greenpoint neighborhood in the northwest corner of Brooklyn faces Manhattan across the East River. Its dense fabric of three- and four-story buildings emerged between 1850 and 1940, fueled by manufacturing and maritime industries along the waterfront. After a century of industrial growth, it had become a destination and home for working-class immigrants. About half its residents were born outside the United States, mostly in Poland, and a minority population of Hispanics had also settled there. Greenpoint's industries began a slow decline after World War II, but by the 1980s the neighborhood had become a target of preservationists, who gained it a spot on the National Register of Historic Places. It also grew more appealing to middle-class New Yorkers looking for more affordable housing.

In 2005 the city approved the rezoning of 175 acres in Greenpoint and neighboring Williamsburg to allow the conversion of a million square feet of existing industrial capacity. Redevelopment will bring a projected 7,300 new housing units to the area along with 250,000 square feet of new retail space. In recent years the pace of construction has increased, with developers taking advantage of relaxed building-height regulations along the waterfront and adding as many as seven stories to some of the existing structures.

Eighty percent of Greenpoint residents rent their homes, most of which are apartments or row houses in two- to four-story buildings. The urban tissue is consistent with much of Brooklyn, with long narrow blocks less than four acres in size. As is the case throughout New York City, the long sides of the block are reserved for residential use, while commercial uses occupy the narrower ends, forming spines that also serve as transit corridors. The tight configuration of lots leaves little room for off-street parking, and most residents do not own cars.

With more than 37,565 ppsm, Greenpoint is denser than most North American neighborhoods. Vertical housing expansion will bring the number even higher. This density, combined with walkable streets and commercial diversity, helps keep Greenpoint's VMT low. Currently, 57 percent of residents take a bus or subway to work, 13 percent walk, and only 16 percent drive alone. With most residents already using transit, there is a concern that further intensification will overburden the system. City planners expect that safer bike access to city streets and a continuous waterfront pathway will shift more travel to biking and walking.

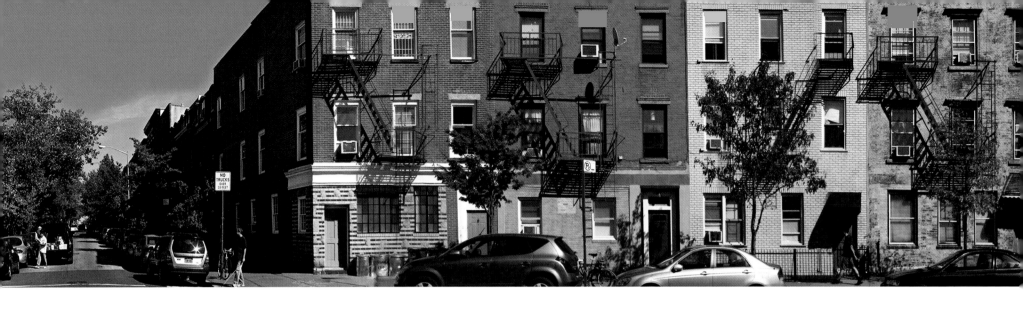

CONTEXT

◄ Unlike other Brooklyn neighborhoods, Greenpoint has only one subway line and indirect access to Manhattan, which may contribute to its slower development pace and unique identity. Still, the G Train and several bus routes offer links with one of the largest rapid transit systems in the world.

▼ Half of Greenpoint residents were born outside the United States, among them its large contingent of Polish immigrants, who offer a range of services along the commercial spine of Manhattan Avenue.

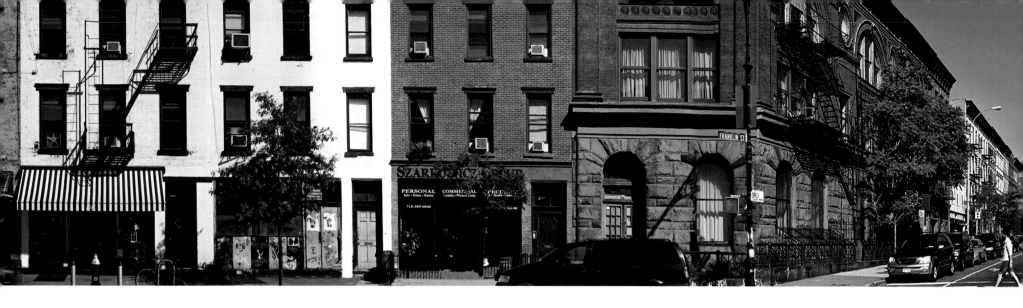

◀▼▼ Greenpoint buildings sit on narrow lots and span the width of their parcels with no side setbacks. Sharing party walls, they form an unbroken edge along the length of each block. Even grand public buildings, such as schools and churches, conform to this pattern. You can see the effect in the figure/ground diagram as the streets become legible even though they are shown in the background color (white).

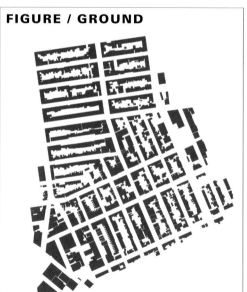

FIGURE / GROUND

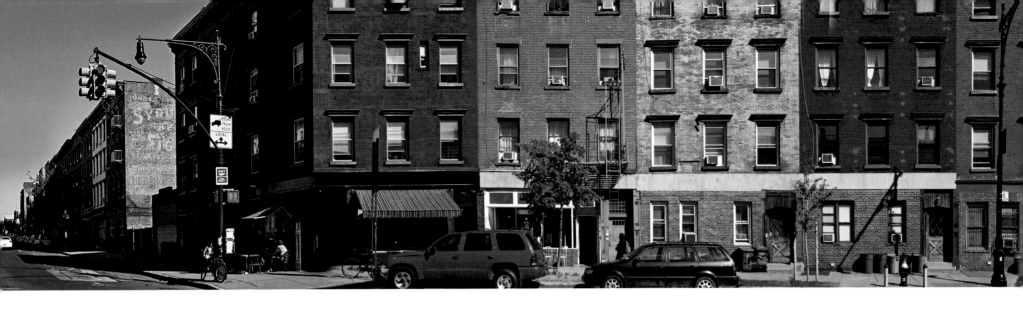

▼ Greenpoint features a pattern consistent with many Brooklyn neighborhoods of its era. Except for the occasional cafe or corner store, commercial services are confined to major thoroughfares. Schools, libraries, and other civic institutions are situated on residential streets. Laundromats are abundant in Greenpoint, most likely due to the high number of renters (80 percent) and the relatively small housing units. The existing urban tissue—narrow parcels with limited street frontage—constrains the size of shops and increases variety along the street.

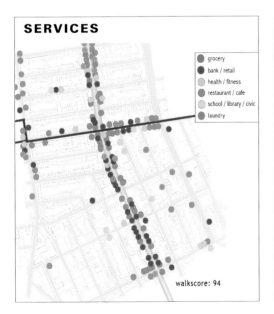

SERVICES

- grocery
- bank / retail
- health / fitness
- restaurant / cafe
- school / library / civic
- laundry

walkscore: 94

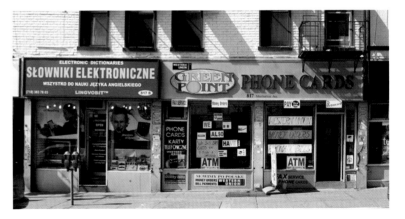

Greenpoint, Brooklyn, New York

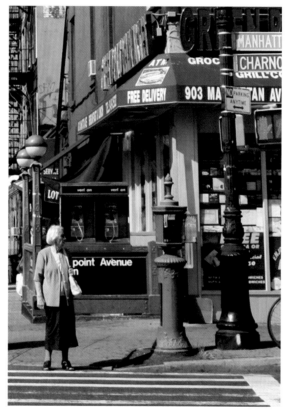

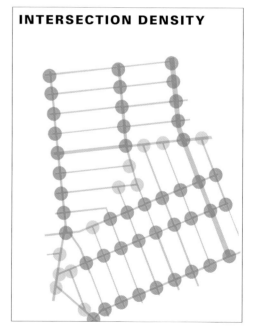

▼ *Blocks here range in area from two and a half to four acres. With 56 intersections in 130 acres, pedestrians and bicyclists are able to choose from many routes as they move about the neighborhood.*

INTERSECTION DENSITY

▼ Greenpoint densities are high. Given the extensive building coverage and continuous fabric of multistory structures, this is hardly surprising. Small unit sizes contribute to higher densities as well.

▼ Greenpoint's geography has affected how its population is distributed. Riverfront parcels, long used for industrial purposes, have few residents, while interior blocks are quite dense.

HOUSING DENSITY

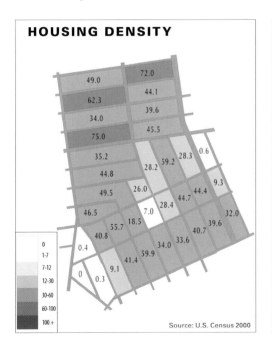

49.0	72.0
62.3	44.1
34.0	39.6
75.0	45.5

35.2 28.3 0.6
59.2 28.3
44.8 28.2
26.0 9.3
49.5 44.7 44.4
28.4
46.5 7.0
55.7 18.5 39.6 32.0
40.8 40.7
0.4 34.0 33.6
41.4 59.9
0 9.1
0.3

Legend:
0
1-7
7-12
12-30
30-60
60-100
100 +

Source: U.S. Census 2000

POPULATION DENSITY

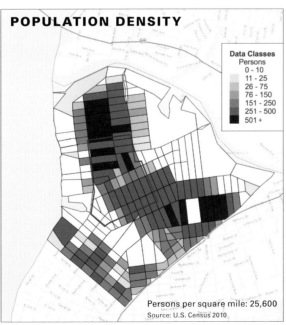

Data Classes
Persons
0 - 10
11 - 25
26 - 75
76 - 150
151 - 250
251 - 500
501 +

Persons per square mile: 25,600
Source: U.S. Census 2010

▲ Public school, Meserole Street.

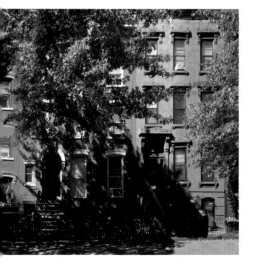

▲ Noble Street.

NEIGHBORHOOD PATTERN

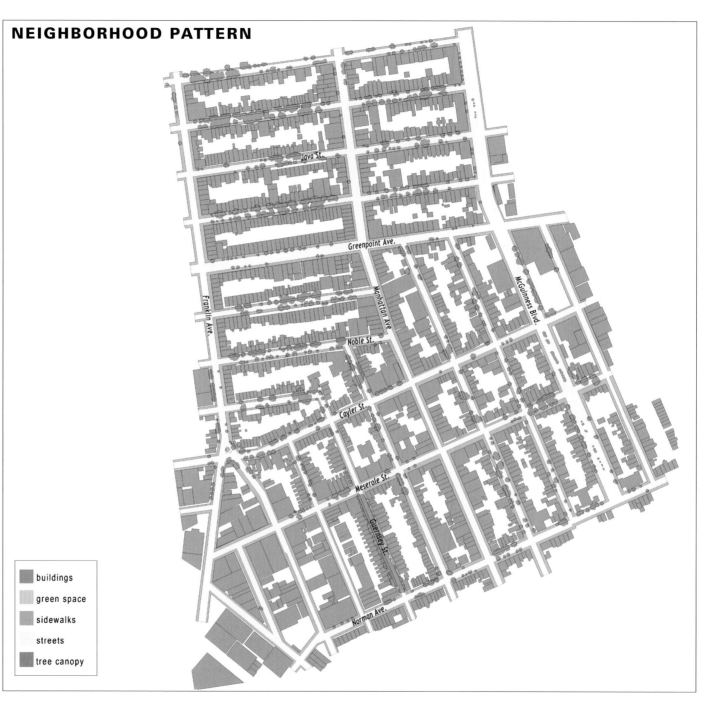

- ■ buildings
- ■ green space
- ■ sidewalks
- ■ streets
- ■ tree canopy

Made for Walking

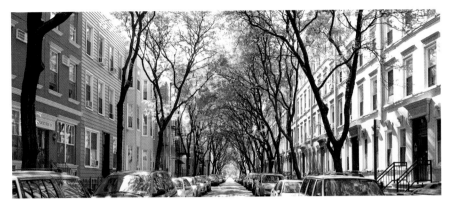

GREEN SPACE / PEDESTRIAN NETWORK

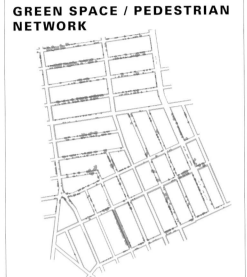

◄ Despite its many assets, Greenpoint has very little green space. A few playgrounds and small parks can be found on its periphery, but residents must travel to nearby Williamsburg to find green space of any significant size. In other areas of Brooklyn and neighboring Long Island City, Queens (photo below diagram), New York City has recently created new parkland from vacant industrial land along the East River, but Greenpoint's waterfront has yet to be reclaimed. The neighborhood's main green feature is the mature tree canopy shading some residential streets.

▼ Noble Street.

Along with shops and galleries, India Street is home to many of Little Italy's restaurants. Trattorias, cafes, and pizza parlors predominate, and many have outdoor seating. One of the neighborhood's piazzas protrudes into a narrowed cross street. The two newest structures on this stretch of India Street are four or five stories tall—a height that forms a stronger backdrop to the street than the lower older buildings. They increase density and make a wider range of uses possible. The single-story buildings here nurture activity along the sidewalk, but lack sufficient stature to enclose the street. Upper floors increase density and encourage diverse uses for the street. Still, despite its humble profile, India Street is the center of a lively social scene, hosting many of the neighborhood's Italian-themed festivals, including an annual carnevale.

LITTLE ITALY
SAN DIEGO, CALIFORNIA

Italian immigrants, many relocating from San Francisco after the 1906 earthquake, settled this grid of streets and small blocks that spreads northward from downtown San Diego. For 70 years they prospered by harvesting and processing the tuna caught in San Diego Bay, and by midcentury 6,000 families lived in the district. Like many other urban neighborhoods, Little Italy's fortunes began to change in the 1960s. Unlike communities in Columbus, Albuquerque, Denver, and other cities whose prosperity was built on rail, however, its economic slide resulted from a declining natural resource rather than shifting transportation modes. Tuna stocks dropped off and unemployment rose. The neighborhood was dealt another blow when the state chose Little Italy to be the northern entry route for Interstate 5 into San Diego. When the highway was finished in 1975, it had nearly destroyed the neighborhood, claiming a third of its streets and homes.

After almost 30 years of decline and commercial stagnation, the community organized. The Little Italy Association, formed in 1996, tasked itself with reviving business, and the Centre City Development Corporation (CCDC), San Diego's redevelopment agency, helped attract creative developers to build new residential and commercial structures. In the 1990s and early 2000s the organizations' goals were realized. Mid- to high-rise apartment buildings filled in vacant lots around existing buildings, adding street-level retail and other commercial uses. As in other cities, the recession in 2008 halted the boom, and many of the most recently constructed projects remain empty while the real estate market recovers.

Nevertheless, Little Italy has become a model for urban planning and infill development. The CCDC is applying the same principles to other downtown neighborhoods adjacent to the Metro's light rail line. Little Italy has eleven residential and six public works developments in construction or preconstruction phases. Among the residential developments proposed, buildings from three to twenty stories tall will represent a significant addition to the district's housing stock. A CCDC transit-planning study projects that with the completion of residential infill the population of Little Italy and neighboring Midtown could rise from 8,623 to 19,440 by 2030.

Assuming the commuting rate stays constant, this significant increase will overburden the district's parking and road systems. Current data indicate that 66 percent of the district's workers use private vehicles to get to work. To address this challenge, the district and the city as a whole plan to improve the transit infrastructure with a political and financial commitment to increasing trolley, bus rapid transit, and rail availability by 2030.

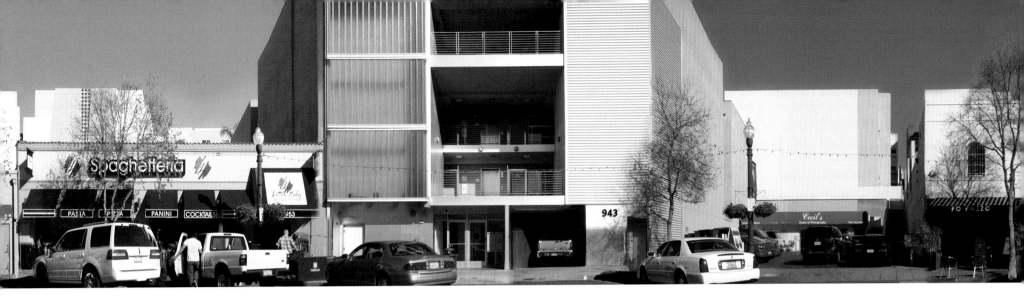

CONTEXT

◄ Little Italy sits on a gently sloping hill between the 1,200-acre Balboa Park and San Diego's waterfront. It connects to the larger region through a network of trains, ferries, and buses. Residents can even take a pedicab to the nearby airport.

▼ Balconies, patios, roof-top decks, and sidewalk cafes allow residents to spill out into San Diego's year-round mild weather.

Little Italy, San Diego, California

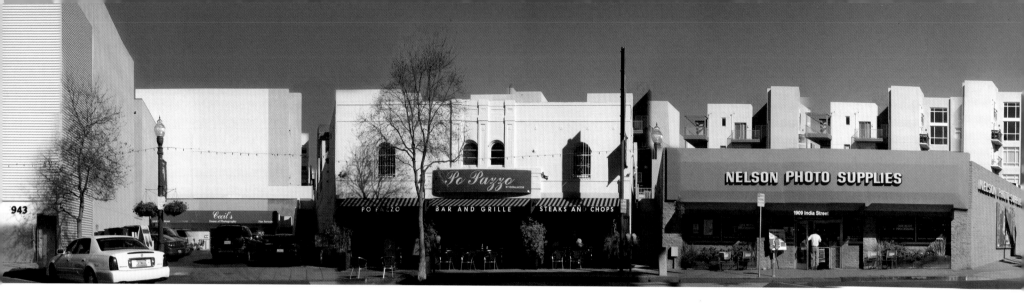

▶▶ *Little Italy's urban fabric came unraveled in the last century, but infill buildings have helped mend it by re-establishing edges along many streets.*

▶ *India Street apartments.*

▼ *Many redevelopment projects encompass entire blocks. The city encourages large residential projects to include direct street access for individual units. This offers multiple building openings and lends more animation to the streetscape.*

FIGURE / GROUND

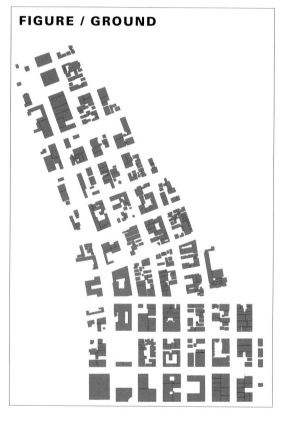

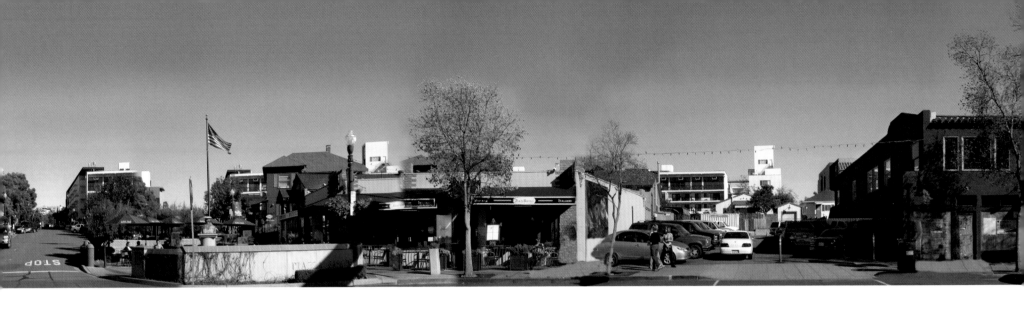

SERVICES

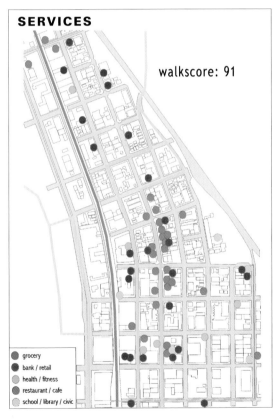

walkscore: 91

- ● grocery
- ● bank / retail
- ● health / fitness
- ● restaurant / cafe
- ● school / library / civic

◀ *Although it tends to be the focus of neighborhood activity, India Street is not the only Little Italy locale that offers services. Retail businesses are located throughout. A bus route (shown in blue) offers residents transit service within the neighborhood while the light rail line (orange) provides access to downtown and the northern suburbs.*

▶ *One of many Italian-style outdoor cafes on India Street.*

▲ *Every Saturday, this block of West Date Street is closed to traffic and lined with vendors from local farms.*

▶ The street grid features a high intersection density and good connections throughout the Little Italy district.

▶ Looking south toward downtown San Diego along Union Street.

▼ The city has set both minimum and maximum densities (measured as a floor area ratio, or FAR) for the downtown area. The FAR for blocks such as these along Beech Street can be as high as eight and must be at least five. That yields a total building floor area from five to eight times the area of the lot on which it is built.

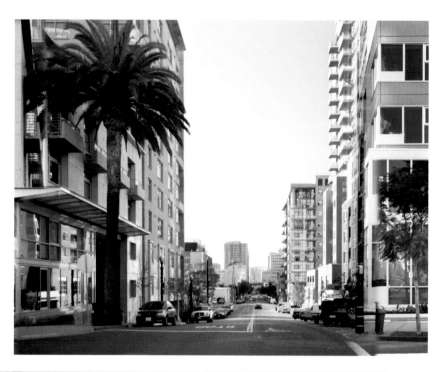

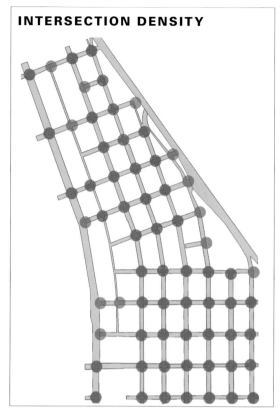

INTERSECTION DENSITY

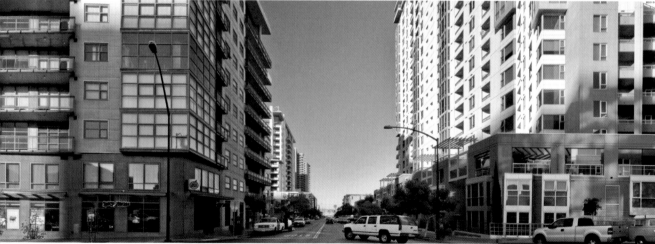

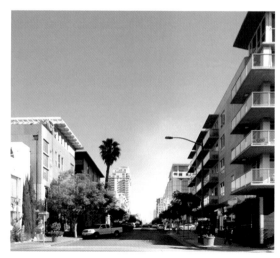

HOUSING DENSITY

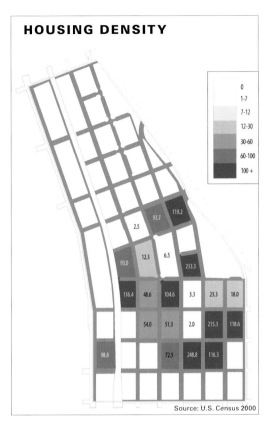

0	
1-7	
7-12	
12-30	
30-60	
60-100	
100 +	

Source: U.S. Census 2000

◄ *The CCDC's efforts to populate the downtown clearly have paid off. The 2000 census showed the results in the southern half of Little Italy, where mid- and high-rise apartments have filled in several blocks. The population increase in the northern half has occurred since 2000, which is apparent in the 2010 population map. With more projects on line, these numbers continue to increase.*

POPULATION DENSITY

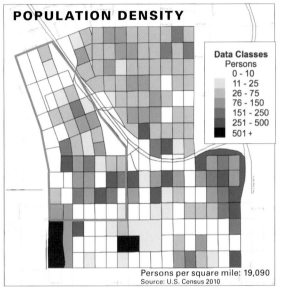

Data Classes
Persons
0 - 10
11 - 25
26 - 75
76 - 150
151 - 250
251 - 500
501 +

Persons per square mile: 19,090
Source: U.S. Census 2010

▲ *West Date Street.*

▼ *State Street.*

► *Garages along a street can have a deadening effect, but when their doors are dark, small, and set back behind a prominent front door, it's possible to maintain a pedestrian-friendly character.*

▼ *India Street market.*

NEIGHBORHOOD PATTERN

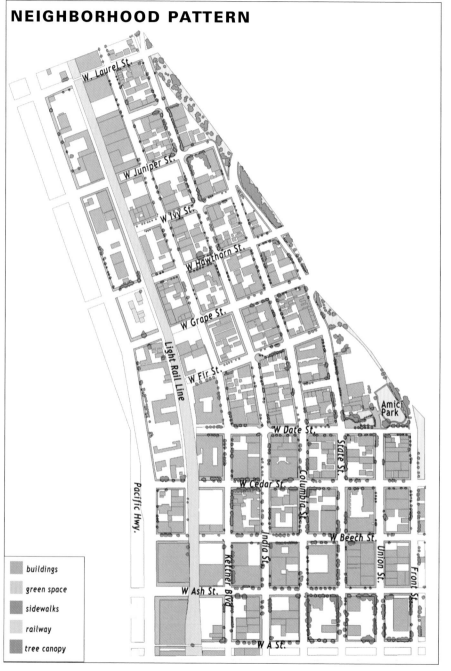

- buildings
- green space
- sidewalks
- railway
- tree canopy

▲ Bocci courts at Amici Park.

▼ The planners and developers of Little Italy understood one of the secrets of pedestrian design—public spaces don't need to be large in size to have a big effect. They created several small piazzas by combining sidewalks with on-street parking spaces. At Piazza Villagio they designed a building with a corner niche to enclose a fountain and sitting area.

GREEN SPACE / PEDESTRIAN NETWORK

◄ Little Italy's location between Balboa Park and the waterfront helps make up for its short supply of green space. Amici Park offers a few outdoor recreation options.

▼ West Cedar Street.

CAMBRIDGEPORT
CAMBRIDGE, MASSACHUSETTS

Brookline Street forms a transitional edge between two different realms of Cambridgeport—the large apartment complexes and institutional buildings around University Park and the smaller, historic houses on the neighborhood's western side. Recently, the redevelopment of these blocks took place on industrial land owned formerly by MIT and leased to a nonprofit affordable-housing developer. The two- and three-story multifamily buildings, which house 137 families, bridge these two worlds. They share the characteristics of nearby historic houses while they also convey a more urban scale and density. The development also links both sides of the neighborhood with a central courtyard that leads to the University Park District. The permeable streetscape includes closely spaced building entrances and several streets and walkways that lead to points beyond.

The 130-acre site makes up the northern portion of the Cambridgeport neighborhood near Central Square. It encompasses a former industrial zone that was redeveloped by the Massachusetts Institute of Technology (MIT) and is now known as the University Park District. Cambridgeport's history extends back to colonial times, when it was a farming district engaged in trade with neighboring Boston. Industrial activity arrived with the railroad in the mid-1800s, and a wave of immigration followed, signaling a demographic shift for the neighborhood. Over the next 100 years, immigrants from all over Europe, the West Indies, and Africa made this area their home.

Cambridgeport's story followed a typical trajectory—early industrial expansion led to economic prosperity and growth that were followed by decline in the postwar era as industries and residents sought opportunities in the suburbs. Prosperity returned in the 1990s with substantial investment in public infrastructure and the rise of new industries, in this case pharmaceutical, video game, and dot-com start-ups. Cambridgeport's long history of diversity generated a cosmopolitan neighborhood rich with ethnic restaurants, churches of all denominations, and an animated night scene focused around Central Square.

The University Park District is Cambridgeport's new economic engine. It emerged from a partnership between MIT, a development company, and the City of Cambridge. Attempts at redevelopment in the late 1960s had resulted in auto-oriented office parks, but by 2001 MIT and the city were determined to restore an urban fabric to the neighborhood by acquiring key parcels and redeveloping them in a dense, mixed-use pattern. This plan included renovation of the existing buildings as well as replacement of parking lots and lawns with four new buildings. To 10 acres of land, they added more than a million square feet of floor space, mostly for university-related uses but also including retail and other amenities geared to neighborhood residents. Other developers stepped in to build new lofts and convert factory buildings into apartments. The revitalization also included the construction of midblock pocket parks, pedestrian walkways, and new green spaces along the busier streets.

With much of its space committed to life science laboratories, offices, and the hotels and restaurants that serve them, the University Park District provides a more staid counterpart to the diverse and lively atmosphere of Central Square. Between these two poles is a bustling neighborhood with high-paying jobs, cultural diversity, entertainment, quiet green spaces, and a variety of housing types.

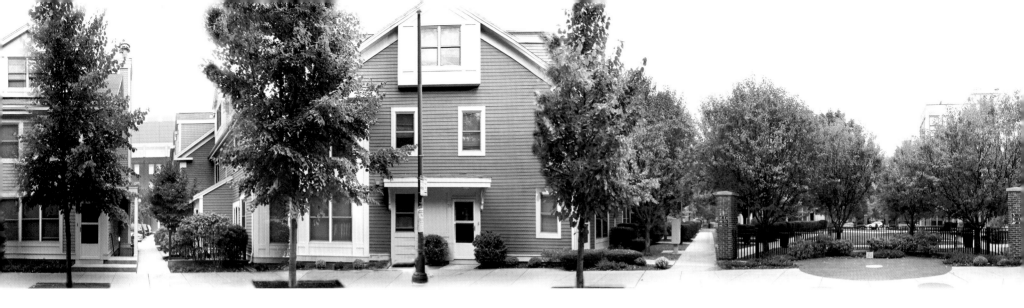

◄ Many of the city's main avenues lead to Central Square, which is also a crossroads for transit routes. By subway, residents have direct access to downtown Boston, where several of the area's larger parks are located.

▼ In Cambridgeport, sleek new high-rise research facilities and hotels have joined nineteenth-century industrial buildings repurposed as apartments and small offices.

Cambridgeport, Cambridge, Massachusetts

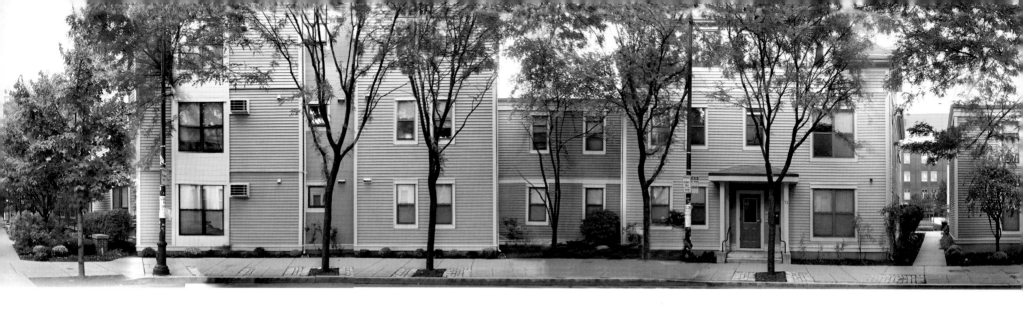

▼ A century ago, triple deckers and duplexes were popular building forms in the industrial neighborhoods of New England. Several remain along Auburn and other Cambridgeport streets.

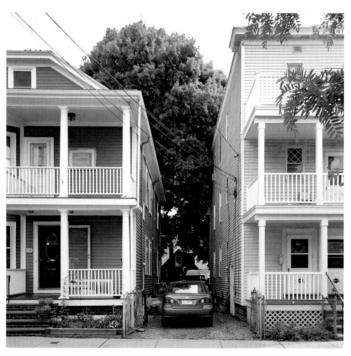

▼ Ownership patterns, and hence building footprints, in the western half of Cambridgeport contrast sharply with those in the east, where blocks are under single ownership, which makes large footprints possible.

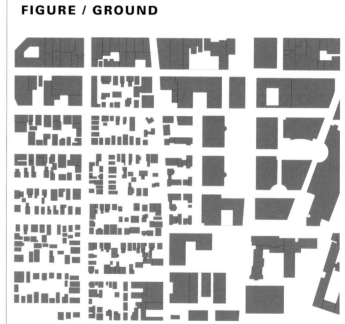

FIGURE / GROUND

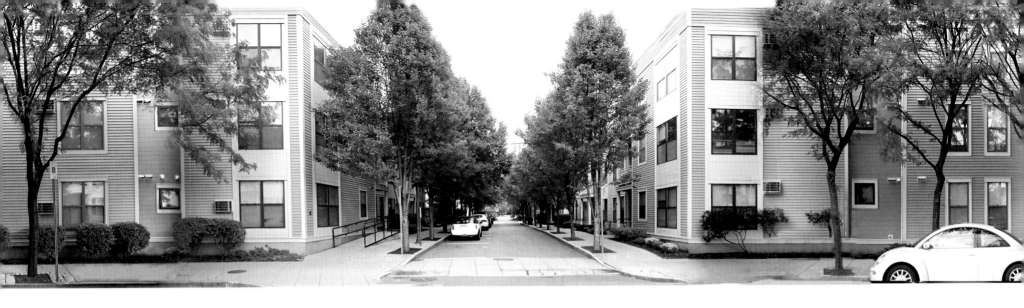

The commercial action is on Massachusetts Avenue (or Mass Ave to Bostonians), where buses pass at frequent intervals. A supermarket and a few other businesses have located in the University Park District to take advantage of the newer buildings' large floor plates.

◀ The Lafayette Square fire house on Massachusetts Avenue is a neighborhood landmark.

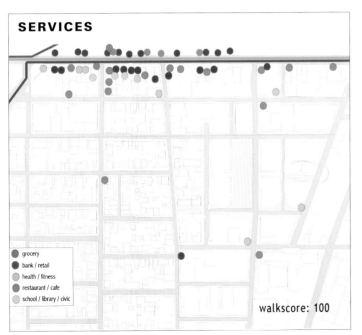

SERVICES

- grocery
- bank / retail
- health / fitness
- restaurant / cafe
- school / library / civic

walkscore: 100

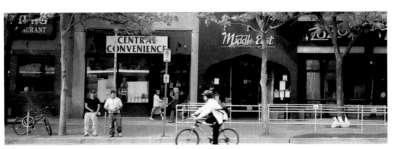

◀ Massachusetts Avenue.

▲ An apartment building on Massachusetts Avenue that offers retail space on its ground floor.

▼ In University Park, the Auburn Street right of way was transformed into a series of pedestrian malls. These tree-lined passages link several recently created green spaces.

INTERSECTION DENSITY

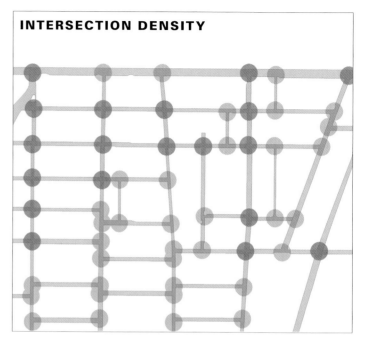

▲ The southern half of Cambridgeport's urban grid shifts slightly and transforms through streets into T-shaped intersections. The result is a high number of three-way intersections that require motorists to make many stops and turns. This tends to discourage cut-through traffic.

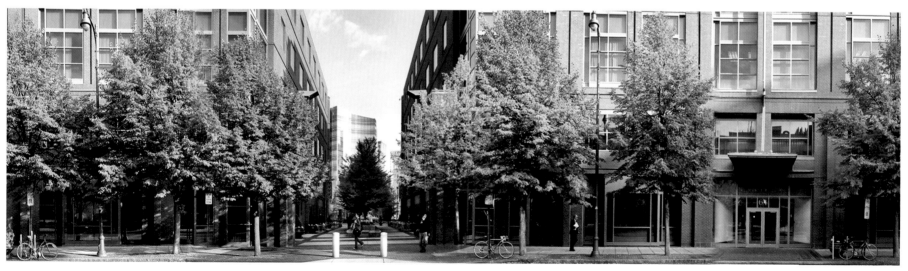

HOUSING DENSITY

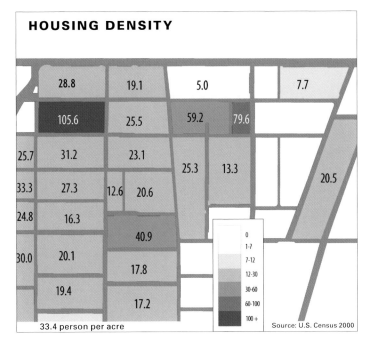

28.8	19.1	5.0	7.7
105.6	25.5	59.2	79.6
25.7	31.2	23.1	
33.3	27.3	12.6 20.6	25.3 13.3
24.8	16.3		20.5
	40.9		
30.0	20.1		
	17.8		
19.4			
	17.2		

0
1-7
7-12
12-30
30-60
60-100
100+

33.4 person per acre

Source: U.S. Census 2000

▲ *The large stock of multifamily housing located in the Central Square vicinity has kept this neighborhood occupied at relatively high density levels. The numbers taper off in the southern blocks, where attached single-family homes are more common than apartment buildings.*

POPULATION DENSITY

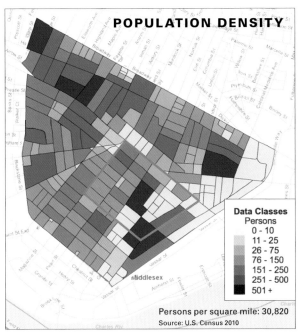

Data Classes
Persons
0 - 10
11 - 25
26 - 75
76 - 150
151 - 250
251 - 500
501 +

Persons per square mile: 30,820

Source: U.S. Census 2010

▲ *As of 2010, the densest blocks are the newest ones located around University Park.*

▼ *Historic attached housing on Watson Street.*

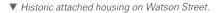

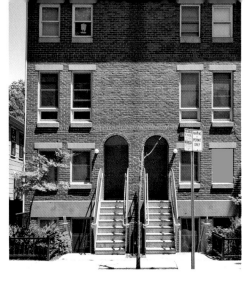

▼ *19 townhouses replaced an auto repair facility on a block along Decatur Street.*

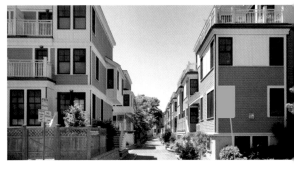

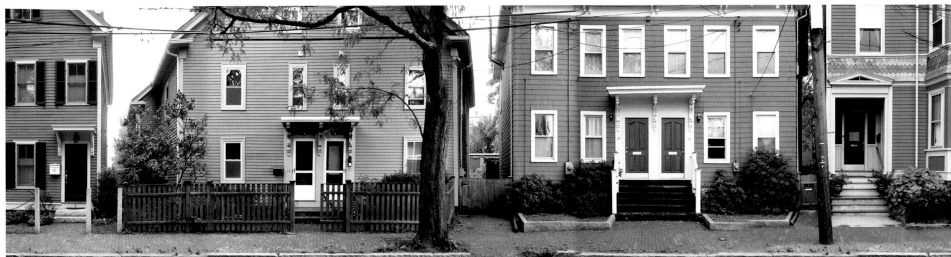

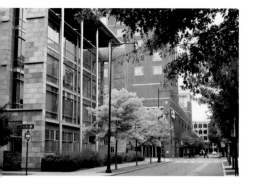

▲ *Loft apartments on Franklin Street.*

▼ *Massachusetts Avenue.*

NEIGHBORHOOD PATTERN

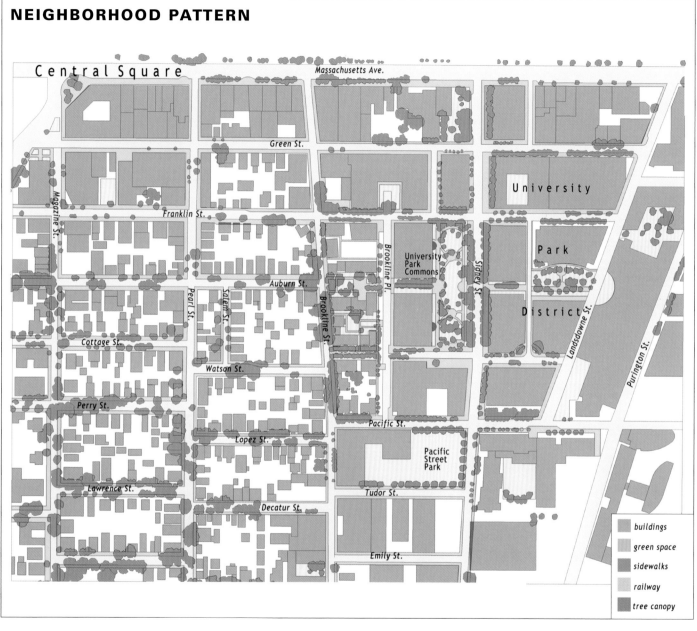

Central Square

Massachusetts Ave.

Green St.

Magazine St.

Franklin St.

University

Park

District

Auburn St.

Pearl St.

Salem St.

Brookline St.

Brookline Pl.

University Park Commons

Sidney St.

Landsdowne St.

Purington St.

Cottage St.

Watson St.

Perry St.

Pacific St.

Lopez St.

Pacific Street Park

Lawrence St.

Tudor St.

Decatur St.

Emily St.

	buildings
	green space
	sidewalks
	railway
	tree canopy

▲ *University Park Commons.*

▼ *Auburn Street pedestrian mall.*

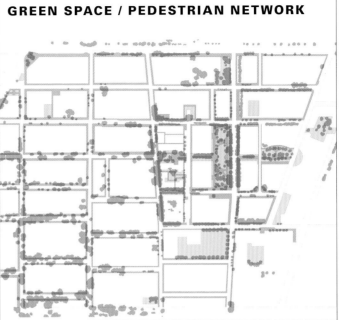

GREEN SPACE / PEDESTRIAN NETWORK

◄ *Cambridgeport enjoys a fairly extensive tree canopy that helps keep building interiors cool in summer. Development of the University Park District increased the number of trees substantially, but the project greened up Cambridgeport in another significant way as well: buildings are arranged around several new landscaped public spaces linked by pedestrian-only corridors.*

▼ *Many of the pedestrian malls run along the Auburn Street corridor, connecting the University Park District to the neighborhood through the courtyard of this new housing complex.*

Cambridgeport, Cambridge, Massachusetts

OLD PASADENA
PASADENA, CALIFORNIA

The birthplace of Pasadena lies within this stretch of Colorado Boulevard. The general store and post office that once stood here provided the anchor for early commercial activity and the center point from which a grid of streets spread outward in the late 1800s. As the boulevard's intersections filled with hotels, stores, and restaurants, it became the city's main artery and shopping street. When widened in the 1930s, many of its original Victorian buildings were updated or reconfigured in the Spanish Colonial Revival and Art Deco styles popular at the time. After its midcentury decline, Colorado Boulevard has regained its role as a shopping destination, this time with a mix of high-end retail chains and local restaurants.

Old Pasadena, also known as Old Town, is Pasadena's original commercial center and is still considered its downtown. The district emerged in the late nineteenth century, fueled in 1885 by a railroad link to the commercial infrastructure of Southern California. Within a generation, Colorado Boulevard was clogged with traffic, and in 1930 the city responded by widening the road. Businesses were relocated 14 feet back from the curb to increase the flow of vehicles. The project transformed the heart of downtown but it failed to prevent the exodus of businesses from the city center in the succeeding decades. As in so many other cities, the tide of mid-century surburbanization drained vital services from Main Street, leaving behind flophouses, dive bars, and pawnshops.

But the downtown area retained its unique quality and evolved into a center for Southern California's liberal and pacifist movements. In 1979 growing interest in Old Town's heritage saved the decaying district from destruction. The city adopted regulations to protect its architectural character. In 1990, One Colorado, a $70-million investment in the retail center, spurred a districtwide revitalization that included restoration of many historic structures.

The Old Pasadena Management District was formed in 2000 to help the city manage the district's business interests. Since then, advocates have worked to make Old Town an attractive and walkable city center. Their efforts have included the revitalization and maintenance of public spaces and acqusion of three parking garages to encourage a park-and-walk system. Revenues from the city's parking meters fund public improvements. The arrival of the Gold Line light rail service from downtown Los Angeles afforded the community an opportunity to plan for transit-oriented development.

Pasadena's current planning goals include building up mixed-use neighborhoods around Gold Line transit stations and major intersections. City planners project that the number of residents living within one-quarter mile of a Gold Line station will increase from 3,588 to 9,467, thus reducing citywide greenhouse gas emissions by 12.1 percent per capita. Currently, 61.3 percent of residents use private vehicles to get to work, while 27 percent walk—nearly 10 times more than the 2.8 percent of the people living in the Los Angeles urbanized area who walk to work.

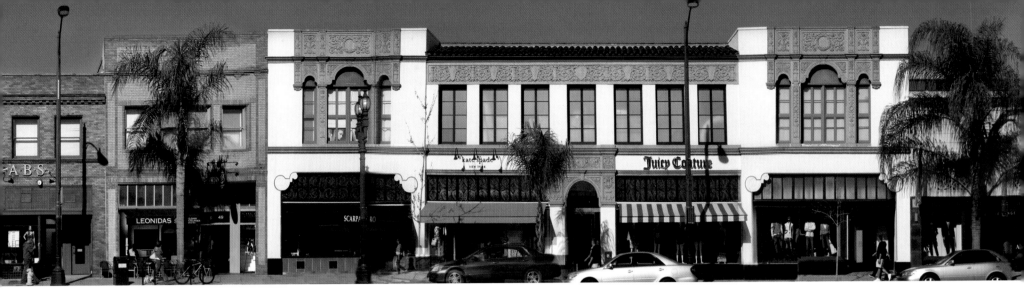

CONTEXT

◄ Parks make up only 15 percent of land in the Los Angeles area, but the metropolitan region is ringed with mountains. Old Pasadena is located at the northeastern edge of the Los Angeles Basin, about five miles from the peaks and canyons of the 1,000-acre Angeles National Forest.

▼ Light rail tracks run through one of the buildings in the Del Mar Station complex. Trains stop and load passengers in the courtyard beyond.

Old Pasadena, Pasadena, California

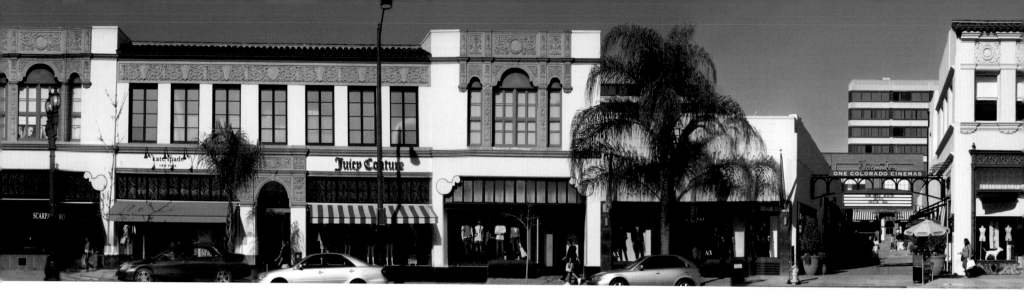

▲ *South Fair Oaks Avenue.*

▶ *Pasadena's tradition of historic preservation is evident in the abundance of its original narrow buildings. In most cases, where larger structures have been added to the urban fabric, they were aligned with the sidewalk to maintain a consistent street edge.*

▼ *South De Lacey Avenue.*

FIGURE / GROUND

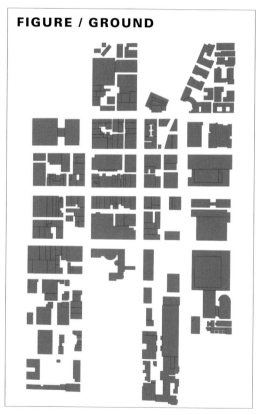

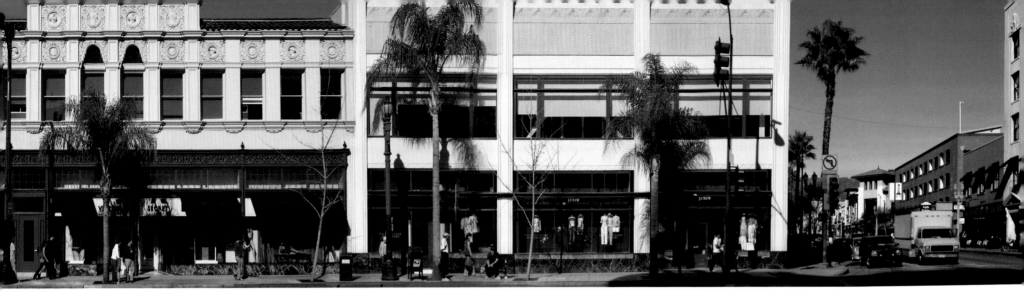

SERVICES

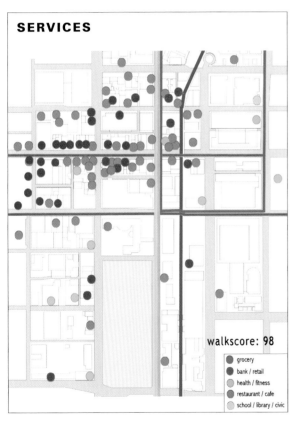

walkscore: 98

- ● grocery
- ● bank / retail
- ● health / fitness
- ● restaurant / cafe
- ● school / library / civic

◀ *Its historic buildings and pleasant walking environment have made Old Pasadena a destination for Los Angelenos. They can travel via the Metro's light rail Gold Line. Shopping, eating, and entertainment are the primary activities offered.*

▼ *Shoppers on Colorado Boulevard.*

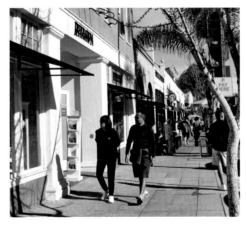

▼ *Gold Line trains glide beneath the Holly Street apartments. Here residents can board trains for downtown Los Angeles.*

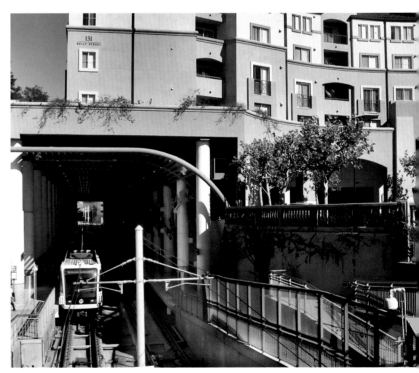

▶ Del Mar Station is both a light rail stop and a new neighborhood with apartments, shops, and restaurants located in the buildings that form this courtyard.

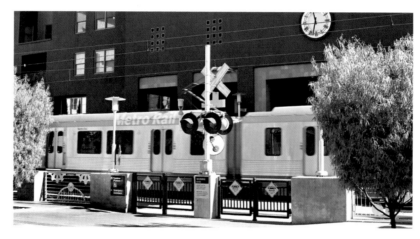

▼ The alleys that bisect many blocks serve the buildings and increase the quantity of connections.

INTERSECTION DENSITY

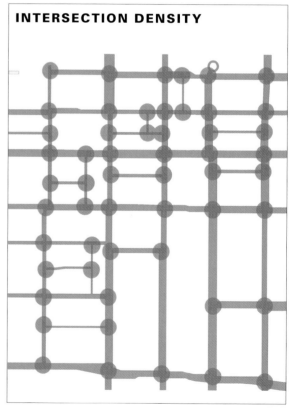

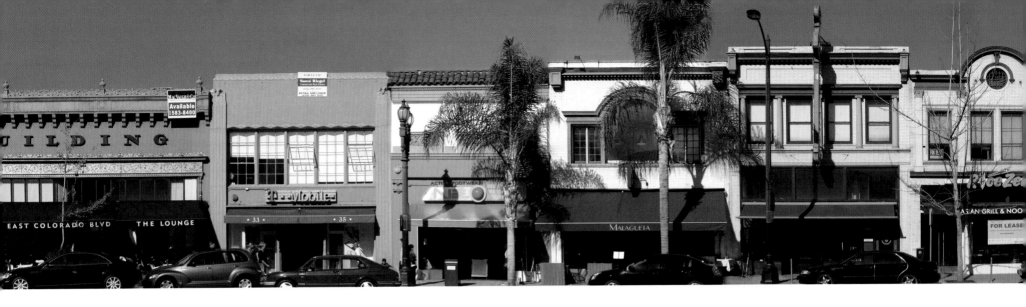

HOUSING DENSITY

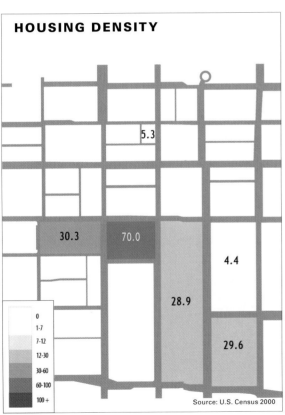

5.3

30.3 | 70.0

4.4

28.9

29.6

| 0 |
| 1-7 |
| 7-12 |
| 12-30 |
| 30-60 |
| 60-100 |
| 100 + |

Source: U.S. Census 2000

POPULATION DENSITY

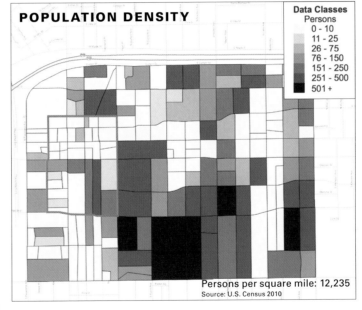

Data Classes
Persons
| 0 - 10 |
| 11 - 25 |
| 26 - 75 |
| 76 - 150 |
| 151 - 250 |
| 251 - 500 |
| 501 + |

Persons per square mile: 12,235
Source: U.S. Census 2010

▲ Although many people come to shop and play, few have lived in Old Pasadena in the last few decades. This is changing, however. Of the four significantly populated blocks, three were built recently and at relatively high density. They are harbingers of change for the neighborhood, which has been targeted for dense mixed-use development along the light rail line.

▲ The backs of West Dayton Street lofts.

▼ Old Pasadena is a mix of old and new tied together in a streetscape where pedestrian comfort is a priority.

Old Pasadena, Pasadena, California

▲ An outdoor cafe in Paseo Colorado, a former alley/loading zone reconfigured as a pedestrian space.

▲ West Dayton Street.

▼ East Green Street.

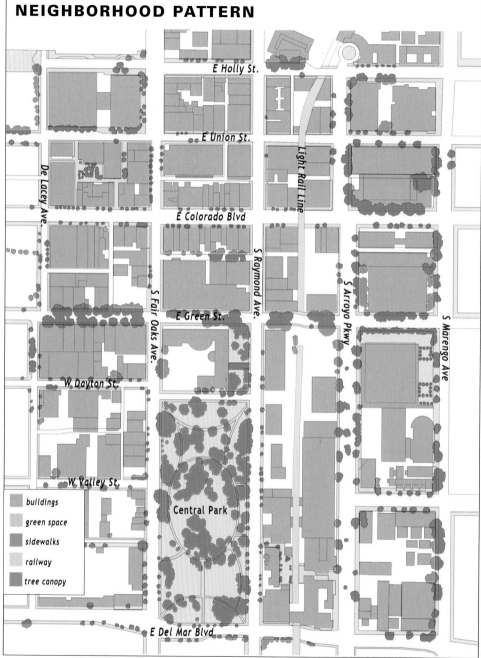

NEIGHBORHOOD PATTERN

E Holly St.

E Union St.

De Lacey Ave.

E Colorado Blvd

Light Rail Line

S Raymond Ave.

S Fair Oaks Ave.

E Green St.

S Arroyo Pkwy

S Marengo Ave

W Dayton St.

W Valley St.

Central Park

E Del Mar Blvd

- buildings
- green space
- sidewalks
- railway
- tree canopy

▲ Paseo Colorado, one of the many alleys that have been transformed into pedestrian streets.

▼ Looking south on South Raymond Avenue toward one of the apartment towers of Del Mar Station.

Old Pasadena, Pasadena, California

▲ The intersection of Fair Oaks Avenue and Colorado Boulevard was the location of Pasadena's first business—a general store and post office—and is still considered the city's center.

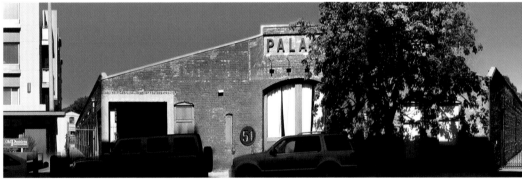

▲ West Dayton Street.

▼ Pedestrians stroll through Mercantile Place, one of the landscaped alleys between shopping streets in the downtown area.

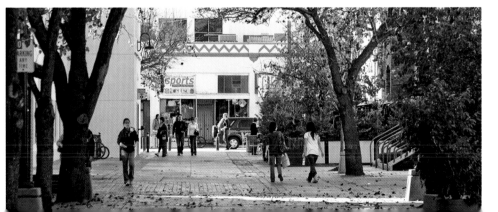

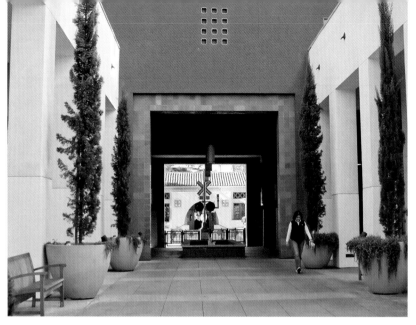

▲ One of a series of public spaces that lead pedestrians through the block toward the rail station and park beyond.

▼ Courtyard, Holly Street apartments.

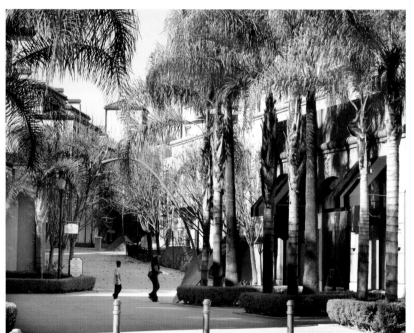

▶ Colorado Boulevard is Old Pasadena's main promenade, and Central Park is its green heart. Tree-lined streets connect the two community destinations. Pedestrian-only alleys thread through several urban blocks following a tradition maintained in the design of Del Mar Station, which provides cut-throughs for pedestrians who wish to reach Central Park from the city's east side.

GREEN SPACE / PEDESTRIAN NETWORK

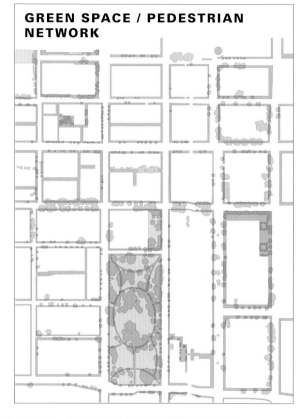

▼ Central Park.

5 Low-Carbon Neighborhoods

Compared to most North American neighborhoods, the dozen sites featured in *Made for Walking* have low carbon footprints. Environmentally benign travel options in places like the Pearl District, Short North, and LoDo allow residents to cut their driving—and the emissions it generates—to levels below those of the average suburbanite. Transit-accessible households use about 93 million fewer British thermal units (BTUs) per year than those located in an auto-dependent subdivision (Jonathan Rose Companies 2011). But the truth is, even these neighborhoods are not as green as they could be.

A third of the carbon dioxide emitted in the United States every year comes from the tailpipes of vehicles, but an even greater amount emerges from stationary sources such as buildings. About 41 percent of carbon emissions from fossil fuels in 2010 came from commercial and residential structures (EPA 2012). Like transportation, the building sector is heavily dependent on fossil fuels. The vast majority of American homes, offices, and factories are heated, cooled, and powered by oil, coal, or natural gas. While the last of these contains less carbon than the other two sources, like gasoline all three release significant quantities of CO_2 as they are burned to create electricity, heat, and hot water.

Coal train, Denver, Colorado.

The building sector need not be so heavily dependent on fossil fuels. In recent decades the industry has made much progress toward developing techniques to conserve energy through better building design. Initiatives such as Leadership in Energy and Environmental Design (LEED) have helped the efforts along by setting environmental performance standards that have been embraced widely by developers and policy makers. We've learned to build structures that take advantage of natural processes and innovative materials to heat, cool, and light them far more efficiently. Now we can make our cities even greener by extending the goal of environmental performance beyond individual buildings to whole neighborhoods.

DENSITY SAVES

We all know by now that thermal insulation, double-glazed windows, and compact fluorescent light bulbs help conserve energy. We've retrofitted homes and offices with these materials to cut heating and electricity costs. While these practices are helpful, we can save more energy by reducing the size of our homes and arranging buildings into tighter spatial configurations.

Unit size has a direct impact on energy consumption. With fewer square feet to heat and cool, smaller homes require less energy to keep their occupants comfortable. In fact, size matters more than technology or building materials. In terms of energy efficiency, a small house with few energy-saving features outperforms a large one with all the bells and whistles of green technology. Reducing a home's size by half from the typical 2,200 square feet to 1,100 reduces its greenhouse gas emissions by about 36 percent (Oregon Department of Environmental Quality 2010). Smaller homes are more common in urban neighborhoods, where apartments, townhouses, and duplexes outnumber detached houses, and the size of single-family homes is constrained by smaller lots.

Multifamily structures use energy much more efficiently than detached and single-story structures because fewer walls are exposed to outside temperatures. Including its roof, a detached house has five external surfaces. A duplex unit has four, and a townhouse has just three. From the perspective of energy efficiency, the more shared walls the better. Even with the best insulation and Energy Star–labeled appliances, a single-family house can't approach the efficiency of an apartment. A single-family house consumes an average of 108.4 million BTUs per year, while an apartment in a building with at least five units uses only 54.4 million BTUs annually (U.S. Energy Information Administration 2005). In a neighborhood with more than 12 housing units—primarily multistory, multifamily buildings—the energy savings per acre can really add up. These energy-efficient buildings coupled with more modest use of gasoline in vehicles help keep city dwellers' per capita carbon footprints relatively low.

Siting buildings close together makes it possible to produce and distribute energy across a shared system. District heating systems operate by distributing heat in the form of steam or hot water from a single location to many buildings through a network of underground pipes. One central boiler replacing many individual furnaces is not only more efficient but less polluting. Older systems—like the one Consolidated Edison operates to supply steam to Manhattan skyscrapers—have relied on fossil fuels to generate heat, but as district heating becomes more common, renewable energy sources like biomass, geothermal, and waste incineration are being used more often. Better yet is the practice of cogeneration—locating a heating district beside an electricity-generating facility to capture the waste heat,

which otherwise would be discharged into the atmosphere or a nearby waterway.

A districtwide system can also be used for cooling. It sends cold water from a deep lake, the sea, or an underground source to a network of buildings. As with heating, the source is centralized, which eliminates the need for chillers in each basement. On its campus in Ithaca, New York, Cornell University uses this method instead of conventional air conditioning, and it has reduced cooling costs by 87 percent. Toronto also installed a district cooling system that draws water from the lower depths of Lake Ontario to cool downtown office buildings. After the cold, clean water chills the air it is used for other purposes. The city estimates the cooling district will reduce CO_2 emissions by 400,000 tons per year (Martineau 2005).

These more efficient systems are not feasible in low-density suburbs. District heating and cooling requires a compact layout and must be located in a densely populated area where the significant cost of construction can be spread among many users. Since the bulk of the cost comes from laying pipe, many households must be able to tie into the system to help pay for installation (NECSC 2006). Proximity keeps the length of the system shorter and more cost effective and efficient. Although the conduits are insulated, there is a limit to how far hot water or steam can travel before it begins to cool. The same principle applies to electric power, which dissipates as it is transmitted. Cogeneration works best when the energy load—the number of customers using the electricity—is located close to the plant. It's possible to site a combined heat and power plant far from its users, but it would use a third more fuel, require more water, and produce more emissions than a cogeneration plant located in a population center (Martin 2002).

GREEN URBANISM

Greenpoint, Cambridgeport, Little Portugal, and other older neighborhoods that have grown up around rail transportation have the attributes that encourage low-carbon travel, but their buildings and infrastructures were not designed to limit their environmental impact. They were built in an era when oil seemed to be both

Cogeneration plant, Cambridge, Massachusetts.

plentiful and benign, and ecological approaches to sewage and stormwater were not yet on the horizon. Later counterparts, such as the transit-oriented development (TOD) at Eisenhower East, are more efficient, but they, too, were not designed to the highest energy performance standards. Even many of the newest "green" developments that tout their energy-conserving buildings and ecological site designs are located in auto-dependent suburbs rather than urban infill locations.

Fortunately, green design and sustainable transportation are no longer considered stand-alone goals. Developers and planners are beginning to combine the two in a new approach called "green urbanism" or "green TODs" (Cervero and Sullivan 2011). They hope to optimize environmental benefits by combining state of the art building design and compact site layout with accessible locations.

Green TODs are more common in European countries, where high energy prices and public concern about climate change have accelerated the pace of experimentation. Long committed to alternative transportation, Europeans now are applying themselves to the challenge of sustainable urban development and exploring ways to integrate renewable energy into urban environments. Projects in Germany (Vauban) and Sweden (Hammarby Sjöstad) highlight the possibilities for combining ecological design with travel-efficient form.

Hammarby is one of the more impressive attempts at sustainable development. Efficiency is built into every aspect of this new neighborhood located on a reclaimed industrial site in Stockholm.

Hammarby incinerates its waste, composts wastewater into biogas, and uses rooftop solar panels to generate its own heat and electricity and then distributes them to every household in the district. The whole complex was designed to collect and purify stormwater and rainwater. Waste is not pumped out or trucked away as in conventional neighborhoods, but is recycled into energy or compost in a closed-loop system in which 95 percent of the waste produced onsite is reclaimed. The development consists of tightly spaced, multistory apartments, and it is served by convenient transit. As a model for alternative development, Hammarby's environmental performance is being monitored closely. At midconstruction it was at least a third lower in energy use, carbon emissions, and pollution than similar, conventional developments in Stockholm, and more than half of residents' trips were made via transit (Cervero and Sullivan 2011).

LEED FOR NEIGHBORHOODS

North America has been slow to embrace green urbanism. LEED-certified buildings are now common, but environmental high-performance standards have not been applied to whole neighborhoods. This situation is beginning to change as the U.S. Green Building Council (USGBC) promotes its newest certification process. LEED for Neighborhood Development (LEED-ND) lays out standards for designing neighborhoods that require fewer resources and result in lower impact on the land and natural systems on which they are built. It focuses on the "where" and "how" of development—where it is located and how its buildings are arranged (USGBC 2011).

The LEED-ND system echoes current thinking on low-carbon travel, but it describes the five Ds by other names. Its Smart Location and Linkage criteria reward destination accessibility by crediting development in or close to existing communities. To gain certification, a project must be located on a redeveloped urban site, brownfield, or underused suburban parcel so that it maximizes the existing infrastructure and services. It assigns points to projects within a specified proximity to transit services and to those that provide facilities onsite.

LEED-ND addresses diversity and design in its Neighborhood Pattern and Design category. It credits developments that create diversity onsite by mixing uses and combining housing types. The criteria list the design elements that make streets comfortable and safe for walking, such as connected streets, continuous sidewalks, functional entries, and street trees. It also defines measures for each element, for example a minimum number of intersections per square mile or uses per quarter mile.

Setting a standard for density, however, poses a problem. LEED-ND criteria are meant to be applied to a broad range of settings, but although universally important, density is highly relative. What's appropriate in Baltimore, Maryland, is not right for Bozeman, Montana. As mentioned earlier, there is no one ideal density, only a minimum based on transit efficiencies. To make the system applicable to smaller communities, LEED-ND sets the density minimum at a threshold of seven units per acre, which is the lowest-possible density at which to achieve certification. In locations within walking distance to transit, that number is higher—twelve units per acre. Developers that build to higher densities gain additional credits, so there is an incentive to add density where it's appropriate. But for urban settings with abundant access to transportation and services, seven or even twelve units is too few to make the most of those benefits.

LEED-ND is just emerging from its pilot stage. As of April 2012 it had awarded certification to 106 projects in various stages of development (USGBC 2012). The hope is that the program will help make green urbanism much more common in the United States and Canada. Its criteria offer a measure of location efficiency that public agencies such as the U.S. Department of Housing and Urban Development (HUD) find useful. HUD plans to apply LEED-ND standards in scoring its grant applications and to give preference to projects sited in less auto-dependent areas (Donovan 2010). If local, regional, and state agencies follow suit and use location efficiency as a prerequisite for public investment, many more people will find themselves working and living in places where they can easily walk, cycle, and take transit.

PLATINUM GREEN

One of LEED-ND's star pilot projects, which has earned Platinum ratings—the highest level awarded—is rising from a brownfield in Victoria, British Columbia. Dockside Green, which sits on a 15-acre (6-hectare) parcel near downtown, will be home to 2,500 people. Responding to a request from the City of Victoria to rejuvenate derelict industrial land, VanCity—Canada's largest credit union—has taken up the challenge of creating a low-carbon neighborhood. Dockside Green is a new urban district that has a dense, connected pattern similar to those of the 12 model neighborhoods in this book. Like those places, its location and physical form reduce driving, but this new development was designed to limit carbon emissions in many other ways as well. The project combines travel-efficient form with sustainable building and site design practices. It is also intended to be ecologically restorative. Dockside Green consumes far fewer resources and generates less waste than most traditional development projects. It gives more than it takes.

Dockside Green does not rely on fossil fuels. It generates energy from renewable sources such as a nearby lumber mill's wood shavings, which are used in the development's biomass plant.

Dockside Green. *This new development sits on discarded industrial land across the harbor from downtown Victoria (top). After extensive site remediation, 23 percent of the project has been completed. Although gaps remain, enough elements are in place to demonstrate its environmental features and for the developer, VanCity, to measure performance.*

Hot water goes out and cooled water comes back in a closed-loop system. Distributed energy is not uncommon in institutional settings, but this is one of the first instances to serve a residential neighborhood and to use an alternative and renewable fuel source.

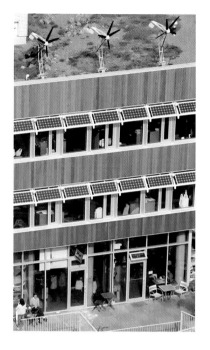

◄ Although the neighborhood imports most of its power from hydroelectric dams in British Columbia, a small amount of electricity is generated by rooftop wind turbines and photovoltaic panels. All of Dockside Green's buildings are stingy in their use of energy, employing thermal mass and orientation to capture energy. During daylight hours, concrete walls and floors absorb solar heat through large windows, then release it into the building after sunset.

▶ Motorized awnings on south- and west-facing façades extend automatically when the sun shines to keep interiors cool in hot weather. Buildings are highly insulated and equipped with efficient lighting and appliances, but here residents are given additional tools to curb their individual energy use. Metering technology allows them to track their usage of heat, hot water, and electricity and make adjustments online. Combining building technology with educational programs has helped cut energy use at Dockside Green to a level 50 percent below Canada's model energy standard.

▶ Most building materials are made from natural resources. They require energy to manufacture, and in the process often result in the release of CO_2. This is true especially of concrete, which puts out one ton of CO_2 for every ton of the material produced. The concrete used at Dockside Green contains a 35 percent mix of fly ash (a byproduct of coal-burning power plants), which reduces the consumption of a carbon-intensive product and puts a waste material to good use.

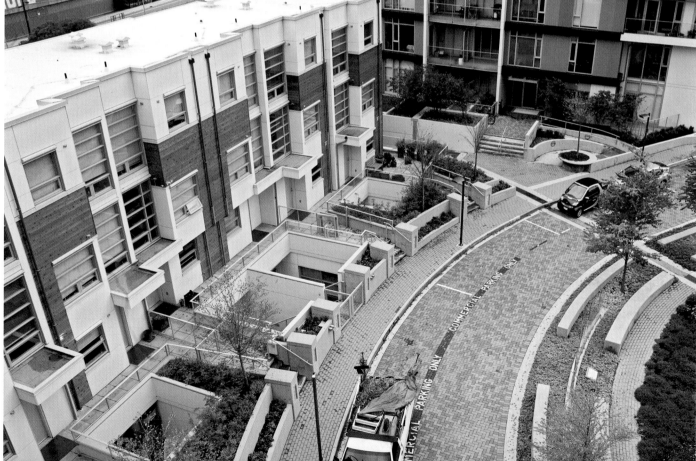

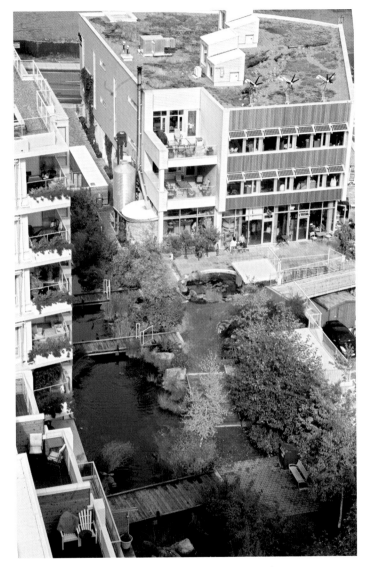

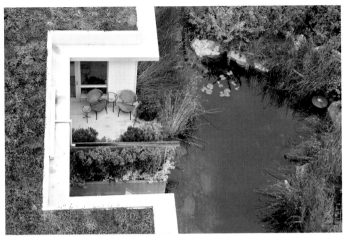

▲ Most horizontal surfaces in the development contain soil and plant materials that absorb water during rainstorms.

▼▶ A naturalized creek along the corridor physically separates public space from private while visually connecting the two. The reflections and movement created by the water enrich the small space, and the creek provides a shelter for wildlife, bringing nature into what essentially is a high-density urban setting.

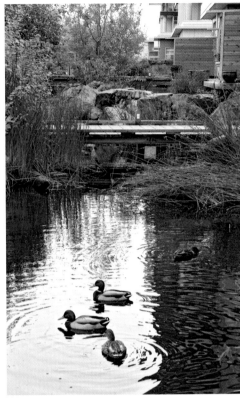

▲ One of the most impressive aspects of the Dockside Green site plan is that relatively small spaces perform a multitude of functions. The central greenway is an organizing element that connects buildings along a walkway. As a public space it lends an identity to the neighborhood and offers places to gather. But it is also a natural system that provides a host of ecological benefits.

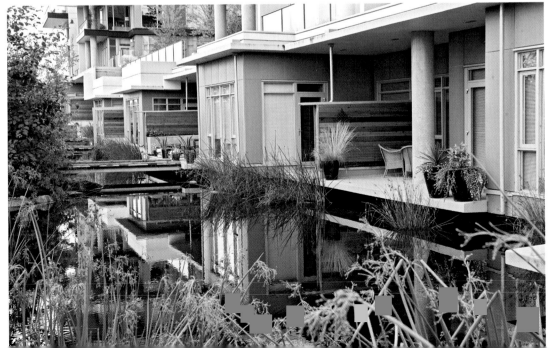

► To reach downtown, residents walk to Victoria's Inner Harbor and cross the Blue Bridge, which takes about 15 minutes. They may instead take a bus downtown or to other destinations. Two routes serve the site, and more than 350 buses pass nearby daily.

▲ The Galloping Goose Regional Trail hugs the shoreline near Dockside Green and extends 34 miles (54 kilometers) through the suburbs and into more rural stretches of Vancouver Island.

▼ Another transit option is the ferry, which makes stops along the harbor and at the new dock on reclaimed land adjacent to the site. Many residents store kayaks in the parking garage and launch them from this spot. One of the goals for this new waterfront park was to provide a key link between the Galloping Goose Regional Trail and downtown Victoria.

▼ Residents grow vegetables on the rooftops of two apartment buildings.

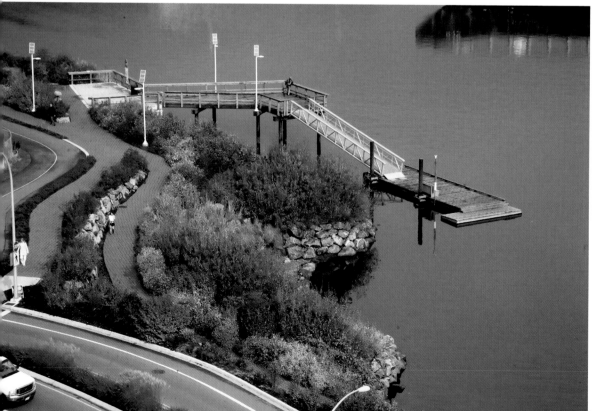

Made for Walking

◀ Despite the project's convenient location, good transit options, and stated goal of low car ownership, one onsite parking space is allotted per dwelling unit. The developers are threading the needle between market demand and sustainability goals by providing a parking space, but they offer a discount to residents who don't use it. In this way, they've "unbundled" the cost of parking from the cost of an apartment. Affordable housing units have added incentives to dispense with the car in the form of subsidies for opting to travel by bike, transit, and the car-share vehicles available onsite.

▶ Urbanites are often forced to park their bikes in a living room or hallway. Here, they store them in basement bike rooms and outdoor stalls.

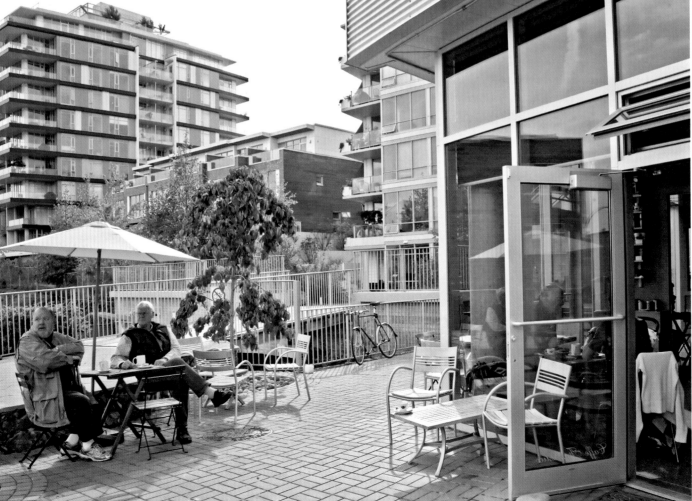

◀ Dockside Green will host a mix of stores, offices, light industry, live-work studios, condominiums, and apartments priced both at market rates and for affordable housing. At full build-out, residential density will be high—166 units per acre (412 per hectare). Environmental features keep its carbon footprint low, but good design makes it an attractive place to live. Most of the neighborhood's buildings are oriented to a series of connected open spaces that vary in character and use.

The smart technology and ecologocially based systems put in place during construction to keep Dockside Green running require far less energy—estimated at about 5,200 fewer tons of CO_2 per year—than a conventional neighborhood of its size. In addition to the efficient buildings and closed-loop resources, operational systems encourage residents to conserve and make it convenient for them to do so. Dockside Green attracts buyers and tenants who want a low-impact lifestyle, but it also introduces the concept to others, who may not have considered it. People who move into the neighborhood simply because it's attractive and conveniently located tend to adopt energy-conserving practices. It's the easier and cheaper option.

The LEED-ND pilot program helped make Dockside Green what it is, but as it turns out, it wasn't relevant to the design process. The master plan was well underway before the pilot project came into being. The developers had set their own criteria based on what they call their "triple bottom line"—putting environmental and social needs on par with economic ones. But a LEED-ND endorsement—particularly a high-scoring one—helped gain credibility with the community during the public review process. It also gave VanCity the opportunity to clarify and document its strategies. The checklist gave the organization a way to measure how close it was to its economic, environmental, and social equity goals.

Like LEED-ND itself, Dockside Green is a grand experiment. Many eyes are on this project to see if it actually will meet its own high standards and, if not, to learn why. VanCity, which produces yearly sustainability performance reports, has determined that it needs to work harder to reach its benchmarks for affordable housing and social equity. But it claims the efficiency systems are performing well. The City of Victoria will continue to audit Dockside Green regularly, applying its own set of indicators to find out how this experiment in sustainabiltiy is affecting the city. It appears to be an approach worth replicating. As the buildings go up and more people move in, and as the biomass district heating plant, sewage treatment facility, and stormwater system ramp up to full capacity, it will become clearer what works and what doesn't.

Low-carbon neighborhoods like Dockside Green feature the best qualities of traditional urban design, but with much lighter environmental impact. Unlike most North American places that depend on the steady flow of cheap oil and gas, they require fewer resources and produce less waste. Low-carbon neighborhoods can be sustained over time, not just for years but for generations. They are designed to do more with less—to use form, layout, technology, and natural processes to produce energy as well as conserve it.

6. The Shape of Things to Come

While many people say they consider sustainability to be a virtue, it's not usually at the top of their "must have" features when searching for a new home. Other forces at play, however, may lead to denser, more walkable neighborhoods over time. A 2011 survey conducted for the National Association of Realtors indicates that Americans have become more willing to consider alternatives to the quarter-acre lot (Belden Russonello & Stewart 2011). The survey was designed to measure the effects of recent upheavals in the economy and housing markets—unemployment, foreclosures, sinking home values, and rising gas prices—on housing preferences.

While the survey confirmed a steadfast commitment to single-family homes— 80 percent of respondents say they still want one—people seem willing to downsize if it means living closer to work and spending less time in the car. Almost 60 percent of the 2,000 respondents said they would choose a smaller house and yard if doing so would reduce their commute to 20 minutes or less. The vast majority (88 percent) said that neighborhood matters more than house size, indicating they would opt for lower square footage in exchange for living in a neighborhood with good schools, sidewalks, and services within walking distance.

Lake Oswego, Oregon.

Seattle, Washington.

THE FLIGHT TO QUALITY

Preference surveys may tell us what we want, but the real estate market tells us what we actually can afford. The persistent recession since 2008 has caused many people to shift their dreams of even a small house to the reality of a rental apartment. Every year, the Urban Land Institute and the consulting firm PriceWaterhouseCoopers interview leaders in the real estate industry to determine current trends and to forecast conditions for the coming year. Their report, *Emerging Trends in Real Estate*®, provides investors with general guidance concerning the state of various sectors of the market. The 2011 installment cited rental apartments as one bright spot in an otherwise grim market (ULI/PWC 2010). In the current economic slowdown marked by widespread foreclosures and stagnant wages, the apartment is the housing type in greatest demand, and rental properties are expected to continue to perform well in the coming years.

In some ways the recession has been acting as a filter and demonstrates what many people really want, which is what they're willing to pay for because they're confident that it will hold value over time. *Emerging Trends in Real Estate 2011* describes this as a "flight to quality," where investors look for real estate in the most select locations (ULI/ PWC 2010). Thirty years ago "the best" in retail may have meant the new mall near the interstate. Now it's an infill site in an urban or urbanizing district linked to public transit. Retailers want to be in mixed-use centers with pedestrian access in order to be closer to their customers. The tide has turned from the far edges of suburbs toward urban downtowns and suburban nodes that resemble them.

The report examines the prospects for this shift in various cities and regions in North America and cites a few places as best bets for investment because of their relatively robust real estate markets. Washington, DC, and New York City rise to the top, followed by San Francisco, California; Boston, Massachusetts; Seattle, Washington; Toronto, Ontario; and Vancouver, British Columbia. These cities have a lot going for them, including international airports accessible to overseas markets, 24-hour activity, and high-paying "brainpower jobs" (ULI/PWC 2010). They are also among the continent's densest cities, with effective public transportation networks and pedestrian-oriented urban form.

The salient trend for 2011 and beyond seems to be living smaller (and more affordably) in more efficient, less car-dependent locations that are close to shopping and work. When the economy does recover, the authors of the forecast don't expect development to resume at the metropolitan fringe, where it left off. Instead it will consist of high- and midrise housing integrated into urban centers and suburban shopping and commercial districts (ULI/PWC 2010).

As economic realities nudge the market toward more compact forms of housing, changes in the population will supply an additional shove in that direction and fuel a growing interest in smaller, more conveniently located homes and apartments in places that offer transport options. This is the prediction of Arthur C. Nelson (2011), who studies how demographics shape the real estate market. The coming decades will bring a much greater demand for rental housing because tighter lending rules are limiting access to financing. Nelson expects the home ownership rate to slip from its 2005 high of 69 percent to 60 percent by 2020.

So much depends on the baby boomers. The great demographic splash they made when they entered the world in the 1950s and 1960s continues to reverberate as they begin to depart. Millions of growing families fueled the migration to the suburbs. Now, as they enter retirement, the boomers are retreating from the housing market. According to Nelson, by 2030 close to half of the U.S. population will be at least 65 years old, and many will be selling their homes—or trying to sell them, as they compete with each other for a dwindling pool of qualified buyers. By then a third of U.S. households will be comprised of just one person, and only 10 percent will include children. Chances are that neither of these groups will be looking for large homes in remote subdivisions.

Nelson points to another trend that will make it difficult to move the oversupply of suburban houses into younger hands. A growing number of people (16 percent of households) are doubling up and sharing their homes with relatives. He predicts that 20 percent of households will be multigenerational by 2020, which further dampens demand for new houses.

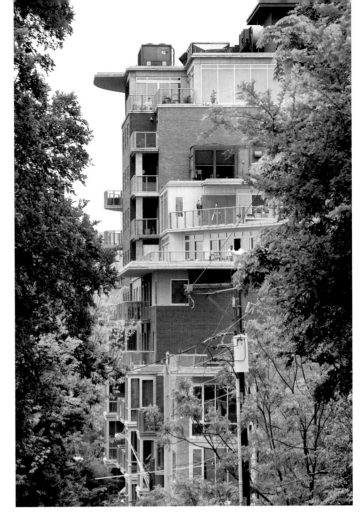

Austin, Texas.

Although three-quarters of baby boomers now live in single-family homes, more than half of them will look for an apartment or attached house when it comes time to move. They are most likely to seek out places that look similar to the neighborhoods in this book—those with smaller homes within walking distance of shopping and transit. And it's not just empty nesters who want a change. Their children are opting for city life as well. The young people who graduated from college in the late 2000s—widely known as Generation Y or the Millennials—are shunning car-dependent suburbs, and three-quarters of them are living (or plan to live) in urban cores (Doherty and Leinberger 2010). Compared to their predecessors, fewer of them own

cars or even have driver's licenses. These lifestyle choices, combined with the reality of high gas prices and frustration with suburban traffic, are causing the changes that increasingly predict greater population density in cities of the future.

SUPPLY AND DEMAND

Unfortunately, there's a big gap between the neighborhoods we want (and will most likely need) and the supply we've inherited from prior generations of homebuilders. Surveys show a distinct preference for lots comprising fewer than 7,000 square feet, yet more than half of existing house parcels are larger than that (Nelson 2011). Many Americans have become willing to trade yard space for other amenities and the ability to walk to the store. We just need neighborhoods with stores in them and stores that fit more gracefully into a neighborhood setting.

San Diego, California.

The challenge is to provide shopping and office space that works for people traveling on foot. The supply of commercial buildings, like the housing stock, is looking more and more obsolete. The paradigm that worked well in low-density settings—single-use, stand-alone buildings surrounded by parking—no longer applies. As of 2011, more than 15 percent of suburban office buildings stand vacant, and no demand for that type of space is on the horizon. Retailers are less interested in space at the mall. In fact, regional malls are rarely being constructed anywhere in the country (ULI/PWC 2010). Beginning about 2008, retail rents have grown about two-and-a-half times faster in central business districts than those in metropolitan statistical areas as a whole (Lynn 2011).

Growing demand for downtown retail space has sparked renewed interest in the insula building type. Incarnations of this old standby are showing up in redeveloped strip malls and infill housing developments as suburban communities target areas for dense, mixed-use growth. With the addition of bus service onto commercial roadways and of light rail systems, the insula type makes sense once again. Just as trolleys reshaped the metropolitan regions of the early twentieth century, transit service now is transforming development patterns by introducing pedestrian access.

Driven by a changing demographic, this trend toward compact, transit-oriented growth is likely to continue. But finding the right sites for new development may not be easy. Given a limited supply of urban parcels, developers will look for opportunities in suburbs where transit investments are already underway (Nelson 2011), but not just any suburban location will do. Infill projects that thrive tend to be in places that have a continuous fabric with an existing population and services. This is why developers would prefer to insert new housing into an established shopping district than try to build a new center from scratch (ULI/PWC 2010). Not only should the resulting pattern be human-scaled and suited to pedestrians, it must also be extensive and unbroken.

Who creates that urban fabric? Unless they are building a whole new town, developers don't shape the framework of streets, blocks, and tissue. That is created and regulated by a municipality.

◀ Atlanta, Georgia's Midtown district is filling in with two- to four-story insula-type buildings located along the bus routes that serve the neighborhood.

◀ The insula building type is employed extensively in the transformation of grayfields into "lifestyle centers." This five-story building with apartments above its ground-floor shops is one of many at Belmar, a complex of apartments, shops, and restaurants in Lakewood, Colorado. Built on the site of a defunct shopping mall, Belmar is served by more than five Denver-area bus routes.

▼ Light rail service through South Pasadena, California, has stimulated a more compact growth pattern, replacing older one-story buildings on this suburb's Main Street with multilevel, multiuse structures. Duplexes and townhouses were added to an adjoining property, increasing the population of an existing neighborhood of single-family homes.

As in Denver, Colorado; Portland, Oregon; and Alexandria, Virginia, developers depend on local governments to put the framework in place—a fine-grained network of streets and sidewalks as well as a suite of zoning regulations and policies that favor density, diversity, and alternative transportation.

ADDING VALUE

As the evidence piles up that the housing option Americans long have aspired to—a big house on a big lot—bears too great a cost for both individuals and society, we can despair over what we've lost, or we can refocus our efforts on the alternatives. We can make the small house or apartment the best it can be. We can furnish the surrounding neighborhood with comforts and, using good design, emphasize the advantages rather than tolerate the shortcomings of living closer together.

The structural elements illustrated throughout *Made for Walking* —streets, blocks, sidewalks, and connected open spaces together with the intricate mixing of uses—make walking and biking convenient and enable mobility with a vastly reduced carbon impact. These qualities, combined with a comfortable streetscape, create the type of pedestrian-oriented environment that lures people out of their cars. A few other physical qualities may not contribute directly to lowering a place's carbon footprint but are also essential ingredients in a successful urban neighborhood. These elements, which can be designed into a place to add value, include the things all of us need in varying degrees—greenery, privacy, variety, and a sense of spaciousness.

Urban neighborhoods require both master planning and attention to detail more than low-density districts do. Public spaces can make up for the lack of private yards, but they need to be located, shaped, and furnished to provide the most benefit. The best neighborhoods have not only a single park or green, but several open spaces of varying sizes and characters in order to suit different needs. They also have a variety of building types and styles to accommodate a more diverse population and to prevent visual monotony. Good design can make small spaces, both indoors and outside, seem larger than their square footage suggests, and it can maximize natural light and ventilation as well as minimize noise. Design can endow smaller, compactly arranged townhouses and apartments with all the comforts of home, which were never exclusive to large-lot, single-family housing anyway.

In Atlantic Station, a large master-planned infill development in Atlanta, a grand central park is at once the focus of the neighborhood and an amenity for the larger city.

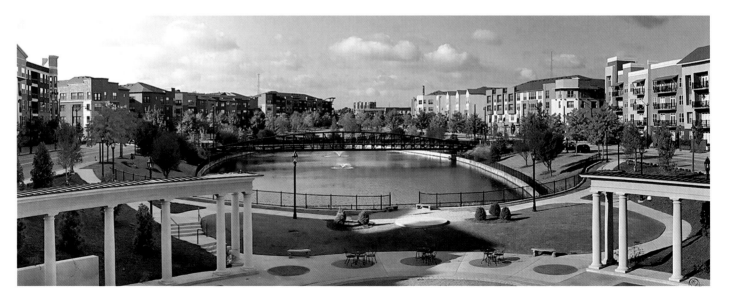

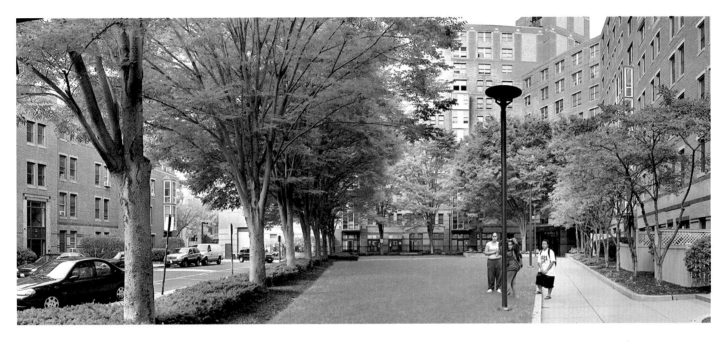

Although it is open to the public, this courtyard in the Tent City development in Boston is located in the interior of the block, has a semiprivate character, and is used primarily by residents.

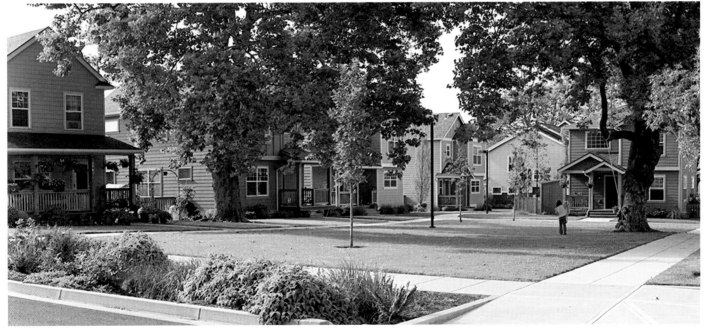

This corner green in the New Columbia area of Portland serves as a public park and an extended front yard for the houses around it.

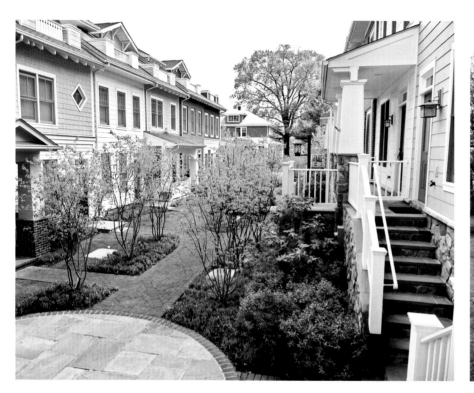

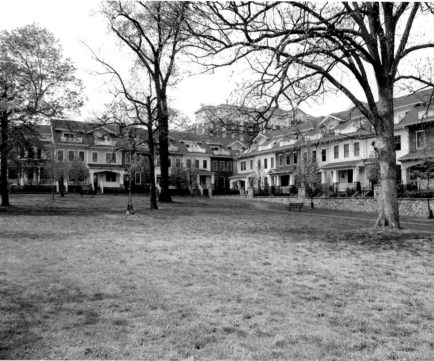

In Arlington, Virginia, townhouses face onto small courtyards (left) shared only by the dozen other houses on this lane, but a common "front yard" (right) leads to a larger green that is used by the whole neighborhood.

Senior housing units face a simple, shared courtyard in Tucson, Arizona.

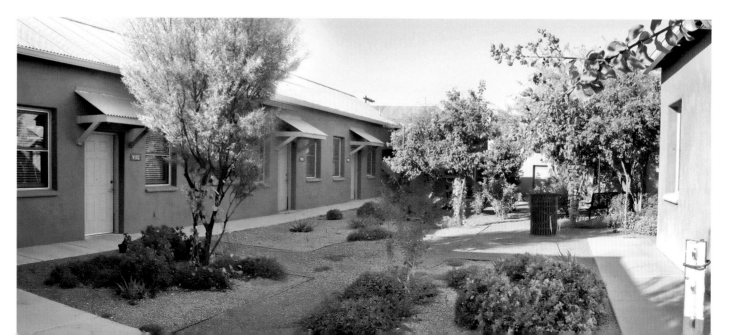

▲ A mere 15 feet—the distance between the front walls of these Boulder, Colorado, townhouses and the edge of the sidewalk—can offer varying degrees of privacy. The sidewalk is clearly public. Although you can step onto them, these yards belong to the houses. And while you can see into each porch, the roofs make those spaces more intimate. Upper-level deck balconies add another layer of semipublic transitional space.

▶ Courtyard housing makes sense in Arizona, where grouping buildings around a central open space creates much-needed shade. The units in this Scottsdale development enjoy a common garden on the ground level and private upper balconies and decks. Flat roofs make it possible to create many levels of private "yards."

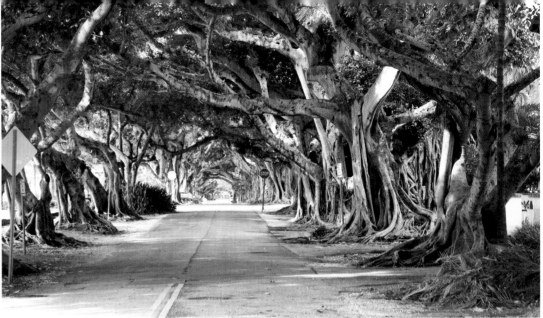

▲ Closely spaced, large species of trees add enormous value over time. Mangrove trees in a neighborhood of Coral Gables, Florida, do so much more than merely shade the street in a hot climate and provide shelter for wildlife. They create a memorable space within an otherwise mundane corridor of a suburban right-of-way.

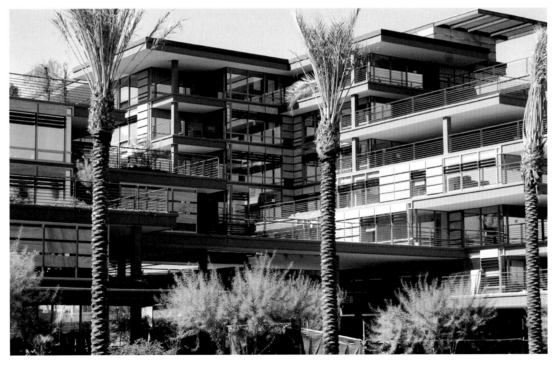

The Shape of Things to Come

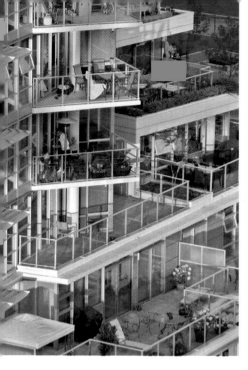

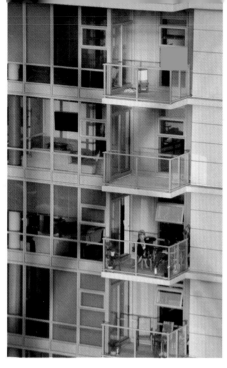

▲▲ *Even at high densities it's possible to offer outdoor space. This Vancouver apartment building is laced with balconies, and its stepped-back design creates rooftop decks (left). Smaller, more affordable units also have balconies from which to enjoy the sunset (right). Large windows maximize natural light.*

▲ *Affordable housing units in Bellingham, Washington, have small yards that are controlled and maintained by residents.*

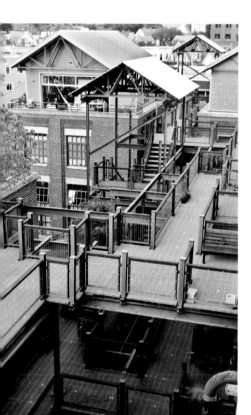

◀▼▼ *This apartment complex In Somerville, Massachusetts, was designed with attention paid to both the indoor and outdoor experience. Two dozen units in four buildings are connected by exterior platforms on each floor that serve as both walkways and public spaces, with a small sitting area fronting each dwelling. Top-floor units take full advantage of roof surfaces for larger gardens and garage-type doors that open to outdoor rooms. Oversized windows flood the apartments with breezes in the warmer months and natural daylight year round.*

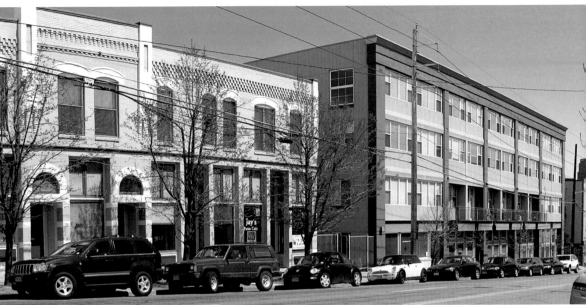

The Highland neighborhood, an early streetcar suburb of Denver, offers a broad range of housing—flats above shops (top right) along with attached and detached single-family homes (above and below). New footbridges to LoDo and downtown Denver have spurred development of multistory apartment and loft buildings (bottom right), increasing the range of units available to people who wish to live in this conveniently located and transit-friendly neighborhood.

The Shape of Things to Come

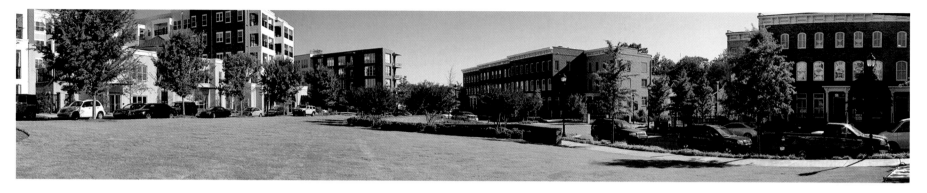

Recently constructed studios, lofts, one- and two-bedroom apartments, and townhouses all overlook a new green in the Inman Park district of Atlanta. Before this project was built, living in the neighborhood was an option only for those who wanted, or could afford, a single-family home. Inman Park Village consists of higher-end housing, but the 321 new multifamily units offer homebuyers a wider range of price points and a measure of diversity.

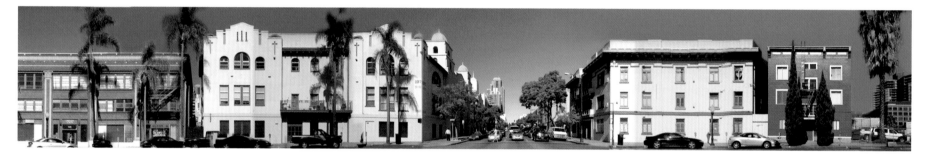

Market-rate units and affordable housing are mixed together along a street in San Diego.

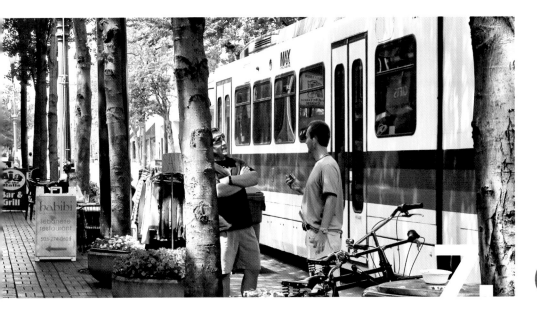

7. Good Bones

Short North, LoDo, Old Pasadena, Greenpoint, and the other featured neighborhoods in *Made for Walking* can tell us a lot about how transportation shapes cities. Most of these districts were mere scatterings of buildings until train, trolley, or subway services arrived in the nineteenth century. Offering links to distant markets or nearby jobs, various types of rail lines transformed hamlets into urban neighborhoods. This faster, cheaper way to move people and goods made it possible to build factories, employ workers, develop housing, and create other businesses to serve the community. But unlike the highways that came later, rail was a density generator. Anyone stepping off a trolley went by carriage or foot to his final destination. Cargo was hauled by cart or along rail spurs to nearby workshops and factories.

In a rail-based transportation system, the best way to give the greatest number of people access is with intensive development in the vicinity of a train station or trolley stop by intermixing new homes with businesses in multistory structures or side by side in small blocks knitted together by closely spaced streets. It made sense to maximize space along the street by keeping rights-of-way, frontages, and shop bays narrow. High land values within narrowly defined areas prompted an urban form that, although intimate in scale, offered easy access to a wide variety of spaces and services.

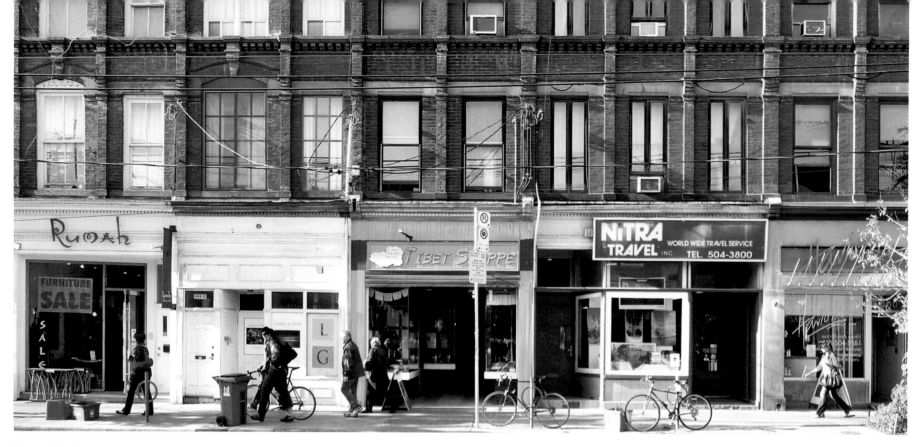

Toronto, Ontario.

With few exceptions, this book's 12 neighborhoods share a similar narrative arc—bustling industry and growth followed by decline and depopulation as the rail-based transportation system was abandoned for one that dispersed economic energy in more diffuse patterns at the edges of cities. For most of these places, the bad years took their toll, eating away at the intricately connected urban fabric. By the end of the twentieth century, however, the story had changed. Frustration with the negative side effects of low-density sprawl led to a realization that these older, urban neighborhoods had a lot to offer. First a trickle and soon a steadier stream of investment flowed back toward cities and into downtown neighborhoods, such as Little Italy, Flamingo Park, and the Pearl District.

Their "good bones"—historic, human-scale buildings and ready-made networks of small blocks and connected streets that shorten distances and make walking easy—are drawing people back into these neighborhoods. As developers invest in empty lots, the existing, long-established tissue dictates the shape and alignment of new buildings. It is a matter of filling in the blanks.

Given our car-based culture, it is difficult to create a truly walkable, human-scaled environment from scratch. In urban areas, though, predetermined ownership patterns and very real constraints require a certain discipline in allocating space. Land has already been claimed for other uses and, as a result, less of it goes to cars. In places like Flamingo Park and Kitsilano, it is difficult to widen a street or add a parking lot without taking away something useful or valuable. But greenfield sites, with their large, empty parcels, pose fewer restrictions. As space is allocated, the perceived demand for parking often trumps density and proximity.

Many urban places owe their revival to location. Proximity to density, the attribute that served them so well in their early years, still

Made for Walking

Santa Monica, California.

favors them. Those areas sited outside the central business district are either next to or not more than a few transit stops away. Each of the 12 neighborhoods is part of a larger entity that also serves as a regional center, and that association opens up all kinds of possibilities for the people living and working there. If no suitable job is available in the neighborhood, one may be located downtown or in a nearby district. If walking or biking can't get someone to regional destinations like medical centers, sports arenas, universities, and parkland, then transit will. Remember the five Ds: good destination accessibility and a short distance to transit make car-free living possible and open up the opportunity for greater density.

Blessed with proximity, these neighborhoods share their wealth by welcoming new residents into recently added houses and apartments. Greenpoint and Little Portugal, both of which held onto their populations through the challenging years of the 1960s and 1970s, have few vacant parcels and limited infill opportunities. But other neighborhoods are growing denser. Cambridgeport and Kitsilano, though relatively built-out, have boosted their numbers with the addition of a few key high-density apartment buildings. Portland, Oregon; Denver, Colorado; and Alexandria, Virginia, targeted the Pearl District, Central

Platte Valley, and Eisenhower East, respectively, for high-density uses close to existing train stations, then encouraged developers to fill the empty blocks of vacant industrial land with mid- to high-rise apartment buildings. Short North in Columbus, Ohio; Little Italy in San Diego, California; and downtown Albuquerque, New Mexico are attracting residents, hoping to lift their numbers back up to levels that will sustain a diverse and lively urban environment.

If transportation is a primary shaper of cities, what happens if the prevailing auto-centric model is turned on its head? While researchers conduct studies on the effects of urban form on travel behavior, city transportation planners are running their own experiments on real streets. They're approaching the form-travel question from the opposite angle—testing the result of a shift back toward a pedestrian- and transit-focused system.

The biggest innovator, New York City, has learned that by favoring alternate modes in the design and regulation of its streets it is changing the way people move around the city. Within the past few years, its Department of Transportation has carved space from vehicular travel lanes and parking spaces to widen sidewalks and create bike lanes. This work has closed a few streets to motorized

Atlanta, Georgia.

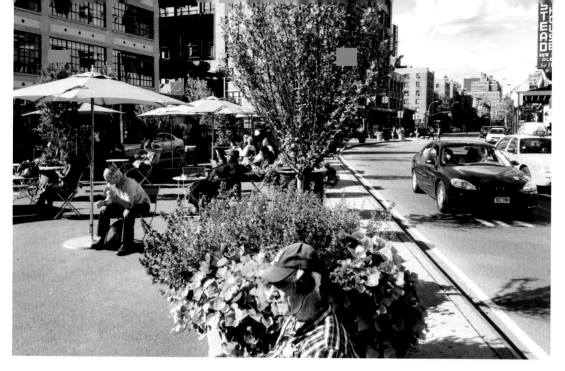

New York City.

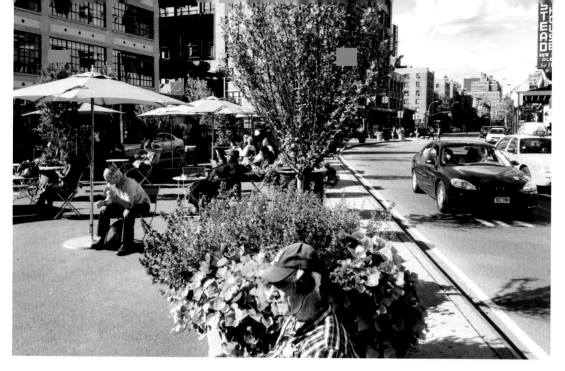

pedestrians
bicycles
public transit
trucks/service
taxi/car share
high occupancy vehicles
cars

Figure 7.1 **The Green Transportation Hierarchy.**

vehicles, given priority to buses, and installed rapid transit service along some clogged corridors. With 250 miles of new bike lanes, cycling has jumped by 265 percent since 2000. Traffic volumes have leveled off as transit use rose (New York City DOT 2010). While the city's primary goal was to increase mobility and safety for all travelers, it is enjoying a substantial side benefit—the creation of badly needed public space on newly calmed streets and intersections (New York City DOT 2008).

By making foot, bicycle, and transit travel easy and driving alone more expensive and inconvenient, New York City has upended the twentieth-century transportation paradigm. While it has yet to embrace it officially, the city is moving toward a "green" or "sustainable" transportation hierarchy in which priority is ranked according to the resource-efficiency and public benefits of each mode (figure 7.1). According to this model, infrastructure funding, design standards, and pricing strategies address the needs of pedestrians first, because walking has the lowest cost and is the most space-efficient and environmentally friendly form of travel. Bicycles and other non-motorized vehicles come second, public transit third, and service vehicles, taxis, and other shared vehicles further down the list. Due to

its negative impacts, the single-occupancy vehicle comes last in line for public investment (Littman 2011). Already a dense place with a transit network the rest of the continent can only dream of, New York City is now redressing the imbalance along streets disproportionately dominated by motorists. In the process, it is building public streetscapes worthy of its density.

In more dispersed cities, however, adopting a green transportation hierarchy can help make higher density levels possible. Portland, Oregon, has long used transit to lay the groundwork for livable density. In the 1970s, when other cities were staking their futures on highways, Portland launched a light rail system and in the decades that followed steadily expanded its bus and streetcar systems. Transit riding has become the norm for Portland residents, thus making it possible for the city to grow denser. With a critical mass of population not dependent on cars, the need for parking lots, garages, and travel lanes has dwindled.

In the Pearl District and River Place, scarce urban land has been given over to homes, shops, cafes, parks, and other amenities that make city life convenient and pleasurable. Portland still has a long way to go to reach the density that many North American cities enjoyed a century ago, but embracing the green transportation hierarchy, as it did in 2010, will certainly help. Its *Bicycle Plan for 2030* ranks priorities for different modes of travel, favoring the needs of pedestrians, bike riders, and transit users over private vehicle drivers as it sets policy and makes future infrastructure investments (City of Portland Oregon 2010). This is, after all, the approach to transportation that made the 12 neighborhoods—and most great urban places—what they are. To the men and women who built them, low-impact, resource-efficient travel was a necessity, not a choice, but it shaped the kind of neighborhoods that, in the twenty-first century, can serve us well and make us proud to pass them on to the next generation.

What does it take to create more places where families like the Hursts and the Russes can step away from their vehicles and still get to the places they need to go every day? How can we make more Jamaica Plains, where a family of seven can move through their

weekly routines while their car remains in the driveway? This book has described and illustrated the scale, mix, density, and physical attributes that make up walkable neighborhoods. As we redevelop cities and suburbs, the Ds provide a perfect checklist. We can lighten our environmental footprint and enjoy the many benefits of reducing our dependence on cars. The Ds can help us decide where to increase density—which locations are well on their way to achieving walkability and which will require more intervention.

Existing urban neighborhoods endowed with proximity, connectivity, and historic fabric—like those in Albuquerque, Columbus, and Pasadena, California, for example—already possess many of these elements and require fewer resources to fill out the rest. These elements can be found in every North American metropolis: older neighborhoods and inner-ring suburbs with good bones that languished during the sprawling decades, but are now ripe for revival. Derelict industrial land and urban rail yards may not be dense or pedestrian-scaled yet, but these brownfields are often the best places to grow. They offer access to transit and destination accessibility—the two Ds hardest to come by.

Planners in Denver and Alexandria saw the potential of vacant land adjacent to downtown rail lines, and they incorporated the other three Ds—density, diversity, and pedestrian-oriented design. As they continue to fill in, Central Platte Valley and Eisenhower East will possess all the attributes that make car-free mobility possible. Given North America's limited public transportation network, it makes sense to maximize the limited supply of land adjacent to train, subway, and light rail stations.

The five Ds make neighborhoods walkable, but a host of other attributes make them livable. Some, like open space, depend on larger systems that extend well beyond the confines of a neighborhood and require big thinking, long-term planning, and broad cooperation. Neighborhood parks are essential, but greater density demands more than that. It requires many varied, high-quality green spaces—large and small, formal and wild, for active recreation and solitude—that form a network across the metropolis and to wilderness areas beyond.

Comprehensive planning and design are needed to build an open space system that fills the needs of a diverse and growing population. But livability also depends on large systems beyond the realm of physical design. Public safety, education, affordability, and municipal services are among people's chief concerns when they are deciding where to buy or rent a home. They want an affordable place in a safe neighborhood where the schools are good, the streets are swept, and the trash is picked up. If an urban neighborhood can't satisfy these needs, people will move to a low-density suburb to find them, even if it means spending more time and money owning and driving a car.

Long Island City, New York.

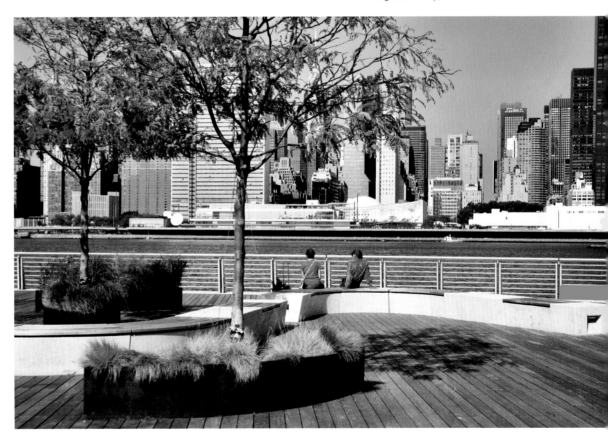

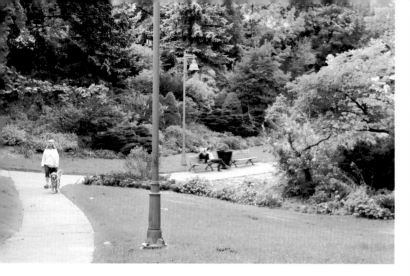

Toronto, Ontario.

Birmingham, Alabama.

Boston, Massachusetts.

Denver.

Vancouver, British Columbia.

Boston.

Vancouver.

Miami Beach, Florida.

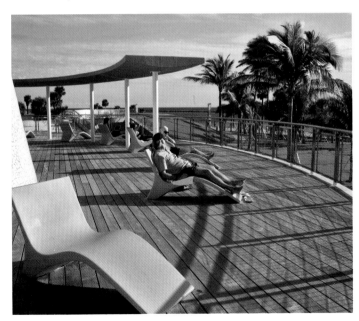

HANDS, HEARTS, AND TIME

As this book makes clear, the physical environment matters. It affects how we move and interact. But in the end, cities are about people. The urban experience depends on the communities we build and the institutions we create Dense neighborhoods need strong school systems, municipal governments, civic organizations, and cultures that support a common good.

Planners, designers, developers, and others in the business of city building can apply the principles of good urban form. They can work through the checklist of physical attributes that will make cities green, walkable, and livable, but that is only laying a foundation. Great places emerge over generations; they are shaped by the interplay of people, culture, and geography. Good urban form makes it possible for a neighborhood to become lovable—the kind of place to which people devote their lives and hearts—but it comes later, once its residents have made their mark.

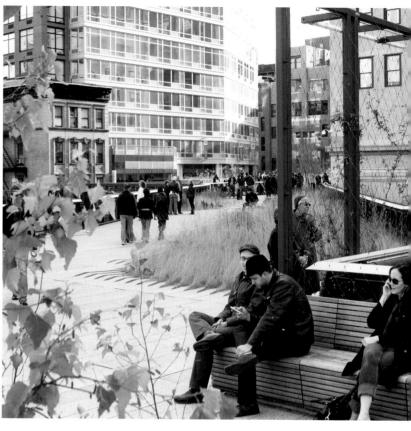

New York City.

Tucson, Arizona.

By highlighting the design principles of walkable density, the focus of *Made for Walking* has been placed on what makes a dozen selected neighborhoods similar. But their differences matter, too. Looking through the book, you've probably noticed how much the neighborhoods vary from one another. As you might expect, San Diego doesn't look a bit like Toronto. But it's not quite like Albuquerque either, or even Pasadena, which is only 130 miles away. You can see the shades of difference when you study the details. They are apparent in the photographs—in the architecture, of course, but also in the plants, the signs, the cars, the quality of the light in the sky, or the way people are dressed.

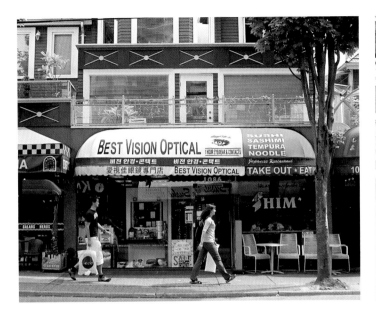

Vancouver.

Chicago, Illinois.

The images give hints about the climate and natural environment of each place. And they reveal the aesthetic sensibilities, lifestyles, business practices, ethnicities, and even politics of the people who live there now or who did at one time. Urban form provided an essential framework on which each neighborhood's residents improvised. The structures and enterprises they built created environments that fit the particular requirements of their time and place.

The traits these 12 neighborhoods share—small blocks, narrow setbacks, multistory buildings, and connected sidewalks—distinguish them as a group from North America's low-density subdivisions. But what really casts them in sharp relief is their distinctly different characters. Unlike the subdivision, whose form and details are stubbornly resistant to the effects of geography and culture, each of these places has a strong sense of identity.

Great neighborhoods begin with design, but they can't be designed. The ingredients of urbanism can be combined to build a physical framework that allows density and enables walking, but making a neighborhood is a much bigger job. It takes many hands and

Miami Beach.

Milwaukee, Wisconsin.

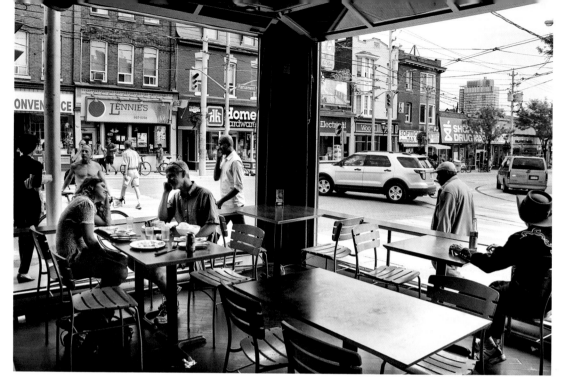

Toronto.

hearts, and it takes time. The process has been set in motion in many North American cities, but in others it is long overdue. For all the positive examples highlighted in this book, many more opportunities await—derelict industrial sites, defunct shopping malls, and distressed neighborhoods in need of investment.

In 1931 historian James Truslow Adams coined the phrase "the American Dream," which articulated the values key to American identity at the time. Like earlier statesmen and writers who had tried to define this uniquely American ethos, he deliberately distinguished material prosperity from the larger goal of achieving a better life through realizing one's potential. "It is not a dream of motor cars and high wages merely, but a dream of social order in which each man and each woman shall be able to attain to the fullest stature of which they are innately capable and be recognized by others for what they are, regardless of the fortuitous circumstances of birth or position" (Adams 1931, 404).

Somewhere along the line, between those lean years of the Great Depression and the swelling prosperity of the 1950s and 1960s, notions of a better, richer, and fuller life became bound up with the goal of home ownership. By the time the tide of suburban expansion crested six decades later, the primary icon of that dream—the detached single-family home with yard—had ballooned in dimension. Now, in the early years of the twenty-first century, hard economic times have prompted us again to examine our notions of a better life (Kamp 2009). It's time to redefine our aspirations by balancing material prosperity with opportunity, choice, and access to shared resources, and our neighborhoods are a good place to start. Reshaping them will bring us closer to the things we need—and to each other.

REFERENCES

Adams, James Truslow. 1932. *The epic of America*. Boston: Little, Brown and Company.

Angel, Shlomo, Alejandro Blei, Jason Parent, and Daniel A. Civco. 2011. The decline in transit-sustaining densities in U.S. cities, 1910–2000. In *Climate change and land policies,* ed. Gregory K. Ingram and Yu-Hung Hong, 191–210. Cambridge, MA: Lincoln Institute of Land Policy.

AP (Associated Press). 2012. American drivers turn to smaller, better engines. *Dallas Morning News* (14 July). www.dallasnews.com/business/autos-latest-news/20120714-american-drivers-turn-to-smaller-better-engines.ece

Belden Russonello & Stewart. 2011. The 2011 community preference survey: What Americans are looking for when deciding where to live. Washington, DC. www.realtor.org/sites/default/files/smart-growth-comm-survey-results-2011.pdf

Cambridge Systematics. 2009. *Moving cooler: An analysis of transportation strategies for reducing greenhouse gas emissions*. Washington, DC: Urban Land Institute.

Cervero, Robert, and Kara Kockelman. 1997. Travel demands and the 3Ds: Density, diversity, and design. *Transportation Research Part D: Transport and Environment* 2(3): 199–219.

Cervero, Robert, and Cathleen Sullivan. 2011. Green TODs. *Urban Land* (30 March). http://urbanland.uli.org/Articles/2011/Mar/CerveroGreenTOD

City of Portland Oregon. 2010. *Portland bicycle plan for 2030*. Part 2: *A framework for bicycling policy*. Adopted 11 February. Portland: Bureau of Transportation. www.portlandoregon.gov/transportation/44597?a=379133

Davis, Stacy C., Susan W. Diegel, and Robert G. Boundy. 2010. *Transportation energy data book: Edition 29*. http://info.ornl.gov/sites/publications/files/Pub24318.pdf

Doherty, Patrick C., and Christopher B. Leinberger. 2010. The next real estate boom: How housing (yes, housing) can turn the economy around. *Washington Monthly* (November/December). www.washingtonmonthly.com/features/2010/1011.doherty-leinberger.html

Donovan, Shaun. 2010. Prepared remarks for Secretary of Housing and Urban Development Shaun Donovan at the Congress for the New Urbanism. Atlanta, 21 May. http://portal.hud.gov/hudportal/HUD?src=/press/speeches_remarks_statements/2010/Speech_05212010

EPA. 2012. Inventory of U.S. greenhouse gas emissions and sinks, 1990–2010: Executive summary. (15 April). Washington, DC: U.S. Environmental Protection Agency. www.epa.gov/climatechange/Downloads/ghgemissions/US-GHG-Inventory-2012-ES.pdf

Ewing, Reid. 2010. Lecture at New England Smart Growth Leadership Forum, Boston, 10 December.

Ewing, Reid H., Keith Bartholomew, Steve Winkelman, Jerry Walters, and Don Chen. 2008. *Growing cooler: Evidence on urban development and climate change*. Washington, DC: Urban Land Institute.

Ewing, Reid, and Robert Cervero. 2010. Travel and the built environment: A meta-analysis. *Journal of the American Planning Association* 76(3): 265–294. www.tandfonline.com/doi/abs/10.1080/01944361003766766

Ewing, Reid, Arthur C. Nelson, and Keith Bartholomew. 2009. Response to Special Report 298, Driving and the built environment: The effects of compact development on motorized travel, energy use, and CO_2 emissions. Salt Lake City: Metropolitan Research Center, University of Utah. www.oregon.gov/LCD/TGM/docs/responsetodrivingthebuiltenvironment.pdf?ga=t

Ewing, Reid, Colin Quinn-Hurst, Lauren Brown, Meghan Bogaerts, Michael Greenwald, Ming Zhang, and Lawrence Frank. 2011. Prediction of transportation outcomes for LEED-ND pilot projects. In *Climate change and land policies*, ed. Gregory K. Ingram and Yu-Hung Hong, 213–243. Cambridge, MA: Lincoln Institute of Land Policy.

FHA. 2004. *Summary of travel trends: 2001 national household travel survey*. Prepared by Pat S. Hu and Timothy R. Reuscher. Washington, DC: U.S. Department of Transportation, Federal Highway Administration. http://nhts.ornl.gov/2001/pub/stt.pdf

————. 2009. The "carbon footprint" of daily travel. *NHTS Brief* (March). Washington, DC: U.S. Department of Transportation, Federal Highway Administration. http://nhts.ornl .gov/briefs/Carbon%20Footprint%20of%20Travel.pdf

————. 2011. Policy information: Travel monitoring: Historical monthly VMT report. Washington, DC: U.S. Department of Transportation, Federal Highway Administration. www.fhwa.dot.gov/policyinformation/travel/tvt/history

Jonathan Rose Companies. 2011. Location efficiency and housing type: Boiling it down to BTUs. http://epa.gov/smartgrowth/pdf/location_efficiency_BTU.pdf

Kamp, David. 2009. Rethinking the American dream. *Vanity Fair* (April). www.vanityfair .com/culture/features/2009/04/american-dream200904

Littman, Todd A. 2011. Introduction to multi-modal transportation planning: Principals and practices. Victoria, BC: Victoria Transport Policy Institute. www.vtpi.org/multimodal_ planning.pdf

Lynn, David J. 2011. Renewed urbanization will drive change in retail strategies. *National Real Estate Investor* (6 April). http://nreionline.com/property/retail/renewed_urbanization_ retail_0406/

Martin, John R. 2002. Siting power plants in the Pacific N.W. Portland, OR: Pacific Energy Systems. www.pacificenergysystems.com/SitingPowerPlants.pdf

Martineau, Chantal. 2005. From lake depths, a blast of cool for consumers. *Washington Post* (29 August). www.washingtonpost.com/wp-dyn/content/article/2005/08/28/ AR2005082800715_pf.html

NECSC. 2006. Community-district energy systems: Preliminary planning and design standards. San Diego, CA: National Energy Center for Sustainable Communities. www .necsc.us/docs/Community_District_Energy_Systems.pdf

Nelson, Arthur C. 2011. Resetting the housing market: Demographic and economic drivers to 2020. Lecture at Journalists Forum on Land and the Built Environment: The next city. Lincoln Institute of Land Policy, Cambridge, MA, 16 April.

New York City. 2011. Mayor Bloomberg and Transportation Commissioner Sadik-Khan announce 14 percent growth in commuter bike riding compared to last spring. Press release PR-275-11 (18 July). www.nyc.gov/portal/site/nycgov/ menuitem.c0935b9a57bb4ef3daf2f1c701c789a0/index.jsp?pageID=mayor_press_ release&catID=1194&doc_name=http%3A%2F%2Fwww.nyc.gov%2Fhtml%2Fom%2Fhtm l%2F2011b%2Fpr275-11.html&cc=unused1978&rc=1194&ndi=1

New York City DOT. 2008. *World class streets: Remaking New York City's public realm.* New York: New York City Department of Transportation. www.nyc.gov/html/dot/downloads/pdf/ World_Class_Streets_Gehl_08.pdf

————. 2010. *Sustainable streets index 2010.* New York: New York City Department of Transportation. http://www.nyc.gov/html/dot/downloads/pdf/sustainable_streets_ index_10.pdf

Oregon Department of Environmental Quality. 2010. A life cycle approach to prioritizing methods of preventing waste from the residential construction sector in the State of Oregon. Prepared for DEQ by Quantis, Earth Advantage Institute, and Oregon Home Builders Association. Portland: State of Oregon Department of Environmental Quality. www.deq .state.or.us/lq/pubs/docs/sw/ResidentialBldgLCA.pdf

Perrin, Noel. 1997. Lecture at "Life beyond the car" panel, University of Vermont Horticultural Farm and Shelburne Farms, Shelburne, VT, 7 October.

Rodriguez, Daniel A., Jub Huh, Brian J. Morton, Elizabeth Shay, and Yan Song. 2011. Built environment and transport-related greenhouse gas emissions in the Charlotte (NC) metropolitan area: An integrated transportation-land development model. Working paper. Cambridge, MA: Lincoln Institute of Land Policy.

Scheer, Brenda Case. 2010. *The evolution of urban form: Typology for planners and architects.* Chicago: American Planning Association.

Small, Kenneth, and Kurt Van Dender. 2005. The effect of improved fuel economy on vehicle miles traveled: Estimating the rebound effect using U.S. state data, 1966–2001. Energy Policy and Economics working paper 014. Berkeley: University of California Energy Institute. www.ucei.berkeley.edu/PDF/EPE_014.pdf

Transportation Research Board. 2009. *Driving and the built environment: The effects of compact development on motorized travel, energy use, and CO$_2$ emissions*. TRB special report 298. Washington, DC: National Academies Press. www.nap.edu/catalog.php?record_id=12747

ULI/PWC (Urban Land Institute and PricewaterhouseCoopers). 2010. *Emerging Trends in Real Estate® 2011*. Washington, DC: Urban Land Institute. www.pwc.com/us/en/asset-management/real-estate/assets/emerging-trends-real-estate-2011.pdf

U.S. DOT. 2010. *Transportation's role in reducing U.S. greenhouse gas emissions*. Report to Congress. 2 vols. Washington, DC: Department of Transportation. http://ntl.bts.gov/lib/32000/32700/32779/DOT_Climate_Change_Report_-_April_2010_-_Volume_1_and_2.pdf

U.S. Energy Information Administration. 2005. 2005 residential energy consumption survey: Energy consumption and expenditures tables. Washington, DC. www.eia.gov/emeu/recs/recs2005/c&e/summary/pdf/tableus1part1.pdf

USGBC. 2011. LEED for neighborhood development: Rating system. Washington, DC: U.S. Green Building Council. www.usgbc.org/DisplayPage.aspx?CMSPageID=148

————. 2012. LEED for neighborhood development certified pilot projects and plans list. Washington, DC: U.S. Green Building Council. www.usgbc.org/ShowFile.aspx?DocumentID=5205

Weinberger, Rachel, John Kaehny, and Matthew Rufo. 2010. *U.S. parking policies: An overview of management strategies*. New York: Institute for Transportation and Development Policy. www.itdp.org/documents/ITDP_US_Parking_Report.pdf

White, E. B. 1982. *One man's meat*. New York: Harper & Row.

Wright, Steven. 2010. Jokes by Steven Wright. www.wright-house.com/steven-wright/steven-wright-Kn.html

WSJ. 2012. Market data center: Auto sales. *Wall Street Journal* (3 July). http://online.wsj.com/mdc/public/page/2_3022-autosales.html#autosalesA

INDEX

ACKNOWLEDGMENTS

This book began as a sequel. *Visualizing Density* (2007) offered a panoramic view of American neighborhoods that left many readers curious about what those places looked like from the inside. I am grateful to the Lincoln Institute of Land Policy for responding to that need and in particular to Armando Carbonell for helping make the book more than a sequel. In typical Armando fashion, he raised big questions that expanded the scope of the project, leaving me sometimes overwhelmed and always challenged. His campaign to insert visual information into the planning process has supported much of my recent work, and it continued here with his encouragement to develop new graphic techniques for illustrating urban streets. I am also grateful to Lisa Cloutier for her insightful suggestions. In her quiet way she offered me the kernels that grew into the book's graphics.

Hearty thanks go to Ann LeRoyer, who oversaw the editing and production of *Made for Walking* from the its first tenuous days to its completion well beyond her expected retirement date. Her dedication to quality and accuracy was exceeded only by her patience with my insistently vernacular writing style. Thanks to Brian Hotchkiss, Peter Blaiwas, and Glenna Collett of Vern Associates and Tom Longval of Capital Offset, who transformed 85 pages of double-spaced Times New Roman and 500 tiff files into a thing of beauty. They made it look easy, but it required a collaborative dance involving many partners and long hours.

Between the research and writing phases of the book I was able to pause and reflect for a year of unstructured study. I am grateful to the Loeb Fellowship at Harvard University's Graduate School of Design for that gift and for the warm embrace of the Loeb family led by Jim Stockard and Sally Young. I was buoyed by my fellow fellows from the class of 2010: Rob Bleiburg, Patti Brown, Michael Creasey, Jose DiFillipi, Weiwen Huang, Gil Kelley, Neal Morris, Peter Steinbreuck, and especially Donna Graves, who read the manuscript and persistently reminded me that cities are about people. During that year I enjoyed the instruction of Connie Hale and the support of fellow writers in a Nieman Fellowship class on narrative nonfiction.

Darcy Hurst, Sally Brown Russ, and Etty Padmodipoetro graciously agreed to let me scrutinize and publish their families' travel rituals. Several people opened their homes and offered inside perspectives on the neighborhoods I visited. I am grateful to Daphne Ballon, Steve Butler, John and Hele Wolff, Mary Cregan, David Hohenschau, Ron Kellett, and Madonna Blunt for their hospitality and insights. Kelly O'Brien, Doug Bell, and Blair Galinsky provided key pieces of information on development projects. Thanks also to sometime traveling companions Simon Kassel and Tom Rowell, who joined me in the hunt for walkable neighborhoods.

Luc Brodhead, Simon Kassel, Spencer Wright, and Clara Campoli gathered background information and data on the case study neighborhoods. Thomas Kassel lightened my graphic load by preparing many of the montage images. I am fortunate to have generous friends and colleagues who offered suggestions, advice, and moral support: Alysia Abbott, Maria Balinska, Valerie Bang-Jensen, Beth Humstone, Jan Kelley, Judy Layzer, Alex MacLean, Aaron Naperstek, Andres Sevtsuk, and Tim Stonor. As always, my deepest thanks go to John Kassel, who makes anything seem possible.

— Julie Campoli

ABOUT THE AUTHOR

Julie Campoli, an urban designer, is coauthor of *Visualizing Density* and *Above and Beyond: Visualizing Change in Small Towns and Rural Areas*. In both her design practice and writing she combines a planner's perspective and a designer's sensibility to illustrate the built environment and the processes that shape it. Her research on land settlement patterns has been supported by grants from the National Endowment for the Arts, the Graham Foundation, and the Lincoln Institute of Land Policy, and she was a 2010 Loeb Fellow at the Harvard University Graduate School of Design. Julie's firm, Terra Firma Urban Design, is based in Burlington, Vermont. Contact: juliecampoli@gmail.com

ABOUT THE LINCOLN INSTITUTE
OF LAND POLICY

The Lincoln Institute of Land Policy is a private operating foundation whose mission is to improve the quality of public debate and decisions in the areas of land policy and land-related taxation in the United States and around the world. The Institute's goals are to integrate theory and practice to better shape land policy and to provide a nonpartisan forum for discussion of the multidisciplinary forces that influence public policy. This focus on land derives from the Institute's founding objective—to address the links between land policy and social and economic progress—which was identified and analyzed by political economist and author Henry George.

The work of the Institute is organized in three departments: Valuation and Taxation, Planning and Urban Form, and International Studies, which includes programs on Latin America and China. We seek to inform decision making through education, research, policy evaluation, demonstration projects, and the dissemination of information through our publications, website, and other media. Our programs bring together scholars, practitioners, public officials, policy makers, journalists, and citizens in a collegial learning environment. The Institute does not take a particular point of view, but rather serves as a catalyst to facilitate analysis and discussion of land use and taxation issues—to make a difference today and to help policy makers plan for tomorrow. The Lincoln Institute of Land Policy is an equal opportunity institution.

LINCOLN INSTITUTE
OF LAND POLICY

113 Brattle Street
Cambridge, MA 02138-3400 USA

Phone: 1-617-661-3016 or 1-800-526-3873

Fax: 1-617-661-7235 or 1-800-526-3944

E-mail: help@lincolninst.edu

Web: www.lincolninst.edu